THE DREAM

THE DREAM
A DIARY OF THE FILM

Mohammad Malas

Introduced and annotated by
Samirah Alkassim

The American University in Cairo Press
Cairo New York

First published in 2016 by
The American University in Cairo Press
113 Sharia Kasr el Aini, Cairo, Egypt
420 Fifth Avenue, New York, NY 10018
www.aucpress.com

Translated by Sonia Farid

Exclusive distribution outside Egypt and North America by I.B.Tauris & Co Ltd., 6 Salem Road, London, W4 2BU

Dar el Kutub No. 27120/15
ISBN 978 977 416 799 7

Dar el Kutub Cataloging-in-Publication Data

Malas, Mohammad
 The Dream: A Diary of the Film / Mohammad Malas. —Cairo: The American University in Cairo Press, 2016.
 p. cm.
 ISBN 978 977 416 799 7
 1. Refugee camps — Lebanon — Films
 2. Palestinian Arabs — Lebanon — Social Conditions — Films
 791.43

1 2 3 4 5 20 19 18 17 16

Designed by Jon W. Stoy
Printed in the United States of America

Contents

Introduction

Samirah Alkassim

Film Curator

The Jerusalem Fund and Palestine Center

I first met Mohammad Malas in 2003 when I was teaching film at the American University in Cairo (AUC) and invited him to be a Distinguished Visiting Professor in my department and he accepted. We planned a series of events, including sessions with students, a retrospective of his films, and a roundtable discussion with Egyptian film critics and filmmakers, such as Samir Farid and Raafat al-Mihi among others. This was in the weeks leading up to the U.S. invasion of Iraq, and all of Cairo was on alert, including the universities. In anticipation of massive demonstrations and state reprisals, Malas decided to postpone the visit. When he came a year later, in March 2004, we screened nearly all of his films on three successive days at the Falaki campus of what was then the AUC's location in the heart of Cairo. The auditorium was packed full—of faculty, filmmakers, film critics, media professionals, academics, artists, and some students. It was particularly moving to watch his films in the city of Cairo, with its history and leadership of anti-imperialist struggles and pan-Arab movements of the twentieth century. I know that, for Malas, this was acutely meaningful, especially as this was an audience that truly appreciated his work. They understood where he was coming from, and to them his work was representative of Syria's great

intellectual heritage. Of all the films, it was the screening of *al-Manam* (The Dream) that affected me the most—I recall the emotionally charged atmosphere in the room after the screening. I felt as if the film had touched a deep nerve among the people in the audience, across generations, who like me, were still reeling from the turmoil recently unleashed in Iraq. It must be remembered that the invasion of Iraq incited the largest mass gathering of protestors in Cairo since the days of Abdel Nasser—and Malas's presence in Cairo reminded us of this.[1] Before he left, being the generous person that he is, Malas gave me copies of some of his books, one of which was *al-Manam: mufakkirat film*, published in 1991 by Dar al-Adab in Beirut. Sonia Farid translated the book into English in 2005, and after editing and annotating the translation, I'm pleased to present *The Dream: A Diary of the Film*.

But first, a few words to introduce Mohammad Malas. In truth I have only met him on two occasions over the course of ten years, yet I feel a strong kinship with him, as if I have known him a long time. He is a master of cinema, and it is a pleasure to write about someone whose work I feel I understand, cinematically and personally. Objectively speaking, he is one of the leading film auteurs of the Arab world, whose 'art' films have gained global distinction since the 1980s. In both documentary and fiction film, his signature is the poetic and personal treatment of what might be regarded as 'ordinary' or marginal characters (particularly women and children) as they struggle with social and institutionalized forms of oppression. Like other Syrian directors, Malas's output has deepened despite the severe and inconsistent muzzling of artists and intellectuals in his country.[2] His semi-autobiographical feature films, *Ahlam al-madina* (Dreams of the City, 1984), and *al-Layl* (The Night, 1992), placed him squarely on the map of world film directors. The first two installations of a life-long trilogy, "Dreams of the City" and "The Night" are filmic odes to childhood loss (of the father and of the homeland—Malas's childhood village of Quneitra was seized by Israeli forces in the 1967 war and the Golan was subsequently annexed by Israel). This theme of

loss is prevalent in all his films, and provides a structural element in both this book and the documentary *al-Manam* (The Dream, 1987). Malas's more recent feature films, *Bab al-maqam* (Passion, 2005) and *Sullam ila Dimashq* (Ladder to Damascus, 2013), as well as all of his documentary films, are equally distinctive.

Malas was born in 1945, and in his lifetime Syria assumed a central role in Arab nationalism and Cold War politics in the Middle East, bound by a sentiment of pan-Arab unity even though the roots of such sentiment stretched far beyond the twentieth century. Like many of his generation, he studied filmmaking at the Moscow Film Institute (VGIK) during 1968–74, where he learned a language of cinema that he developed into a vernacular entirely his own. His work, along with that of other important filmmakers, such as Omar Amiralay (who collaborated on the production of "The Dream"), indirectly critiques the abuse of Syria's national narrative—its legacy of successfully expelling French colonialism, fighting Zionism, and embracing a secular nationalism. For readers unfamiliar with modern Syria, it is the abuse of Syria's national achievements by a deadly security state apparatus to justify its hegemony that filmmakers and artists like Malas contest, as has been discussed by Cook and Wedeen, among others.[3] This nationalist narrative began to unravel in the wake of the Arab Spring in 2011, which inspired and brought hope to the youth of Syria, however brutal the Syrian's regime's retaliation, and despite the evolution of the Syrian uprising into a civil war. True to form, Malas would address this unraveling in his 2013 film, "Ladder to Damascus." Not enough can be said about the devastation of a people and a country that has spiraled into a drama of overlapping proxy wars and new enemies unimaginable fifteen years ago.

It is not truly comparable to the Lebanese civil war although the analogy is always close. It makes more sense to regard the 2003 U.S. invasion of Iraq as the root of the manufactured sectarian conflict that has overtaken Syria. However, there is still something instructive in reflecting on the Lebanese civil war, that other very complicated and bloody conflict that began in 1975 and ended in 1990 and resulted

in hundreds of thousands dead and tens of thousands missing. It was a very confusing war, with many factions, parties, and shifting allegiances. It was not just a war between Muslims and Christians, between the Palestine Liberation Organization (PLO) and the Lebanese, or between leftists and right-wing parties. Aptly described by late Lebanese filmmaker Randa Chahal Sabbagh as a series of "heedless wars" in the title and subject of her 1995 documentary *Nos Guerres Imprudentes* (Our Heedless Wars), other major players included Syria, Israel, and to a less visible degree the United States and the Soviet Union, who all pursued their own political, national, and regional interests. The Palestinian refugee stood at the center of this conflict.

This particular text, *The Dream: A Diary of the Film*, reveals Malas's private thoughts and observations as his film takes shape. In other words, through this text, we see the interior of a film project. This is both a film and a book, working in concert with each other—each in a sense incomplete without the other. It is written in poetic prose, often in note form, in a style which by its nature resists building a totalizing portrait or narrative. It is the chronicle of Malas's experience of meeting and filming people living in the Palestinian refugee camps in Lebanon from 1980 to 1981—Shatila, Burj al-Burajneh, Qasmiyeh, Nahr al-Bared, and Ein al-Helweh, among others. This book and the subsequent film (although the film was actually released before the book was published) provide a snapshot of a collective body of refugees at a critical juncture during the Lebanese civil war, at the height of the PLO's presence in Lebanon (on all registers: symbolic, social, cultural, economic, personal, historical), and before the devastating Israeli invasion of 1982. Malas's initial idea of making a documentary about a Palestinian family quickly turned into an observational documentary composed of nocturnal dreams as narrated by Palestinians in the camps. As an observational documentary, every shot was carefully studied and composed before filming—this we learn from the book. This is the technical and artistic aspect that enhances the content; it is the dreams themselves that the film seeks to 'observe.' These dreams

are woven together into an informative text on the statelessness of Palestinian refugees and their right to self-determination. Throughout the process of making this film, Malas sought to discover, without suggesting a monolithic vision, the 'quintessence' of the Palestinian. The dreams of the Palestinians in this work reveal the extent to which their plight recurs and resonates in the fabric of the Arab world.

Perhaps Malas's own experiences of loss, as has frequently been mentioned by scholars and critics,[4] compelled his interest in the subject of this diary and subsequent film. But there is also a commitment to memory as a necessary response to loss. Remembering the dead is necessary in order to grieve, and when we look at his different films and texts, we find that this is a common thread. Loss is part of the picture; it is the motive behind the act of filmmaking, and the act of remembrance. If his own father had fought and died for Palestine (as is suggested in his film "The Night"), was Malas perhaps investigating his own relationship to Palestine and the Palestinian struggle as another way of understanding his father? Perhaps he was trying to find the contours of this feeling in the diary and film, with the desire to heal both self and other. Who are people at their core if they are not their dreams, hopes, fears, memories, and affinities? Perhaps allowing his subjects to share their preoccupations through their dreams would illuminate the collective imagination of stateless Palestinians—who are so often used as pawns in the political games of the region, then and now. The result of this telling is to not only remind us of loss, but of the lives lived, the presences embodied, the experiences that occurred, the spaces that were inhabited, and the dreams that were dreamed. The most important message of this book is to be found in the margins: what came before and after it, what is alluded to in the shadows of someone's eyes or in the narrowness of an alley. The places mentioned—Khalsa, Safad, Acre, and so forth—are real places that these people were expelled from and to which they and their descendants are not allowed to return. As for the other events referred to in the work, the women raped, the houses looted, the buildings demolished, the villages ruined—all of which

have been partially documented in oral testimonies now available on certain websites such as www.palestineremembered.com—reality mixes with dream.

The book is framed by two major massacres of Palestinians during the war in Lebanon: Tel al-Zaatar in 1976 (following on the heels of the Karantina massacre) and Sabra and Shatila in 1982. Tel al-Zaatar was a densely populated refugee camp located on the Christian side of the Green Line in Beirut. In 1976, a unified group of Christian militias called the Lebanese Front, comprised of the 'Tigers' militia, the Phalange Party, the Guardians of the Cedars, and al-Tanzim, entered the camp and slaughtered between two and three thousand Palestinians in the span of fifty-two days. The PLO factions fighting back were Fatah, the Popular Front for the Liberation of Palestine (PFLP), and the Democratic Front for the Liberation of Palestine (DFLP). In two days in 1982, September 16–17, an estimated two thousand or more people were slaughtered by Christian Phalangist militias, with the knowledge and implicit consent of Israeli forces, in the massacre of Shatila and the neighboring slum, Sabra. The massacre was in retaliation for the killing of Bashir Gemayel, the then president-elect of Lebanon and senior leader of the Phalange Party, and was conducted under the supervision of Ariel Sharon, the then Israeli defense minister, who was also the architect of the Israeli invasion.

Some of the survivors of Tel al-Zaatar appear in "The Dream," some of whom, as we are informed at the end of the film, would perish in the Sabra and Shatila massacres. What are we to make of this work that chronicles the dreams of survivors of one massacre who then face death in another? Is "the dream," the parenthetical aside Malas refers to on the first page of his preface, inserted into a reality where nothing changes? Aside from the framing massacres of this text, references are made to many other events, places, and figures central to the post-1948 Palestinian narrative—Land Day, historic Palestine, Shimon Peres, Gamal Abdel Nasser, Yasser Arafat—which project, through the dreams narrated by the film's subjects, an overarching narrative of the Palestinians in the post-1948 Arab world:

their aspirations and hopes, but also their humanity and their right to exist, despite the indifference of Arab and other rulers.

For readers familiar with history, the Camp Wars of 1985–1987 also appear on the margins of this text. When the PLO leaders departed in 1982 it was largely a symbolic departure—many of the PLO fighters remained and were absorbed by different Palestinian factions. The Camp Wars were essentially a struggle between Palestinian factions and Syrian-backed forces in Lebanon, the aim of which was to put an end to the influence of the PLO and Yasser Arafat. It is considered the bloodiest period of the civil war, ending with massive casualties on all sides. The different Palestinian factions were united against Amal, the Shia militia headed by Nabih Berri, which was allied with Syria. Hezbollah, which at that time was just emerging and still a very minor player, received military training from leftist Palestinian factions. Walid Jumblatt, the Druze leader and head of the Progressive Socialist Party, refused to participate with the Syrians and Amal in besieging the Palestinian camps, and allowed the different leftist Palestinian factions to maneuver in his territory. The Lebanese Communist Party leader George Hawi viewed the Camp Wars as an attempt to finish the Israelis' effort to eradicate the Palestinian resistance on all levels.

In the original Arabic text, Malas frequently switches tense between past and present, as if one constantly erupts into the other, or as if the present moment is enveloped in the past. This conveys a temporal register outside the hierarchies of historical time. The style of writing also moves from meditation to observation, from shorthand notes to poetry and synesthetic description. The notation of banal details freely gives rise to poetic reflection. There is also reference to the camera as an organic extension of the filmmaker—just as much his eye and his conscience, the camera is a tool of analytical and humanizing portraiture. Yet at times (as is apparent in the book) this cannot be reconciled with the limitations of what Malas searches for within himself, asking himself questions to which he finds no certain answers.

In a sense Malas began this project at exactly the right time. When he embarked on it in 1980, as a Syrian he had to work hard to convince the different parties of the authenticity of his intentions. Between 1980 and 1981, he interviewed and filmed approximately four hundred people. Following the traumatic events of Sabra and Shatila in 1982, he completely halted the project. It was only after the success of "Dreams of the City" that he was able to return to it. The closing chapter of the book describes his return to Shatila in 1987, after a two-year siege had been lifted, and after a copy of the finished film was smuggled into the camp and viewed by its inhabitants. Completed six years after Malas began the project, the film was edited down to twenty-three dreams with a total of forty-five minutes of screen time. Both diary and film present their subjects somewhere between the past and present, preserved in word, magnetic tape, and now digital code. Umm Hatem, Abu Turki, Umm Yousef, Abu Adnan, Umm Alaa, Intisar, Elham, Ibrahim, and many others who may have perished come to life each time we read these words or see and hear them in the film.

In the end we are left with the sense that the cinema, as magical as its powers may be, is a limited art form, far surpassed by the power of our imagination and feelings. It is this place of imagination, feeling, and authenticity, this transcendent realm, that Malas is always trying to reach. In reaching for the transcendent, this book is ultimately a work of poetry that functions as a requiem for the cinema. Malas closes his text with a special emphasis on the word 'cinema,' turning the second syllable of the word into *ma*', the Arabic word for 'water,' connoting the capacity of both water and cinema to reflect the images and dreams of the human protagonist, so easily disrupted by the waves of other bodies in motion. The diary and the film both present the question unanswered, the problem unsolved, of when will there be justice for the Palestinians.

We have strived to preserve the essential qualities and character of the original Arabic text in this translation, in order to provide English-speaking readers with access to this valuable encounter with the

voices and faces of the people it portrays. While neither book nor film endows their subjects with agency, they offer readers and viewers a form of mediated contact with the affective experience of Palestinian refugees who lived in the camps in Lebanon in 1980–81. More than thirty years later their existential crisis is far from over.

This book is dedicated to the novel
The White Masks by Elias Khoury

The eye is the lamp of the body; so then if your eye is clear, your whole body will be full of light. But if your eye is bad, your whole body will be full of darkness. If then the light that is in you is darkness, how great is the darkness!

Matthew 6:22–23

Preface

I never understood how or why the idea for the film I was about to make took root inside me. It was supposed to be about a Palestinian family, and I was on my way to Beirut.

I vividly recall that moment in the car when the memory of Tel al-Zaatar appeared before me, out of nowhere, like a dream.

Drifting between bitter memory and the merciless collapse of an idea for a film that I was on route to Beirut to make, I shrank behind the windshield and soaked in the warm morning sun. When I reached al-Watani Street,[1] or 'the Last Street,' as members of the Resistance in Beirut called it, this street seemed to me like a parenthetical aside inserted into a dream.

I went down the street alone, trying to grasp the images and motions—the balconies, people's clothing and uniforms, their guns, the loudspeakers, bookshops, women . . . I contemplated the lives lived in the twists and turns of this 'Last Street' and was filled with dreams of making a film.

When I talked to an official at the media center about finding a Palestinian family in one of the camps to film,[2] I realized I was discussing an idea that had already died. The old idea was evaporating while a new one rapidly metastasized inside me.

At the time, fresh posters about historic Palestine were being printed, coming off the presses like hot delicious bread. Preparations for Land Day celebrations had begun, and Israeli warplanes hovered in the sky above.

Nothing changes on al-Watani Street, this last street that eats its daily bread with one hand, closing with its other the brackets of that parenthetical aside.

Surveying and Scouting I

Friday, March 28, 1980

According to Ibn Sireen, it was the prophet Adam who experienced the first vision on earth. God caused Adam to fall into a deep sleep, then from him created Eve in a similar shape, revealing this to Adam in a dream. When Adam awoke Eve was sitting near his head. Then God said, "Adam, who is this sitting near your head?" Adam said, "She is the vision you revealed to me in my dream, God."

A pharaoh dreamed that a fire came out of the Levant and raged until it reached Egypt. It left nothing untouched, burning all of Egypt's houses, cities, and fortresses. The pharaoh awoke, horrified.

I feel like my work has begun.

The day's warmth mingled with the warmth of Jihad's accent—Jihad was the guide who would accompany me. He had recently come from Gaza to work for the Palestinian Film Association.

On the office staircases are women cleaners dressed in black, tranquility, fresh air, and open windows. A man who had gone in to his office early was drinking coffee and smoking his seventh or eighth Rothman cigarette. This is the office that provides escorts to foreign visitors who want to tour the Palestinian camps.

A stream of foreign women comes out. Languages and questions overlap with the ringing of the phone and a general curiosity about, or attempt to flee from, the different delegations.

Then a voice snaps at me, "Do you have a car?"

We get in the escort's car and start out for the camp.

Shatila

The escort knocks on a zinc door and calls out:[3] "Abu Tareq! Abu Tareq!" The door is low, the wall is low, the alley narrow. The windows are at eye-level. Behind the door is a tall green tree, the rattling of a stove, the clatter of pans and dishes, and a voice coming from below bellowing, "Abu Tareq isn't here. He's still at the Committee. Come in."

The room was green and dimly lit. In it we saw a narrow bed had been laid out, on which lay the young man who had invited us in. He explained straightaway that he had undergone an operation on his nose yesterday, and then resumed lying down.

On the wall was a photograph of a martyr, one of the Resistance leaders, framed in such a way that suggests a personal relationship to the man. I got the sense that the escort had knocked on this first door in order to get rid of us. The house seemed to be one of the first in Shatila; its location and the age of the tree suggested this.

I understood from the conversation that Abu Tareq is one of the camp's dignitaries and a People's Committee official.[4] The escort fidgeted and complained, and then decided his job was done. He withdrew, leaving us free to continue the tour. At two in the afternoon Abu Tareq was ready for us. He started speaking animatedly about the People's Committee.

"Water and electricity, paving roads, eliminating pot-holes, emptying sewers, cementing alleys, settling disputes"

We walk toward the People's Committee headquarters. The camp's buildings sit snugly against each other, staircases growing around their waists. It is as if this place is the site of first refuge, the way to the heart of the camp.

I have the sense that I am inside a single yard. Television antennae intersect with each other at eye-level like a swarm of insects.

The People's Committee headquarters is striking.

The public water reservoir towers above the street. The Committee's room was built beneath it; a staircase had been installed on each side, one by the street, the other by the reservoir.

The interior of the Committee's room feels like the captain's room of a sinking ship. The sea breeze and mountain air waft in through the window, but the weight of the reservoir above makes you feel as if you're sinking into an underground refuge.

In the Committee's room is a bracelet of long benches, a table, a safe for money and documents, a telephone, a bulletin board.

A noise pierces the air, intertwined with scattered dialogue, a mixture of recollections, memories, and daily problems. Envoys of the Lebanese electricity company were demanding the Committee intervene to collect the camp's electricity bills, long overdue since the beginning of the civil war. There was no way we could start our survey in this chaos.

Saturday, March 29
Abu Shaker—the eyes

"What do I want to see in the film? I want to see our lives. This is where we've ended up, thirty years later."

We're sitting at the entrance of his store. A man whose features had shrunk, except for his eyes, which were prominent, almost bulging. His hair is white. His shirt is white. His suit is gray. He talks as if speaking to himself. He says something, then throws the kids whatever they've requested—a piece of candy, chewing gum, a composition book, juice.

"This is how bad it's got, and still we thank God. The sun sets and here I am. The sun rises and here I am. It's a prison, this house."

He points to the house opposite the store. The distance between them is probably no more than three meters. Watching his hand point to the house, I thought of opening the film with his walk from the house to the store—and ending with his return from the store to the house.

"What is there to be happy about? For me to be happy, I have to feel that I am safe, that Israel is not constantly bombing me.

"I used to have hope, a lot of it, for myself and otherwise. They were lost, my hopes were held back at borders other than those I had in mind."

Abu Fuad

He was squatting at the entrance of the store, picking seeds from crushed tomatoes before putting them in a bucket of water. He refused to receive us in the store. He got up and led us to his house behind the store's facade. In a room painted blue—reminiscent of coastal cities—a painting of the olive harvest done on cardboard by a popular artist hung haphazardly on the wall.

Abu Fuad is a man who gives the impression of being coiled within himself—a slim, lively mass of nerves and motion. While he talks he invites you to sit down, to have a cigarette, a lighter, some coffee. He gets up, brings you the ashtray, pulls a chair over to you, calls out to his wife, sits down, gets up again.

"I'm a merchant. I crossed Palestine extensively." I was struck by that expression—'extensively.'

"I was a merchant. Now I'm sixty, meaning I was born in 1918. I was in charge of orange groves in Tantura. Tantura overlooks the sea and Jews used to go there to swim. There is no country like ours in the east. The mukhtar, the Jews' mayor, came and said, 'Surrender. There are fifteen thousand armed men surrounding the town.' And us, what did we have? We had ten cartridges and seventy-five young men. They took the seventy-five young men and shot them. Turns out the mukhtar got three stars for that They bring the films made here to Israel.

"Someone told me that he saw our neighbor Abu Turki smoking arghile in Germany. What drove Abu Turki to Germany . . . ?"

Abu Turki

"The arghile is man's best friend because it listens but never talks. You're here for a reason. If it's to visit, you are most welcome.

"Talking is better than filming. We can talk . . . I don't have a problem talking. I even talked to Ted Kennedy when he came to visit the camp. I grabbed his necktie—he was in front of the store—and told him about our problem."

Abu Turki sits down at the shop entrance, his arghile next to him: "King Saud came here. He stood in the forest. A lot of people have come here, and nothing has changed. Thirty-two years in the camp. When my children change their accents, we say, 'What's this, you seem different.' We don't say that someone is from such and such camp. No. We say, 'from this or that village.'

"I had two photographs, one of which I was very proud of. It dated back to 1943. I remember clearly how I went to have my picture taken. There was an Armenian photographer in some street. I was wearing a pullover." This is a man we have to return to. He has a strong memory and he's an excellent talker. His face is full of radiance. I will come back to him a second and a third time.

"I have dreams. I sleep a lot during the day, and I dream. And I'm happy when I sleep.

"I once saw Shimon in my dream.[5] We were sitting in a house. The kids were baking. My hands were sooty because I was cleaning the stove. I found Shimon dressed in white, without that tie of his. He approached me, extended his hand and shook mine. My hands were black. I swear to God, he said, 'How are you? What are you doing here?' I said, 'I live here, as if you don't know!' After a while, I found him saying, 'Gunpowder and canons, gunpowder and canons.' Then I woke up. I have a recurring dream. I arrive at our village. I get close to the house, and as soon as I approach it, I wake up. Not once have I entered the house."

Sunday, March 30
Abu Shaker—the eyes
It's our second meeting, at the house.

I went back to him again, feeling that this man lived in a perpetual state wherein the ground beneath him no longer exists. It was an odd

impression, as if he were standing and there was a space separating him from the ground. About to fly away, he would lift his eyes first. Then, calmly and deliberately, he'd rise a few centimeters off the ground. He had agreed to talk to me about the trip to Palestine in 1972, but he would only talk, not film. We crossed the short distance between his store and the house, and in the house I placed a cassette recorder in front of him and let him talk.

The house, like the store, is clean, neat, with everything in white. Iron bars cut across the window, the four walls are adorned with many photographs, including some of Abu Ammar, al-Aqsa Mosque, and a photograph of a young man and woman in their wedding clothes. The recorder captures both his voice and the lively music coming through the window from the numerous speakers scattered throughout the camp. Ah yes, now I recall, I believe it is Land Day. "I made it to Jenin. I took a car from the bridge and said to the driver, 'I want to go to Acre Province. How much will you charge me?' We agreed on the fare. This wasn't right when I arrived in Palestine; it was one of the things that happened while I was there. We were on our way and I asked the driver, 'Which way would you like to take?' He said, 'From here to Nazareth to Haifa, then we reach Acre.' Our village is between Safad and Acre, around twenty-eight kilometers from Acre. There's a shorter way than the one the driver suggested, from Jenin to the village. I said to him, 'There is another way that's shorter for you. We've agreed on the fees.' He asked, 'What way is that?' I told him we'd drive through Afula, then east of this and west of that. He said, 'I don't know this route and have never gone that way. Are you sure? Where are you from? Are you a refugee?' I told him that, yes, I'm a refugee in Lebanon. He asked what year I left and I told him 1948. We drove while I showed him the way, right and left, until we arrived. I asked him, 'So which is the shorter way—this one or that?' The young think I've forgotten them, that I'm behind the times, old, no longer good for anything.

"We stay up from morning until two or three after midnight. 'Go now, go to sleep,' I tell them. They say, 'No, Uncle, we don't want to

sleep. You're here with us today; tomorrow you won't be. We need to get our fill of you.'" I wonder if we could hear the dreams of the thirty-two nights he spent there. "Thirty-two nights and I swear I didn't sleep, night or day. I swear to God I didn't sleep." He cried. "I just sat there, always distracted, distracted." He cried bitterly. "If I had a dream, I don't remember it now. After I came back I had many dreams, but these days I'm not alert. I don't remember.

"I have zaatar, olives, and yogurt for breakfast.

"I teach my son lessons from the past."

A tiring, anxious meeting. He is constantly distraught, overcome with grief over the land, his eyes bulging and full of tears. I am not sure why, but for me this man is the eyes of the film. I'm considering using the three-meter distance he crosses between the house and the store. I wonder if it's possible to film the moment he returns from the store at night and lies down on his bed as one shot. What can one do with these two or three meters of space?

Monday, March 31
Burj al-Barajneh

The atmosphere has been tense since morning; perhaps a few clashes have occurred. We're trying to obtain a written permit to scout in Burj al-Barajneh camp. Jihad and I are waiting downstairs at the entrance to the building; the official hasn't arrived yet. The employees of the PLO institutions file in gradually, one after the other. It's a warm day. The sun is shining. There still isn't much activity but there is an underlying sense of tension in the air that I don't understand. I hadn't listened to the radio last night or this morning, hadn't read the papers. Tired. A little worried. I feel the scouting is being taken over by formalities. I'm not mixing with the people. I'm watching, not scouting. Sometimes I'm engrossed in watching. I don't have many questions, sometimes none at all, and other times I'm reluctant to ask the questions I have. Time is passing quickly; the results are limited. I don't know how to find a way to access the present moment of these people. People are afraid of the present. Maybe it's a feeling of insecurity or maybe it's

the yearning for the past and the shared memory of tragedy, typical of Arabs. I feel that the Palestinian issue is intertwined and entangled with this yearning. Palestinians are cautious, and the idea of the film being about a family is dwindling more and more. I'm becoming more attracted to the idea of people's dreams and how they narrate them. I'm not at all drawn to how they feel about their dreams, and many of the people I talk to don't conceal their resentment and surprise when I ask about dreams in this turbulent and tense atmosphere.

We obtained the permit at around ten in the morning, and took a local bus to the Burj. I have never visited this camp. Whenever I've passed it, which has happened many times at sporadic intervals in the past few years, I have felt a strong sense of affection for its resonant name and its location in the middle of Beirut. But I always worried about it; to me it looked like a place held tightly by a fist. Today I am happy to have come, because I was here to visit a friend.

In the Armed Struggle Headquarters a young man was assigned to accompany us. He held his weapon and started walking, saying, "Follow me." We followed him on foot, entering the camp's alleys. He didn't ask any questions—I think he thought we wanted to see the camp. I tried to explain the film to him on the way, in case he could introduce us to people. He nodded that he understood. He was a smart and nice young man, and it was clear from his first steps in the camp that the people there knew him and felt warmly toward him. However, honestly, I was quite uneasy scouting while accompanied by a Kalashnikov.

Abu Hatem

Abu Hatem was standing in the alley supervising a construction worker. He had apparently decided to tear out part of the house's courtyard to convert it into a store. The store was now in the process of being severed from the house.

We greeted him, and he responded with a natural, if confused, warmth then led us to the only remaining room in the house. As soon as our armed escort explained the reason for our visit, Abu Hatem

started speaking freely and told us his life story. At first I didn't manage to place the recorder in front of him, and after he started talking I didn't want to interrupt his flow. How I regretted that!

"Twenty-five years in the Ghandour factory. They gave me 10,000 Lira in compensation, which I'm using to build a new store." He is forty-seven now, from Acre Province. He'd moved from Palestine to Anjar, then to Burj-al-Shamali, then to Burj al-Barajneh. "When I came from Palestine, I visited my folks there every single holiday. I used to go alone, secretly. I walked from here, and as soon as the sun set I'd stay hidden in the trees. Then when it got dark, I'd keep walking. One time as I reached our home a man from the village saw me. Later, while I was in the house, the Jews came. They knocked on the door. My father was eighty at that time. They knocked. My father hid me, but they entered and took me. Where did they take me? To Acre Province." His scorched voice has a special depth. "They interrogated me. The superintendent—known as Abu Khader, an Arab-Jew—interrogated me. He had a Bedouin accent. In those days the Jews used to dump a busload of Arabs at the borders every Saturday. Abu Khader said the government refused to let me stay: 'We have to deport you, but this time we'll take you to Abu Tbeekh's.' I said, 'Who is Abu Abu Tbeekh?' He turned out to be King Abdullah, and I really was deported to Jordan. After he deported me, I went back, fled to my folks for one night and snuck back to Lebanon." He is married without kids. He reminds me very much of the pessoptimist.

"I once dreamed that I was dead on a bed in a green room. Somebody knocked on the door. I said, 'Who is it?' A voice replied, 'Open the door.' 'Who is it?' 'It's a guest.' I said, 'The guest of God the Merciful is most welcome.' I got up, opened the door. It turned out to be my father with two mashayikh. My father was dressed in white. His hatta, 'aqal, and qumbaz were all white, and his jacket was white too. The mashayikh were wearing green turbans. They came and stood next to me by the bed. I said to my father, 'What's the matter? No one told me you died.' He said, 'I am dead but alive. Come with me.' I said to him, 'Whatever you want. I'm at your command. If you want me to go, I'll

go. If you want me to stay, I'll stay.' He said, 'No, stay. Not yet. Your time will come later. May God make you happy.' A dream is a merciful thing.

I never dreamed of my mother, but one of my relatives from our village, who is living here now, came to me once and said he saw my mother in a dream. He said, 'I saw your mother dressed in white. I thought, that must be a good sign. May God grant her a place in paradise.'

"One time I dreamed I was going back to the village. I arrived at the village to find that the house had been blown up—that the house in the village was blown up. And as a matter of fact, in 1936 the British,[6] not the Jews, blew up this house. At that time, its owner built a house next to it,[7] not in its place. I thought, 'How long has it been like this?' We went to Lebanon, and when I returned to Palestine the man still hadn't rebuilt his house. I continued on, there was a mosque and a holy man's shrine further up. I read the Fatiha and said to him, 'Master, you are one of God's holy men. Deliver us from this plight.' I turned around and saw myself surrounded by emptiness. I walked back toward the house but woke up before I arrived.

"I've never dreamed about the factory owner, but I did dream about his son once.

"Before he died, the factory owner's son used to speak to me very rudely. In the dream I said to him, 'Listen, Nizar. I worked with your brother for sixteen years and never heard him say such things. You've been here for three years, and you've been out of line three times. Look, two mountains may never meet, but human beings do.' This is what I told him in the dream, after he died."

What am I doing? Am I buying people's dreams? What will I do with them? Serve up a handful of their souls and leave? I forgot to write down that he told me he didn't participate in the Ghandour factory workers' strike because he is Palestinian.[8]

Abu Khalid—the vendor

He asks us to produce an informative cinema. "The Revolution subsided, and so did we. For us to sustain our enthusiasm, we must have films that excite us.

"The film should be the pain of the Palestinian people. I want to feel pain and fury at the same time. I, as a storekeeper, can be of great use to you. For example, I can show you what people buy here in the camp."

The bastard wants an informative cinema and suggests a magnificent documentary idea. Let me elaborate: as we buy people's dreams, let's see what people buy for themselves . . .

"We have a miserable situation here. Prices have soared. Some people don't have money to buy food. There are no jobs. Some people turn to the Revolutionary Council for food. Two hundred grams of meat costs eight liras. Nobody lends money any more; there are no loans. There are only ten pages in my account book.

"Sometimes I have dreams. I feel I'm in Deir al-Qasi cultivating the land. Sometimes I'm sitting under the olive tree, sometimes I see myself sitting in a cage. My father lives with me. He is seventy. I have nine kids. Now my sister has brought her kids here too. She fled Rashidiyeh to escape the bombing. By the way, Rashidiyeh is empty. There is nobody there but fighters."

Abu Ibrahim

"We're ruined."

We're sitting in his store, silent. Abu Ibrahim is in no state for talking. He sits at the front of the store, not looking at us. He stares ahead, head lifted as he watches the street. He says a few words followed by a long silence; then he says something else, as if continuing his own private conversation. He looks my way cautiously. He watches my hand. He looks at the notebook and the pen. Then he looks at the road again. When our armed escort—it seems Abu Ibrahim likes him a lot and knows him very well—tries to cheer him up and urges him to talk, he shakes his head, looks at me, contemplates the notebook for a while, then goes back to looking at the street, tossing a word or two to the air.

"We're responsible for what happened."

It seems he has a son who was martyred recently.

"I just want one thing: to die in my country."

In the front section of the store hang two photographs in golden frames. One is a photograph of King Faisal, and the other is a photograph of Abu Ibrahim in pilgrimage clothes in Mecca. He fidgets in place, groaning as if suffering from an illness. "We fellaheen like eating spicy food. Now I have testicular inflammation. Before that, I had hemorrhoids and a dermoid cyst." Fighter planes passed overhead. The noise caused anxiety and tension. This was followed by the sound of rapid anti-aircraft artillery. After quiet resumed, I noticed for the first time the absence of the radios that usually fill the camp with a medley of songs. Now it is silent.

"Take him," he says, waving toward our armed escort, "to Hussein. Let him fill this notebook of his." Of course he means my notebook. "We don't talk about anything except the land."

When some fighters passed by the store he commented, "They no longer want to be educated or to work. They want to come and go. Whoever is martyred is just dead. No matter how bored you get, Palestinians won't say anything to you except 'I want my country.' Others will tell you the same thing I told you: 'Open Palestine to Israel? That's absurd!'" Suddenly he's shouting, then his eyes fill with tears and he cries. He calms down, and continues speaking about his physical pain in a broken voice.

"I buried my son and father here. I swear to God I won't leave them here no matter what happens. But we turn toward the Qibla." For him, the Qibla is Palestine. In Lebanon both Palestine and the Qibla are in the same direction.

I'm thinking about how to shoot this—what if I came to the store, placed the camera here in front of him, and let it record him without anyone asking questions or waiting for answers? I looked carefully at the place, considered the lighting options and chose a spot for the camera, but—damn—these spontaneous moments usually fall apart when shooting.

"I swear I won't wake up. I lost a son. I swear to God I'll follow him. No one was dearer to me than my son, except God. He visits me every day in my dreams, he and my father. I always find them there, in

Tarshiha. He came to me two or three days ago. He hit me and said, 'Do you want to die?' I replied, 'No.' He said, 'You want to die because you want to cry for me.'"

It is hard to determine whether the son said this to him in a dream before he was martyred, hence as a portent of death, or if he meant his son came to him after he was martyred. Dreams mix with reality like a combination of illusion, intuition, and hallucination.

"I'm going to die. If you want to come back here to film, you won't find me. Palestine is the mother of the poor. Some 140,000 Lebanese used to come, and we would issue identification cards for them, when we were in Palestine. We don't want identification cards; we just want them to bear with us a little bit. There were thirty-six mortar rockets at my son's funeral. They took my grandson to Mecca. He's there now. He is two years and one month old, at Princess Qaoud's.[9] Before he died, I knew. I used to say that Mahmud would die when he was twenty-five years and ten days old. A day before he died, I told them that Mahmud would die." Another attempt to convince himself. "That day I was sitting here, and whenever someone passed by and looked at me, I suspected something had happened to Mahmud. I no longer want our land. I will take my father and son and erect a tombstone and die with them. I will take them, erect a tombstone, lie down, and sleep. We used to have 3,663 olive trees. Now I am sick and dying because I no longer drink olive oil."

Tuesday, April 1

In the Armed Struggle Headquarters, we asked for the young man who had accompanied us the day before. We were surprised to learn that he had applied for a leave and had traveled to see his family in Yarmouk camp in Damascus.

We entered the Burj's alleys accompanied by another young man. The day was clear and warm. The Burj's inhabitants spilled into the alleys. Bits of conversation were being exchanged by those who passed by. Women were coming and going through the alleys and courtyards, carrying vegetables, laundry, bread. Some middle-aged men were

getting shaves down narrow side alleys or in small yards. Sounds of life rose and fell. Radios and cassette recorders competed with each other, diverging at times and converging at others. The sound of Warda's song "Our Loved Ones" floated above the sounds of kerosene stoves and the murmurs that could be heard coming from low windows along the Burj's alleys. We were walking around. There was a group of men sitting at a corner right behind the alley discussing something with a woman who seemed to have been walking and then stopped. She was carrying things on her head—maybe she had stopped to take part in their conversation. We noticed them as we passed by and stepped back to listen. When we stopped they quit talking, and the woman looked at us then walked away. The men resumed talking—I don't think they returned to their previous conversation, but they pretended to do so. Now they were discussing Islam, which we'd noticed was a common activity in the camp. One of the men was saying that we have deviated from the path and the law that the Prophet Muhammad provided for us and this was the cause of all that had happened; this is what had brought us rulers such as these: "Is there anything more humiliating than this? And we still don't know what happened to us."

Two of the men were sitting on the same box, an empty wooden tea crate. One was tilted forward a bit, leaning on his knees. He held prayer beads in his hand while the other man leaned on the alley wall. Each was speaking without facing the other. A woman on the other side of the alley had come out of her store to find out why we'd stopped. She was looking toward us anxiously; perhaps one of the seated men was her husband. We squatted and started listening without interrupting the conversation. Then an older man addressed a younger one sitting among them, "I want to ask you something. Nowadays, do you still lay a meter of tile as scrupulously as you used to?" The young man swore he did, but the old man didn't believe him and swore to the contrary. Then the old man turned to everyone and said, "There are no principles any more."

The camp is overflowing with life. The proximity of the houses and the way they embrace each other creates the impression that each

ends and begins with the other. How can I reflect this feeling in the film? When we passed the bakery, a young girl was rolling out rounds of bread dough. The fire's red glow flickered across the dough and her face, radiating warmth to each passerby.

When we passed in front of an open door, a girl had just finished washing the small courtyard inside. She stood in front of a mirror with the bottoms of her jeans rolled up and began combing her hair. The radio played Umm Kulthum's song, "I Swear to You." We sat on the roof of one of the Resistance centers waiting, but it was unclear for what. Maybe to rest a while and drink tea. I think these visits are important. Although the Resistance itself is not part of the survey, the visits help create familiarity and put them at ease with us. I wonder, though, if our work can be limited only to store owners. Most of the people we've seen so far are store owners. During the day, the young men leave the camp, and going to people's houses when no men are home is not easy. That is why we must regroup and change the times of our visits. A beautiful young woman went into a room and then left. She was on the lower level. I looked into the room and discovered that it was once a bathroom or kitchen that had become this woman's house. Her small children were fidgeting, following her, going in and out, lifting the curtain that separates the room from the rest of the house. Whenever the woman went out to do something, she got into a fight with one of the neighbors. Fighting, shouting, screaming, cursing, spilt water, conversations behind the walls. The fighting ended just as we finished drinking our tea, then started up again. When we visited her, we found her narrow vault clean and tidied with extraordinary care. The air was fresh. Her three small children were lined up perfectly next to each other. Her beautiful young face exuded innocence and tranquility.

Umm Hatem

"I have a lot of dreams. Sometimes I see myself playing by the fig trees, other times I see my aunt feeding me butter.

"Once I saw her making bread by the oven. I told this dream to Fathi to get his interpretation."

Umm Hatem was talking to us while washing her husband's clothes in a laundry tub. Her husband was sitting in front of us, ridiculing his wife's story with a sly grin. A slim young man, Umm Hatem's husband is a soldier in the Liberation Army living here for his job. His wife had come to visit him from a suburb of Damascus, and although I don't know why, she didn't remember anything from Palestine except the tomato seeds.

"I stole one of the loaves my aunt was baking and dipped it in a tub of olive oil—it was amazing." Olive oil comes up in all of the stories we hear. "Once when I was asleep I saw a plane coming. It was just like the day our house there was hit. In the dream the plane crashed into the window, hitting the wardrobe and breaking all the glass. I started screaming, 'Auntie! Auntie! The house collapsed on us.' She said to me, 'What can I do about that? God will recompense.' And that day in Damascus, I dreamed that a plane came and shelled us, and the bombing threw me from the bed. I really was thrown from the bed that day, along with the radio that was next to me. Boom! I fell off the bed, and the radio broke. The radio broke for real, not in the dream. God, I'm really afraid of planes. I always dream about them. We were attacked once, in Palestine. I was carrying a plate of food that I was about to serve."

She overflows with vitality, narrating without us asking questions. Fathi, however, was waiting impatiently for her to stop. "Once in a dream my mother came and brought me a handkerchief. 'Why, mother, did you bring me a handkerchief? I haven't seen you in twenty years.' She said to me, 'I don't know. I wanted to give you this handkerchief.' I took it from her. In the morning, I asked my aunt about it. She said, 'You'll have a boy because a gift from the dead is a blessing.' Sure enough I later became pregnant with a boy, but then he died.

"My father is kind. Sometimes I dream about him. Once, he came and said to me, 'Go apply for a passport for me. I don't like living with your aunt.'" He lives in Iraq. "I said to him, 'Come live with me.' He said, 'I'd like to, but your siblings won't let me.' He is suffering with my aunt in Baghdad. I said to him, 'Baba, I can't apply for a passport for you. You have to do that at the embassy there and then come.'

"Once in a dream I saw a bulldozer creeping up to me, one of the big ones, a scary thing. The street was narrow. If I tried to go here, it would crush me. If I tried to go there, it would crush me. The street was high and narrow, like the streets of Nabatiyeh and so on. I was clinging to the edge of the street, hanging there. I said to myself, 'If my hand slips I'll fall, and it's a long way down. If I climb up, the bulldozer will crush me.' I awoke from this dream, shaking for almost an hour, and I was very thirsty."

Umm Yousef

"I stay home all day—cooking, washing clothes, feeding the kids."

She is a thin woman who seems to be all skin and bones. She was moving around animatedly while she spoke, putting out food for her young son who had just arrived. When a bell sound rang, she'd said, "Ahmad will come now. That's the sound signaling the lunch break at SAMED." She was breastfeeding a child in front of us and calming another against her chest. She'd say something to us, then ask if we wanted ashtrays for our cigarettes, coffee too. She said, "Have lunch with us. Please. We haven't been hospitable enough to you," then, "eat, please, or time will run out. Don't be shy. There are no strangers here.

"I've been here since my daughter was born. Where is Suad?" She looked around searchingly. "Suad, dear, come over here a while. God, I haven't seen a movie in a very long time!" She broke into a smile that took her back to a hidden youth, and a strange beauty emerged from the corners of her eyes. "But I saw Palestine. Praise be to God! I saw it twice. How beautiful it is—like a dream, a movie! I went first to the West Bank, then to the lands seized in 1948. I went to Nahariya, Tiberias, Ramla, Acre, and Haifa.[10] But the Jews, those bastards, didn't allow me to enjoy myself. Some people spoilt it. They sent for me and started interrogating me about my husband. He's not involved in anything. He works at the syndicate."[11] I don't know why she told us this about her husband; it was as if she were talking to an interrogator. Something in her eyes suggested that she was leading us on. "My son was with me. Every few days, they took him for interrogation.

Maybe they wanted to make us talk because they were asking about this person or that. I'd tell them, 'I don't know anyone.'"

When SAMED's bell rang announcing the end of lunch break, her young son hurried back to work, and we accompanied him.

In the afternoon, I visited a Palestinian writer. I told him about the film, hoping he could help with introductions to Palestinian families or people I could live with and really get to know. I'd tired of talking to storekeepers or people we'd met by chance. But he showed no noticeable enthusiasm for the project. He said, "I thought the film would be an attempt to study the effect of the Revolution on the sociological aspects of the Palestinian camps, with respect to changing values and ideologies. Haven't you read Frantz Fanon's book about society and the sociology of revolution?[12] You have to read it. Anyway, I'll try to help you. There is a nice woman who works at the Women's Union. I'll call her, and she'll lead you to families and homes in the camps."

One of the young men sitting with us turned to him and said, "Abu-l-Haytham, how about taking him to Saint Simon and letting him see what's there." He said it as if he wanted to show me hell. This depressed me. People always say, "Come look at this," "you have to film these things," "come and see what's happening over there." No wonder cinema has been caught up in presenting and framing tragedy and trauma when people come to you with such things, their souls full of anguish and grief.

I didn't show any enthusiasm at his offer. At first, I interpreted this as the kind of thing usually suggested by eager young people whose understanding of cinema is linked to their hostility to propaganda films and those films put out by certain organizations or national film industries. The young man himself caught my attention more than the name 'Saint Simon.' He had been silent throughout the whole meeting; then he spoke haltingly, slightly confused. He was shy and mysterious. What also caught my attention were his clothes: the loose beige pants that had become the uniform of the intellectual newly arrived in the city and the brown shoes with raised heels and a broad toe that curled upward. The writer turned to him and said, "Good

idea. Let them tell him about Maslakh and Karantina." Then he turned back to me and said, "Brother Ghazi is one of the youths of Jordan and he lives here in Saint Simon. He is a progressive young man. Arrange everything with him. Besides, he's interested in literature and fiction. You can talk and sleep at his place. It's no problem." I was tempted by the idea of spending the night with the people and waking up early to see the camp. I thought I was going to a real Palestinian camp.

So this is Saint Simon? No, it's Saint Michel. Saint Simon is there, behind the wall. We crossed through a hole in the middle of the wall. Ghazi said, "I live here in this chalet." It was not a camp. It was a beach on the seashore where displaced Lebanese and Palestinians had taken refuge.

The weather was hot, suffocating and humid. The sky was blue, as was the sea. There was an air of vague, anxious tranquility, heavy and sluggish, so disorienting that you're not sure what it is you're feeling as you cross the muddy white sand. You struggle with a number of apprehensions, seeing how several subtle changes have transformed a customary scene of summer vacationers into a portrait of another reality. The chalets were packed with people. The few spaces between the chalets were crammed with children. Men and women walked by in their everyday clothes. Air vents had been blocked to protect from the cold and winter rain. Families were stuffed into the casino halls and restaurants. Some huts had sprung up, selling basic goods to people.

This hot, humid air had driven people from their rooms. Everyone was out in the open spaces. There was a dense motion, giving you the sense that people were coming and going, driven by a strange force inside them. The further you advanced into the passageways, the less you felt you were at the sea and more you felt you'd wandered into a maze of optical illusions. The further you went, the more it felt like you were entering into a hell made up of worlds that could no longer be concealed. You wonder whether it's the sea that enables you to see a strange, inner nakedness or whether these people no longer care to cloak their souls. Sounds reach your ears—fragments of stories, questions, looks, desires, missing people, husbands, women yearning for strangers' faces. They never tire of asking about someone they have lost—husbands or

daughters—still carrying the hope of a sudden return. You feel that each gaze at a newcomer is an attempt to make out the features of that missing person. "Maybe it's him." "It is him, but time changed something in him." "Maybe he grew a beard." "Maybe he shaved." "Maybe he lost that much weight." "Maybe he aged that much."

The evening was approaching, and with it, the dark night. They went out to observe the last light of a departing day that would be added to the long list of days that have gone by since the missing disappeared. You walk. You turn. These gaps, this motion, this overlapping coming and going crush you. Some people are returning after a day's work. Some have woken up from a nap, disturbed by nightmares. Different faces. Sometimes you feel you're in a world enslaved. Why don't we shoot the film here? Let it be a Saint Simon film in every sense of the word!

I have the feeling that the key to the puzzle is here in this spot, like a knot: as soon as you get hold of one thread, you feel you must keep going until you reach the other end. Other times, while walking, you get the sense that clandestine things are going on everywhere. Some faces were undoubtedly planted here to spy for somebody. You swallow, and the taste of your saliva pierces your throat with the hidden schemes, plans, and plots being made . . .

We stood on the sand at the border between Saint Simon and Saint Michel. My escort called out to a man in the biggest chalet. Then he turned to me and said, "First you have to meet Abu Khalid. He's an old man, and he talks. He's also a sheikh, the head of a tribe. He manages people's business here."

Abu Khalid Saint Simon

The big hall in the chalet was clean. The bed still had the blue and white sheets that belonged to the former owners. Rugs and pillows were spread on the tile floor, brought at moments of escape or expulsion. In the corner of the hall was a large copper brazier and a coffee pot set on charred pieces of wood on the tiles. The windows were open onto the sea, bringing in a humid breeze that blew forcefully

and made you yearn to shed your skin. A colorless light lingered on things, canceling out the remains of a fading intimacy. You could hear the sound of the sea, and from time to time the screeching sound overhead of a commercial jet about to land. Abu Khalid entered, repeating to somebody behind him in a strict, arrogant way, to bring the coffee. Then he came over and welcomed us. His voice was gravelly and moist, but with a Bedouin accent. His sunburned face sagged from the humidity. He wore a brown qumbaz and dark jacket. He sat cross-legged on the rug and said to us, "There are lots of people here in Saint Simon and Saint Michel. It's a problem. Some people you know and others . . . only God knows! There are lots of strangers, from Maslakh and Karantina, some from al-Zaatar, Nab'a, Burj Hammud, and the South. People flooded here and mixed together. We, Bedouins of Raml came from Maslakh." He seemed to resent this integration.

"The Bedouins of Raml are from Raml in Haifa.[13] I can take you to visit them and observe. As for others, I can't go with you and I don't know what they're doing here. Only God knows. The Bedouins from Raml lost their land in 1936. The land was first taken by the British army." The sound of a civilian aircraft roared overhead, making some of his words unintelligible. "I swear to God Almighty, I used to work naked like the day I was born because of my love for the land, and the land was desirable." Once again, a plane roared above us. "Then we hired a lawyer, by the name of Ahmad al-Shuqeiri. I worked on the land like the day I was born. We cultivated wheat, barely, potatoes, cowpeas, onions, and other things—Arab cultivation. Mr. Ahmad al-Shuqeri is a patriotic guy, a Muslim. He continued to defend our land until a ruling was issued in our favor by the Land Court in Jerusalem. He came to us and said, 'Good news, Bedouins. We got a ruling for the land.'

"We said to him, 'Your news is a good omen, God willing.' We went to him and brought him food—a lamb, some butter, and some milk. But the events of 1948 happened, and we went to Lebanon." Another commercial jet roared loudly above. "Tribes are not a product

of today; they've been around a long time, maybe since the time of Adam. We, the Bedouins of Raml, are from Swayt, but there are many Palestinian tribes, such as Sobieh, Hamdun, Hayb, and Fayez."[14]

A man suddenly entered the room—he was tall, slender, nervous, and carried a black Samsonite briefcase. He seemed to have a specific and urgent mission. Somehow he gave the impression that he was delivering salaries. He sat on the bed, opened the briefcase, took out what looked like a receipt book, then stopped suddenly and said to me, "Welcome, friend. How are you? Tell us how you're doing. I hope you are happy." But Abu Khalid got up and said to us, "Let's go visit the people so you can take a look around." We rose and left the room for the sea. At that moment, the sun was a yellow waxen disk approaching the sea's surface in the far horizon as clouds started to darken the sky.

After some moments, Abu Khalid joined us. We walked together. We crossed through the hole in the wall that separates Saint Simon from Saint Michel. In the yard, a family had taken their food out into the open and started eating. It seemed to be the family of a laborer who had just returned from work. Abu Khalid stopped at the first house and said to me, "This is my daughter's house. She lives in the first house of Saint Michel, and I live in the last house of Saint Simon. That's why I made this hole in the wall. She lives with her five kids. We say that her husband is missing, but he died in Maslakh." Then he called out to her. The kids rushed in through small darkened door-ways. He asked them about their mother. They said she went to buy something, so we left intending to come back.

Abu Adnan—the keys

He's an old man—seventy, pale, and slender. It's impossible to tell whether he's dressed in pajamas or street clothes. He seems to be a collection of separate pieces, soul out of body. He babbles, walks, fidgets; he emerges from a dark doorframe and strolls into another. At all times he carries a round keychain with a bunch of small keys in his hands. He talks to us while walking. Sometimes he sits, so we have to sit. He stands up and leads us to another place. This is how we

discovered his interest in certain places, such as what was previously the beach bathroom. He has devised a door and fixed it, then placed a small lock on it that reminded me of the kind used for luggage. He opens the door and lets us in. Once inside, we discover that this is no longer a bathroom but now a coffee room. Inside, the coal is still lit and the coffee pitcher sitting in the ashes is still hot. He talks a bit, then gets up, and we follow him. Maybe the place we're going to is underneath the cement passageway of the beach. We sit on empty broken wooden boxes that used to contain whisky and beer. He talks to us. The only thing he's confused about is the two exoduses: the first from Acre and the second from Maslakh.

What I recall now is the overall impression, the unlimited cursing of current and former Arab leaders: "Here is the sea, so let them toss us in it." This sentence resonates in my ears. "They put me somewhere. I looked around and I saw something strange. I thought to myself, 'Maybe it's a morgue.' I said, 'That's it.' Three people came, looked at me, and said, 'How old are you?' I said, 'Seventy.' One of them said, 'Stretch out your hand.' I did. They had hatchets. I came from Palestine to Maslakh. When people started building in Tel al-Zaatar, we built in al-Tel al-Zaatar. In Haifa, a lawyer came and said to us, 'Go to Acre.' We left for Acre. We found that the people in Acre were leaving. We left Acre. They bring back married women after they take them, but girls never come back. They use the same hatchets on Palestinians that were used by the Haganah.[15] I can't protect anybody, and nobody can protect me. Can you say, 'That's my brother?' Can you say, 'That's my father?' Everyone is on their own. That's how we left. I left on my own. I didn't know where my wife was. Later, she followed me. My son is in Germany."

The vendor with the paralyzed hand

The evening came. Saint Simon himself vomited.

People dispersed into dark pockets of air. Beirut in the distance was bustling with light, while here the black sea emitted its mysterious monotony. When the vendor emerged from his glass stall—maybe it

used to be the stall where ice-cream was sold—the paraffin color of the Lux receded into the background,[16] and the vendor with the paralyzed hand looked like an old butterfly emerging, trembling, from a halo of light. His movements were carefree, his features pure. He wore gray pajamas that were as clean as crystal. He said, "I was the first person to land in this place. The beach owner told me to live here, and I did. I was fleeing from the hell of Shayah. Then others came, then more. When torpedo boats came here and struck, all the people fled. I didn't. Where would I go? I can't walk, so I stayed. Maybe I'll die and maybe not. The owner of the beach comes here frequently, but he never gives me anything. Whenever he comes, he drops by and starts counting dishes, spoons, forks, and knives. I used to say to him, 'Count on God, man! Nobody takes anything with them when they die.' My daughters come from Shayah to visit every Sunday, on the weekend, that is. They bathe me, clean everything, cook, and then return."

An old woman, over a hundred years old

"I'm over a hundred years old. I came from Haifa to Maslakh. I know them by their voices even if they're masked. They take girls and kill young men. They followed us here to bomb us. Everybody is against us. Even God is against us. Our young men are gone. Our dignity is gone. What can I say? Let sleeping dogs lie. There is no Islam or anything. Only humiliation. Nobody throughout history has been humiliated as much as we've been. My son's son, my brother's son, and my daughter's two sons are all dead. Ahmad died when he was delivering ammunition to al-Zaatar.[17] Marwan died in Kahale. Omar died in Antelias, the sea. Muhammad died in Damour. When the morning comes, I go buy vegetables. I put them here, and the old man sells them. We earn enough to buy bread."

The mother of the man with lung disease

An old woman stretched out her fingers and wiped the surface of the ground. Then she kissed her fingertips, raised her hand to the sky

and said, "Thank God! God above saved them." She meant her son and husband. "Maybe because I have no one else but them. That day I ran, I knocked on every single door, even the door of Gemayel's son.[18] Whenever I told anyone about them, they'd say, 'Oh! They were butchered.'

"We've been in Burj Hammud since the day we left Palestine. Four years. Before we never mixed with refugees, we only got to know such people here."

The violation of honor. Honor—honor is the obsession. The kidnapping of their girls torments them tremendously. Honor replaces the obsession with olive oil in the camps. Many of the women try to give the impression that they fear and are apprehensive of the moral environment shaped here. Behind their words are innuendos of alcohol and debauchery, sometimes drugs. Here, dreams of usurped land disappear from the conversations of the camp's inhabitants and are turned into feelings of defeat, humiliation, and contempt, sometimes with a tinge of immorality.

The woman resumed, "It seems we'll be staying here for a long time. Maybe we will." As the night grew darker, she became more worried about her son with lung disease, who had been summoned by the Armed Struggle and taken at sunset. For her, there was no difference between him being summoned and him being taken. What mattered to her was that armed men and the authorities came and took him. "We've been here for four years and they've never summoned him. What do they want from him? I'm scared." Worried, she twisted in her seat. Her mind strayed; her words were scattered. Everyone here feels surrounded by spies. The chalets don't provide them with a feeling of security. A belief that people are eavesdropping, prying, prevails. The adjacent sea becomes a sky and horizon of the unknown and its impending invasion. Everything is possible. Assassination is likely. It's the spirit of apprehension that pervades the world of smugglers, especially now that the Amal movement—which they don't trust at all—is expanding around them. Before we left this woman, her son with lung disease returned, safe and sound.

Umm Bassam

At night we visited Umm Bassam, the daughter of Abu Khalid, the man who ripped open the wall separating the two saints. He had set her up in the last chalet of Saint Michel, next to himself in the first chalet of Saint Simon.

When we entered, Umm Bassam had set many dishes for dinner on the floor. Her sons sat around them and she started serving beans and rice.

As soon as she finished filling the plates, a man showed up as if by appointment—he said, "I heard you have beans and rice, so I came for dinner." He sat by one of the dishes. Everybody was engrossed in the food. There was one full plate that remained untouched. I wondered if Umm Bassam had served it for her husband, missing for years, in the hope that he might suddenly return to find his dinner hot.

"I thought he went to Burj Hammud. The next day, a Tuesday, the Phalangists came to the mill. In the afternoon. . . They came to the mill. Around half past ten at night, I looked up and suddenly found Eissa, my husband, with us. 'What?' I said to him, 'You came back?' He said, 'There was fighting. I couldn't go.' I asked him to come closer. He did. I gave him a cigarette. I don't remember whether he finished it or not. The Phalangists summoned him. They took my husband and two other men; I haven't heard anything of him since. They also took two women and one girl at the time. The women weren't gone long. One stayed forty-five minutes, the other an hour, the girl an hour-and-a-half.

"The girl returned crying. We gave her a piece of cloth. Instead of putting it underneath her, she put it on her head, over it. She sat there with her face covered for around three hours, crying. When she complained to one of the guys, he said to her, 'Do you know the man who did this to you?' She replied, 'I know him.' He loaded the gun and said to her, 'Come with me.' She went with him, but she never came back.

"I saw him twice in my dreams.

"Once there, at the door to the house. I said, 'You deserve it, I sent you to Burj Hammud. What brought you back to the Phalangists?'

"In the second dream, he'd been released through mediation. He was totally transformed. He stood in front of our house. I said to him, 'First, thank God you were released. Second, who was there with you? Tell us so we can get him released.' He said, 'I don't know any of them except Ahmad, son of Yousef the Khalili.'"[19]

While crossing through the ripped open wall separating the two saints, I watched a girl dance for a group of her female friends to the sound of Arabic music coming from the television.

Ghazi, who was hosting us, commented, "These people are from Beirut's poverty belt in the suburbs. They live in constant misery. Their Bedouin origins just barely keep them from falling apart. There is a rift between them and the leadership. The leadership didn't succeed in achieving the fighters' ambitions. That's why, as you see, they've lost their sense of security and suffer from rising prices. They wonder why they fought."

I spent the night at Ghazi's chalet. I lay down on a military bed under gray blankets that had an odor. Ghazi turned out the light, and I plunged into confusion and darkness. I awoke very early. Looking out the window, I was stunned by the sight of children in blue school uniforms. Watching the children under the cloudy morning sky, as they crossed small puddles left by last night's rain, was like remembering a good dream. I wondered if I should focus on Umm Bassam's family, structure the film as a cinematic diary of Saint Michel and Saint Simon, telling the story of getting up early, what they do, what they dream, what they eat, the rain, the sun, the missing father as described by his kids, the lost salary or allowance. I was determined to look around and do more research.

When I asked about the beautiful nursery school in the camp, they answered that it's the same kindergarten they had in Maslakh. When they moved here, it came with them.

Wednesday, April 2
Qasmiyeh

Umm Qasim said, "I remember Khalsa like a dream.

"I'm thirty-seven years old. We're like despair; we've passed through many stages and have achieved nothing." As soon as we entered Umm Qasim's house another woman rushed in behind us, frightened, thinking that the only reason for our strange arrival must have been an accident, or news—someone's death or something else. Then, after making everyone swear oaths as to our real intention, she started talking. "My name is Umm Nemer. We want your film to show and talk about how oppressed we are and how nobody thinks well of us. We don't like foreigners to see us because they always criticize. God help us!

"If it were not for the village chief, Ahmad Kamel al-Hussein, we wouldn't have left Khalsa. I have three sons. Two of them are in Germany, washing dishes. So what? You thought they'd have an office job? The third is in Libya. I swear the one in Germany never even got me a pair of shoes." She laughs. "But I wish those days would come back. When he was here I used to say to him, 'Damn, Hassan! You'll burn in hell. Are you still asleep?' He used to reply, 'Let me sleep or I'll kill you.'" Everyone laughed in the cheerful and lovely family atmosphere. "The one in Libya hasn't come since the fall of al-Zaatar. I have two brothers. All seven of their sons died in al-Zaatar.

"I swear to you, son, my heart hangs heavy like Mount Malott.[20] It's only thanks to the protection of Prophet Qasim that we're here;[21] it's his land, we're living on his land. The Prophet Qasim protects us, that's why the camp is never bombed—the shells fall around us constantly but not on the camp. If the road to Palestine were opened I'd run all the way there, head straight to the house. I don't need anyone to show me where my house is. "One day I had a fight with my husband, and, angry, I went to Kafr Rumman. The camp in Nabatiyeh was destroyed. Although Abu Qasim was upset with me, he came and said, 'Thank God you were angry and weren't at home. Come on, let's go back and see what happened to the house.' He also hadn't been at home, nor had the kids. We went to the camp. We couldn't find a path through the camp in order to reach the house—the entire camp, from the very entrance, was a series of huge holes in the ground. Each

hole was thirty, forty meters deep, and water was gushing from them. We had a hard time reaching the house. When we got there we stood looking around—there was nothing left! No house, no place to take shelter, nothing at all. Did I feel like crying? I told myself, 'Oh God! Why should I cry? I'm no different from the people in the camp.'"

A woman joined us. Slim, her head wrapped in a white cloth with indigo blue patterns on it, she looked exhausted, as if she was suffering from a severe headache. Bits of damp henna clung to the lengths of her hair. She spoke to us then fell into a fit of anguished crying. She seemed to be Umm Nemer's daughter. Rocking her little baby girl against her chest she resumed talking and crying while standing in the doorway. Behind her were dewy thickets of green lemon and banana trees. "I fled the air raids on Nabatiyeh and went to al-Zaatar. I thought al-Zaatar was safe. Six days after I arrived, on the seventh day, the siege took place. There it got so bad, because of the hunger and the thirst and the bombing, I said to the heavens, if only I were a bird and could fly away. A girl goes to get water and comes back with no hands, no eyes, no legs. I wanted to throw away this daughter of mine. I couldn't carry her any more. My oldest daughter said to me, 'No, Mama. Please let me carry her. Maybe for her, God will save us, and we'll make it of here.' All the agony in our lives is one thing, the agony of al-Zaatar is something else completely.

"I lost my kids while we were fleeing. I was crying, and I asked a young man at the door of the shelter if he'd seen my children. He said to me, 'We haven't seen them. You made it here, and you're crying?' Another woman said to him, 'God damn you! She lost five children to come here.' I threw my things on the ground, sat down, and began to cry. Their father came. He started searching the shelters. He went to his sister and said, 'My children are lost.' She replied, 'Maybe they died in the bombing.' He said, 'No, we didn't find their bodies on the way.' Finally we found them with people who were hiding them. We stayed under the staircase until morning. A young man, my cousin, was martyred. We carried him, put him in a coffin, and left him in the house. Where could we have taken him? Then we saw the house collapse on

top of him from the bombing. I came out from under the staircase like a mad woman and began screaming. Every time I feel a breeze I remember my uncle's words. He came and asked me for a spoonful of milk. He had a three-month old boy, and his mother had no milk. I said to him, 'Uncle, I have nothing except my tears. Shall I give you a spoonful to feed your son?' I see al-Zaatar in my dreams. I see those young men torn to shreds—a brain on a rock, two legs in pants."

Most likely the dream is mixed with memory, and the distance between them fades. "Two months ago I had a dream. I was going to get water. I saw myself running from wall to wall. And when I fell, my daughter came and pulled me by the hand. She was pulling me, the bombs were falling. Later I saw them hanging dead people up in closets.

"I could talk about al-Zaatar for a month and wouldn't get to the end."

Yousef, the young man assigned to accompany us to Qasmiyeh camp, looked like a gigantic boy. He was pedantic, with a voice that seemed to collide with his palate and he pronounced words in an artificial way that makes you sure he's imitating one of his leaders.

On the way to Qasmiyeh, he asked the driver to pass by his house in the mountain on the outskirts of Sidon. We went there so Yousef could get his jacket.

On the way back from Qasmiyeh, Yousef asked to pass by his house again. Then he arrogantly objected when the driver stopped a few steps away from the house: "Can't you get closer?"

In front of the house, Yousef packed the car with bags, blankets, and other household items. We understood that he was preparing to get married and the wedding would be the following Sunday.

He also passed by his fiancée's house and brought her along. Instead of continuing on back to Beirut, he took us to his new house in the depths of the valley, in a place that didn't feel at all safe. We got out and drank tea at his house on dark brown velveteen sofas.

On the way back, alone with the driver, Zafer, he told me about his own wedding day. He'd gone out in the midst of a bombardment to look for a marriage official to conduct the ceremony. When Zafer found an official and brought him to the fiancée's house, she was

sitting in the courtyard washing dishes. "I told her, 'Get up, woman.' She got up. 'Wash your hands.' She washed her hands. 'Give me your hands.' She extended them to me. We contracted the marriage." He has been a member of the Resistance since 1968 and is still a driver. His monthly salary is 625 Liras. He refuses to let his wife work, especially in the Resistance. "God forbid!" he'd said at the idea.

Thursday, April 3
Ein al-Helweh

Mizyan said, "April is like a barefoot bride . . .

"I came to return the powder I borrowed. I didn't know you had guests." She looked at the wooden closet and studied a drawing that had been taped to it, a map of Lebanon that seemed to have been cut from a schoolbook. She laughed like a child and said with astonishment, "What's this . . . a map of Lebanon? Looks like a fat woman What do you want to cook today? I have lentil soup from yesterday."

Elham—who resembles Khadiga in "Advertisements of a City that Existed before the War"[22]—was still in her long blue nightgown. She was engrossed in smoking and trying to hide her shyness, triggered by our sudden presence in the company of one of her dear friends.

Mizyan was distracted by looking at the photograph album. Elham's older sister came back carrying vegetables from the market and sat down to peel potatoes. After some time, their elderly grandmother came in, sat down, and looked around with interest. The gas heater was ablaze, and the smell of coffee filled the place. Steam rose from the coffee cups. The rain was tapping against the room's windowpanes. It was comforting and warm, and for the first time I felt I was in an intimate atmosphere. I was deliberately silent. Everybody was looking confusedly at the different faces in the room. Elham attempted to break the silence with a joke at the expense of the grandmother's bad hearing: "This old woman, the bitch, got married three times." She laughed, turning to her friend who brought us here. "And we don't even get the chance to do it once. I swear to God, three times! I don't know who the first one was. The second one went to

America. We said, 'Okay! Maybe he'll bring us dollars.' The third died in a raid on Nabatiyeh."

Sensing that she was the subject of conversation, the old woman interrupted and said, "I went to the market. They told me, 'Your name is in the newspaper.' I was afraid. I asked them 'Does the newspaper go to Syria?' They had my photograph as well. I swear. I was wearing a headband and carrying wood on my head. I married all of my daughters to Palestinian men so that when we go back to our country they can come with us.

"Holon, the richest land created by God. You plant seeds, and they yield massive crops. Kamel al-Hussein came and said to us, 'Let's go. We have to leave. Take the camels, the children, and go ahead of us.' He stayed there. Afterward, he was killed by one of the laborers who worked for him." She said the word 'killed' with hesitation and caution in a very low voice. "I swear to God we swept those houses. We cleaned and locked them. We brought the keys with us. Later we threw them away. In those days, I was as bright as this." I turned to see her pointing to the red bedsheets. When I asked her what she brought with her, she said, "We sold them and bought zinc to build a shack."

Elham

"We were all born in the camp, except for my older brother, who was born in Palestine.

"My mother is Lebanese from al-Qantara. She's with my father in Saudi Arabia.

"A brother in Libya, a brother in London, a brother was martyred, and Thaer is still young. We were four girls. My older sister is studying at the news agency. After the events in Sidon in 1976 she got a press license,[23] then she got scared of going to Beirut because of the roadblocks. So, she left university and married someone from the West Bank. My sister Eftekhar," she pointed to the one peeling potatoes, "teaches at UNRWA. She's married, but her husband works in Das, Abu Dhabi, an island where only men are allowed. One guy came back from the Gulf insane. Workers are given one vacation every

three months to go and see their wives. When my sister's husband comes, they go and live in Ghaziyeh, south of Sidon. The first woman martyr came from that village, in 1942 or 1946. She was a worker in the Regie." Through the loudspeakers of the minaret came a voice announcing that somebody had lost 150 Liras and that the person who found them would receive a reward.

"I'm active in many social activities within the Resistance. I believe that getting close to the people, living together with them, helps a person develop and improves their ideas. Political work is what creates development. Women in the camp are very limited in their thinking. The role of culture is minor. I don't think like the intellectuals of Beirut that I see. Women in the camps have great potential. I taught some, and they were able to write letters. When the Revolution was first introduced to the camp, I was fourteen years old.

"My mother raised me to be strong. I used to bake. I used to buy stuff at night. She sent me to run errands. I'm not afraid of the night. Sometimes I worked the night shift. I was trained in the militia and worked on a radio set. Afterward, I developed a personal problem that affected me deeply." She smokes. She consults her sister. "This ring means I'm not engaged. The problem is common. I think it's what you think. In the family, it's not a problem to fall in love, but he was Christian. There was fierce opposition even though he's in the Resistance. Besides, he's Lebanese.

"The day Nizar was martyred, I came home and didn't know. I felt that something had happened. In the street it seemed like people were treating me in a special way. They said, 'Don't go home. No one is there.' The security situation that day wasn't normal to begin with.[24] When I went home, I saw that there were people there, sitting. I asked about Nasri since he's in the Resistance. They said to me, 'Nasri is in Sidon.' I immediately thought about Nizar. They said, 'Nizar *the hero* . . .' I screamed and cried until I completely lost my voice.

"I don't feel like I have any kind of stability. I'm lost. That's how things are. Every day, little Thaer wakes me up. I dress him and send him to school. Afterward, I tidy the house and sit smoking and

drinking coffee. I wait until one o'clock, then I go to the university. I sit and complain, shout, curse. I'm tired, and responsible for things I shouldn't have to be responsible for. If I'd been lucky, I wouldn't have had children. Most of the time, I don't even go to the university. I have a friend who is very miserable. I go to see her, or she comes to me.

"Ten days ago I saw Nizar in a dream. I was standing. Someone told me, 'Nizar at the American University[25]—he's sick, there's no hope.' They brought him. He was wrapped in a cloth. They put him on this bed, the bed where I sleep. I looked and saw that he wasn't dead. I hugged him and kissed him. He was laughing without making a sound. "Here's my sister Intisar, she's back. Let her talk, let her tell you about her circumstances."

Intisar

"I've been working in the Resistance's infirmaries for six years.

"I go to sleep at one-thirty, two o'clock in the morning. I wake up late, always frowning because they wake me up. First thing I do every day is wash, drink coffee, and turn on the radio. Every day. I listen to the news and immediately switch to the music station. What do I care—maybe it's Israeli radio in Hebrew. I dance and wash the dishes, and when I see them watching me I leave the dishes and just dance.

"I'm twenty-one years old. I have a strong memory. When Nizar was martyred, I was bringing sandwiches to the fighters. They were bombing the camps from Abra. I stood in the camp. It was sunset. A dark man ran in, asking about my brother-in-law. I asked him if something was wrong. He said no and left. I had a bad feeling. I ran and caught up with him. He was crying." Those present all started crying. "I see him in my dreams. He doesn't talk. He just smiles.

"I had a dream once of him walking away. I said to him, 'Where are you going?' He replied, 'I'll be back.' I said, 'Your shoelace isn't tied. Let me tie it for you.' I knelt and tied the shoelace for him. I kissed him, and he left. Then I woke up. Today I had a dream—I remember now. I had come to take an Arabic literature exam, but I couldn't find a chair or a desk to sit on. I started crying."

Friday, April 4

My friend Nasir, a painter, wanted to introduce me to Umm Emad Sabra—that's what I came to call her. He'd described her in a way that made me long to meet her. When we visited her house—you couldn't tell if it was part of Sabra Avenue or if the street ran through it—Umm Emad wasn't there. I wasn't at all sorry because something inside me wanted her not to be there. I wanted to meet her and film her at the same time, without trying to learn anything ahead of time.

A young Moroccan-looking man accompanied us. On our way to Umm Emad, he told me about a dream of his, where he breaks into the enemy's military stronghold, knowing he wasn't coming back and is martyred in the process. I was struck when he said, "Afterward, I saw the officer's wife standing next to my corpse, touching me." Then he invited me to meet his father, the driver at the SAMED factory.

Abu Adnan—the truck

It's a small house. We sat in the yard. His wife is Lebanese. They have ten boys and four girls. The father sings. He dreams a lot, and he's a good conversationalist. The door overlooking the alley was open, and we saw the man who performs circumcisions on young boys pass by with his antique leather bag. A friend who works in the Lebanese film industry was accompanying me on this visit. She was visiting the depths of the camp for the first time and had a bottle of 'purified' water in her purse. The driver said, "When we were in Palestine, driving was my hobby and passion. I bought one of the trucks left behind by the British army for 170 Palestinian Liras. I painted it blue, mounted a Palestinian license plate on it, and started working with it.

"When the events of 1947 took place,[26] I had a lot of work. I started moving displaced people from one town to another by truck. When Haifa fell, I started moving people from Acre. When Acre fell, I started moving people from Safad. And when Safad fell, I headed north and so on until I started moving people near the Lebanese borders. Then when I couldn't go back, I came to Tripoli, to Nahr

al-Bared. In Lebanon, I tried working with the truck. They refused because the license plate was Palestinian. I parked the car in the camp. I left it there. I tried working with a Lebanese truck for an ice factory, but my driver's license was Palestinian. I applied for a Lebanese driver's license. They issued me a personal license, but I wanted a commercial license. They wouldn't do it. I wanted to work. I worked on the Baalbek bus route. I was stopped by the patrol: 'Your passport.' I gave them the Palestinian passport. It was in Arabic, English, and Hebrew. He said, 'This is invalid.' I said to them, 'I swear I don't have anything but this job.' He said, 'It's invalid.' They confiscated the Palestinian license and the Lebanese personal license.

"I stopped working, but we needed to live. I went to the truck, got a hoist, and towed it. I sold it for 800 Lebanese Liras, and got rid of it. Afterward, I had many jobs. Now, I'm back to working as a driver for SAMED.

"Dreams are another world. Three months ago I dreamed that I came home, opened the door, and saw a tall staircase going up to the sky, no end in sight. There were crowds, and people were climbing up it running, lots of people. I ran too. I went up and up. I looked down and everything looked small. The people were tiny and far away. I was afraid, unable to continue. My children and wife were small, down there. I wanted to go up, but I couldn't. And I was afraid to come down . . . then I woke up."

I asked the SAMED driver to let me accompany him and show me his daily routine: leaving the house, picking up the factory vehicle, then driving the work route; how he would go early to pick up the women laborers. I discovered that his daily route extended from the camp to Fakhani, then across Khalda to Na'meh, and Damour.

During our tour with him, the sun was about to set over the sea of Khalda. If I film the story of this truck, I will film it at sunset, with the driver telling the story to the women who work at SAMED as he drives them home.

Saturday, April 5

A young Palestinian woman who wanted to work in the photography department at WAFA arranged for me to meet with a number of male friends and neighbors who got together after work every evening at one of their houses.

I didn't want to use the recorder, so I wrote down fragmented ideas in my notebook. I gave myself the luxury of enjoying the atmosphere instead of adhering to close observation.

"If the time comes when their princes are devils, their wealthy are misers, and their women decide for themselves, then they are better off buried in the ground."[27]

Abu Fawwaz said, "This is a saying by the Prophet." Abu Fawwaz was an elderly, impudent man—an old feudalist who spoke vociferously about the many people he had met. He knew Syria's natural history and its riches thoroughly. He was extremely agitated when there was a conversation about Syria's attack against the Resistance and said, "It is better for man to be a ram's head than to be a lion's tail." The subject of Syria came up a lot because of my Syrian accent. Abu Subhi, who spent thirty years working at Ghandour factory without social insurance, said, "I'm a desperate man, and our present situation is one of pure desperation because Israel and stability are two things that will never coincide."

Abu Akram, who lives on what his brother sends him from the Gulf, dedicated his life to nursing their elderly mother. His third brother was martyred by a missile that struck the camp. His wife, Umm Akram, was silent, holding a hidden pain behind a hand resting against her chest. The wives were in a corner of the room, watching, listening to what we said, and feeling apprehensive.

Abu Fawwaz said, "I lived in Beirut, but when I lost all my money I came to the camp and lived with the poor." I'd asked Abu Subhi if he was worried about what I wrote. He looked at my notebook and answered, "No. I'm desperate, and desperate people are not afraid."

Abu Fawwaz was wearing a clean, brown ironed suit, a white shirt, and a necktie. He wore a white hatta and an 'aqal. A woman

from the camp comes every day to clean the house, wash and iron the clothes, and cook. He lives alone off money he receives from his son in Abu Dhabi.

Abu Subhi resumed, "I'm unhappy with myself because I can't do anything or be of use to anyone. Is it because I've grown old and can't do anything? Is it because I have no confidence in the current situation? Or is it because I'm desperate? I don't know."

Here Umm Subhi interjected and said, "Why don't you open a store? Then you'll rest and let others rest." Abu Subhi was silent for a long time after which he said, "In 1948 I wrote poetry. I still have some poems. If you want, I can sing for you as well."

I asked him, "Would you be in the film?"

He said, "And I'll be in the film."

Damascus, Monday, April 21—preparing for the shoot

I have to be more specific in the film, consistent in my answers to the following questions: who is the camera for the person being filmed, and whom are they talking to?

Why is the camera there now to film this or that shot or person? I also have to know what motivates the camera to move or follow, and when it should do this.

As for the lighting, I have to admit I have never seen prettier light than that found naturally in the alleys or inside the houses in the camps. So I should rely on the rules and aesthetics of the real sources of light.

I have to deconstruct the various and intertwined elements of the camp's auditory environment, then carefully restructure them to create the film's soundtrack: the radios, the televisions, the stolen conversations, the songs heard over and over, the Qur'an, the call to prayer, the rustle of ordinary everyday life, the wafting of voices through the delicate walls of tightly embracing houses.

Finally, there must be documentary faithfulness to the filmed material—as opposed to ideological faithfulness. This might contradict the official Palestinian mindset.

Tuesday, April 22

What makes Palestinians Palestinian? What are its constituents out-side politics and armed struggle? These are the questions I'm asking myself while preparing to film.

Sometimes I imagine that these people live in a separate world—the dream world—and the current political mode of expression that represents them inhabits yet another world—one of daydreams. Reality is the persistent attempt by everyone to hinder the Palestinian right to self-determination.

These breathless attempts to defend oneself on the one hand, and the continuous losses, the frequent uprooting, on the other, lay the groundwork for their acceptance of any decision, any rights, any fate. The question now is: Who has the power to grant them their rights? Who will draft the plans and make the decisions? What fate will that be? I can't visualize this film yet. I don't yet have a sense of the 'image' I'm after. But I'm hoping to gain access to and express the 'Palestinian condition' of the Palestinians. I will film the rainbow encircling the camp from the mountain to the sea.

My friend Yusri comments that a mental image like this requires being at home with the visual aspects that express and generate it: the place, the people, the daily life. I wonder, can a dream reflect all this?

Sunday, May 4

I woke up from a 'dream.'

In it, the image appeared to be framed with sharp black edges.

In the background of the image strange events were taking place that had no relation to what was happening in the foreground. Light emanated from objects and people, emerging from them. They were bathed in the same damp waxy light. There was no sound. I don't remember and I didn't make out what was happening either in the background or the foreground of the image.

Thursday, May 8

I reached Beirut in the afternoon.

Events in the West Bank were escalating. There are violent demonstrations in Jerusalem. Israeli commandos were deployed last night in Saksakiya. A roadblock was erected, and the military official in Damour was assassinated. These events lend significant leverage to the issue of self-determination, freeing it from the chains of rigid association with the desires of the Arab milieu, and providing it with further potential. I'm uncertain how much I can allude to this, or to other things, in a film like this. At night there is an attempt to deploy Israeli troops in the suburbs of Beirut. The Palestinians are taking cover in Raouche´. The overall atmosphere is very tense.

Shooting I

The Prophet says, "Visions are from God, and dreams are from Satan."

And there are two types of true visions—a clear, elucidated type and a secretive, concealed type in which wisdom and tidings are deposited in the essence of its manifestations.

Ibn Sireen

Monday, May 12, 1980—Shatila

Abu Tareq

We're at his house—we'd met him at the People's Committee building during our first visit. Abu Tareq is a slender sixty-year-old man wearing a gray suit, black shirt, and necktie with a Pakistani-style turban on his head. We positioned him in front of the kitchen wall, which had a zebra pattern on it. His wife was working behind him in the kitchen. There is a large tree in the courtyard but it's outside the camera frame because the yard is so small. It's a very conventional shot. I wasn't satisfied, but I felt I had to start filming. I had no other alternative.

"When I first came to Beirut, I opened a trade and brokerage store in the Rivoli building of the commercial center. But I soon went broke. I could no longer run the business and had to come to Shatila.

"This camp was a piece of land owned by Shatila Pasha, and UNRWA rented it from him. UNRWA brought Palestinians and gave each family a tent that was shaped like a bell. Then people started using zinc to protect their tents from the rain. Prior to that, no Palestinian was allowed to use cement in the camp. When the Revolution broke out, Palestinians were allowed to pour cement and build houses

in the camp. Now there are around 45,000 Palestinians here. Most of the inhabitants of Shatila are from the northern region—the provinces of Safad, Haifa, Acre, Tiberias, and Nazareth. I'm from Lydd. We, the Salamas, are one of the old, respected families in Palestine; we had a lot of property and prestige, we were leaders. That's why the people here, although they're not from the north, elected me." Abu Tareq is the brother of the martyred commander Sheikh Hassan Salama.

"Who elected you?"

"The people."

I smiled. "How?"

"By election. It's true! An election and ballots. There was more than one nominee, and I won with a sweeping majority."

"Cut."

Abu Turki

The camera is in the camp alley, and Abu Turki is in his store. The scent of arghile tobacco mixes with the smell of the plastic shoes filling the shop.

"Many visitors have come to the camp. Everybody comes to take pictures and talk—heads of state and others. I even remember that once, UN Secretary General Rock Philly came.[28] They all come to see, to look at how we live, to talk to us. Some things work in our favor, others against us. Kennedy also came and visited the camp, I saw him. He was a good speaker. He said he sympathized with us and felt our pain. But nothing happened. We even heard things against us from lots of journalists—French, British, Russians, Americans—as if we're a show or some kind of play. But nothing changes; we remain the same, like we were before. Our hopes fluctuate."

"Do you have dreams?"

"Do I have dreams? Yes, everybody has them," he laughs, "but if I have a dream I remember it. My dreams are closer to fantasy than reality.

"I remember one night, either in 1978 or 1979, I was asleep and dreaming. I saw myself in a different house from the one I live in.

There was a grove. Here they call it a 'grove'; we call it a 'garden.' Grove, garden, there were trees and plants in front of us, and the road was for pedestrians. I remember we had a stove. In the dream I was fixing the stovetop, my head bent over and my hands sooty. I went down to wash my hands and ran into someone, President Shimon. He was wearing a white shirt with a tie and no jacket. He greeted me. I greeted him. He asked, 'Where are you?' I said, 'I'm here. I live here, as if you don't know.' He extended his hand to shake mine. I said to him, 'My hands are sooty.' He said, 'That's okay,' and shook my dirty hand. Then I said, 'So, what's up? How's life? Are we going to continue this sort of life?' He looked around him and saw some of his soldiers. He said, 'Go. Go. Gunpowder and cannons. Gunpowder and cannons.'" Abu Turki laughed very deeply.

The first day of filming

There are many stories and one dream. I tried to examine the minute differences between the dream recounted by Abu Turki during the research phase and what he said later in front of the camera.

We didn't use any new shooting techniques in what we filmed. I feel like I'm under some kind of stress. I act as if I'm under duress. I don't feel internally free. I resent the security routine. Fear follows us wherever we go: fears of stray bullets and of officials opposing this film. The Palestinian media is like that of any Arab government; it chases and confines you. But their fears are even greater. Camp residents constantly voice their fear that their photographs might be sent to Israel. I wanted to film a racing stable in Shatila where people bet on horses but I was afraid, so I postponed it. When we were looking at the stable we heard someone say, "What, this guy wants to film the stable in the camp?" I have to break free or else it will be impossible to work.

Tuesday, May 13

Beirut at dawn has a nice feeling. There are moist clouds in the sky by the sea, and the morning breeze dispels the sleep from my eyes.

The idea of the stable and gambling on horses—a metaphor for the economy—preoccupies me, and I wonder how it will develop. As for cinematic narration, I think that if we make the person the people are speaking to absent during filming we might achieve an acceptable and convincing spontaneity, one that communicates the question: "You want to know how I woke up today? Alright, I'll tell you." The intimacy of confession will take shape onscreen, and we'll shape the monologue in the film. Hence, we'll change the conventional position of the viewer.

Nidal

When we went up to see him on the seventh floor of one of the Fakhani buildings he had just woken up. His young friend had brought her daily dish of kunafa. He lifted the lamp. We could see him under the light with his brown eyeglasses and his military suit, with one sleeve empty and swaying elegantly (the elegance of the soul?). I looked at the room and was surprised by its cleanliness. On the wall, there was an oval frame around a picture of Christ; I had never seen him so beautiful before. Outside the window was a cage containing two colorful birds, a drizzling gray sky, and parts of the new Faculty of Engineering building at Beirut Arab University. I said to Nidal, "The film crew is downstairs. The equipment is heavy, and the elevator is out of order. Shall we call them up?"

"I don't want to be filmed. They play movies in Sosol Hall at the Arab University. People come to watch, and the hall fills up. The film starts. After a while, there is no sound. We say, 'Fine. We can watch the movie without sound. No problem.' After a while, there is no picture, and nobody to fix it. You understand what I mean. By the end of the movie around ten people are left. I'm one of those who leave, not one of those who stay. It's been fifteen years since the Revolution started, and we have nobody to show movies. How, then, can one make a movie?"

Before we went up to the seventh floor, Nidal's friend said to me, "Nidal was thirteen years old when he joined a group of Abu Ali

Iyad's cadets to attack an Israeli colony in the Occupied Territories. The whole group was martyred except him. He was injured in the eye—the one he still has. "He was injured many times during the Lebanese civil war. The last time was at the frontline of Shayah, he was presumed dead and put in the hospital morgue. I went to see the body, purely by chance, and discovered that he was still partially conscious. I kissed him, and he talked to me. But whenever he talked, blood came out of his mouth—blood that smelled of gunpowder. I remember what he said to me, 'They struck me with a tank, Nabil. Fuck those bastards, Nabil.' He stayed in the hospital for fourteen days and fled. He came to us in Shayah. He engaged in another battle and was injured by a mortar. But as you see, he's still alive. We even joke with him and say, 'Come with us, Nidal, to look for your arm in Shayah. Maybe we'll find it.' He actually remembers the exact place where he lost his arm. Afterward, Nidal said to me, 'Actually I didn't lose it, it was still attached, hanging by a nerve. I removed it and put it on a sand bag.'"

Nidal has one arm and one eye. Who knows how many pairs of organs there are body, of which only one is left.

Our Lebanese friend Katya, who led us to Nidal, said she was writing a novel called *Nidal*, and he is the main character. I don't know what I want to film. To me it seemed like he was the 'dream.' I didn't have the courage to ask him about his dreams. I placed the camera at the door's threshold, and we set up lighting to boost the natural light of the overcast day. We filmed. He was lying down on the bed like a fish in a boat. I quietly asked the photographer to shoot from angles that help enhance the sense of the bed as a coffin. Meanwhile, his friend Hidiya, whom he calls 'the Cadeau,' was sitting on the edge of the bed, her back to the camera. We started rolling. Nidal looked at the camera for a long time, waiting for the questions . . .

When the silence had gone on for a long time, he grew puzzled and burst out, saying, "What do you want from me? Ask! You're the first one to come interview me. Nobody has asked me anything before. I don't know. What do people want to hear?

"Today, the Cadeau came in the morning and woke me up. She brought kunafa for us to have breakfast together. My friend the Cadeau works at the salon downstairs. She is a hairdresser. Usually she gets me kunafa or mana'ish in the morning. And if she doesn't come in the morning, she sneaks out of work in the afternoon to visit me. The Cadeau is from Tel al-Zaatar. One of her brothers is a martyr, the other lost his leg to a landmine in the Occupied Territories."

Nidal was silent and slightly confused. Then he bent over, ate some kunafa, and turned to his friend while the camera was still on:

"Eat, eat!" He also ate. "It's cold."

"It's good."

"Good, but cold."

She laughed, "Oh, look who's being picky now."

He switched on a recorder that hung at the bedside and music came out. He turned to the camera: "I usually listen to this tape in the morning and the evening." The music was western, romantic, and soft. "I love it. I don't know why.

"I usually listen to it at night before I sleep, and the moment I wake up." He looked around him at the room's ceiling and walls. "The house wasn't like this before. When I rented it, it was run down. Everything was brown and very dirty. I have a sister who is married in Kuwait. She visited me and gave me 2,000 Lebanese Liras. I refurbished a bit. I bought a fridge and a stove that works without matches because it's difficult to light the stove with one hand. I bought a washing machine because I used to wash clothes with my hand and my legs. It was a boxing match between me and the clothes. I finish work at the office at night. The office is close. I come straight home. Sometimes I bring a friend, and other times I come back alone. When I come alone, I listen to music, lie down for a while, and sleep. If a friend joins me, we stay up late and drink. I drink arak. I like it, especially Syrian arak. I love Syria as much as I love Palestine, because I can't go to either.

"I rarely read or actually I don't read at all. Why should I? To be one more person who talks about politics? I think we need people who work."

Cut.

Wednesday, May 14
Umm Alaa

When we went to film Abu Fuad, whom we'd met while scouting, we found him sitting sadly in front of his store. He was wearing a black jacket. He told us in tones of loss and grief that his son had a hunting gun, and a bullet had been fired by mistake and injured someone. I think he was lying—nobody here has a hunting gun, everyone has Kalashnikovs. We were unable to film Abu Fuad, so we went to meet Umm Alaa. After she'd immediately recounted for me a number of her dreams, I felt that I had discovered the Giaconda of the film,[29] which gave me an idea as to how we might film her. It was afternoon. The window of Umm Alaa's house overlooks a horizon of western groves near the sea.

I asked her to stand beside the window with her back to the horizon and the light. We didn't try to enhance the room's lighting. The afternoon sun grew and faded in strength, in sync with the scattered clouds in the sky. This triggered alternating effects of light and shadow on Umm Alaa's face while shooting.

"I'm Umm Alaa from al-Zaatar.

"Long ago, I had a dream.

"It was raining and cloudy, windy and cold . . .

"I was walking, and saw light all over the place. The sky was full of Qur'anic verses. I read every verse that appeared in the sky, every verse . . .

"After a while, I saw a large group of people. A woman dressed in white, whom I'd never seen before, came up to me and said, 'Why don't you pray?' I replied, 'I don't know how. Teach me.' She said, 'Okay. Come. I will teach you.' After she taught me, I started praying. Then a little later, I went back to see the group of people and thought, 'Oh God! What's going on?' A man all dressed in white approached me. I asked, 'Who are you?' He replied, 'Me? I was sent by God.' I said, 'Okay. Why are the people assembled like this?' He said, 'We triumphed.' I said, 'No way. That fast?' Then he said to me, 'We wanted to triumph. We had to triumph. All the people are happy because we will triumph.' After a while I woke up.

"After my father was martyred and we left al-Zaatar, I dreamed I returned. There was nothing at all, no food, nothing. Everything was in ruins. We were staying in a totally destroyed house. I said to my mother, 'We need to light the stove. How can we? There's no gas, no oil.' In the dream, my father hadn't been martyred. He was asleep inside. He said, 'What do you want?'

"I replied, 'We want gas. Shall I go and get some from them?' He said, 'No, don't go. If you go, they'll kill you. Don't go.' I said, 'Okay, but there's no bread. We want to make bread. How are we going to make bread?' He said, 'You stay here now. We'll work something out in the morning.' After a while, I saw him sleeping. I said to my mother, 'It looks like Father went back to sleep.' She said, 'Maybe he's tired. He wants to rest. Don't be upset.' I said to her, 'Okay. Here we have gas. Let's light the stove.' After my mother lit the stove, I woke up frightened.

"I have a brother who disappeared when he was leaving al-Zaatar. I saw him once in a dream. He came to us at the house. Nobody was home. We had a plant, and he said, 'This plant you have is pretty. Where's my mother?' I said to him, 'Mama is in Damour.' He said, 'Okay. I came, and I want to bathe.' I said, 'I'll heat water for you now to bathe. Sit down. Rest. If you want to eat, I'll feed you.' He replied 'I don't want to eat, and don't do anything for me. I'm leaving. Tell mother I came and left.' I said, 'Okay.' After he left, I no longer dreamed of him.

"When we were searching for my lost brother, I saw my father again in a dream. He said, 'See? Your mother has gone to Syria to look for your brother. Tell her I'm fed up.' I said to him, 'Then where is my brother? Tell us where he is.' Then he said, 'He's not with me. If he were with me, I would tell you to reassure you. God knows.'"

I asked her what he meant by "not with me."

"It means with him in the afterlife. It means he's not with him in the afterlife." At this, the recorder ran out of tape and stopped, and Umm Alaa's smile in reaction to the naivety of my question about what her father had meant was still visible on the videotape without sound, an extraordinarily beautiful and meaningful smile.

Umm Amal

"My husband was martyred in al-Zaatar. First he worked at a gas station, then he joined the Resistance and started working with them. He was injured in al-Zaatar. When we left he was at the hospital in a good condition."

"Do you see him in your dreams?"

"I saw him yesterday. We were running an errand, and he said to me, 'Go buy some bread and roasted chicken, we'll take the kids and go outside and eat together.' I went with my cousin. We found a lot of bread, stacks of it. I started looking around and asking where I could find roast chickens. I didn't find any. I woke up and realized I'd been dreaming."

Thursday, May 15

Today when we went to film the alleys of Shatila camp in the morning, we discovered that the students were on strike. When we asked them about it they told us, "What's wrong with you? Today is May fifteenth."[30] Official schools would only hold two classes. The UNRWA-affiliated schools were on full strike. Lebanese schools were on strike for another reason: teachers' demands.

In Shatila's main street, a water pipe had burst and turned the ground to mud. In the afternoon, Israeli planes frequently appeared in the sky of Beirut. Counter-artillery was firing heavily, making everything shake. In the evening, we learned that the People's Front carried out an operation inside the Occupied Territories, that Israeli planes had bombed al-Bas and al-Rashidiyeh camps, and that Israeli torpedo boats were approaching Damour. At night, I went on a preliminary scouting trip in Burj al-Barajneh to think about the visual concept of the film before we filmed there. Today, we filmed the following:

– A large military kitchen for preparing food for fighters

– A vegetable market

– A mosque

– A prison

– A view of the camp from the roof of the school on strike

– Men cutting beans

– A soldier cutting lamb

– Israeli planes in the sky

Friday, May 16
Gladys

"My brother was shot in the head during the latest events. He died as soon as he was hit, martyred. A month after my brother died, my father lost his arm, also in the events. Everything about him changed when he lost his arm. His whole mentality was different, he became overly impatient, he couldn't look at us or stand having us in the house. It got so he'd see us and it was as if he'd gone blind. He got worse, started drinking. I was in school at the time and they took me out. I started working.

"I saw my father once in a dream. I saw him beating my mother. I tried to defend her, so he struck me with a bottle and beat me. Blood ran from my head. I woke up and started screaming." Gladys wept vehemently. Suddenly, her weeping was met with the sound of all the sewing machines turning off, a sound that was a slow hum resembling sobbing. We discovered that the electricity had gone out. The sounds of shots outside indicated the presence of enemy planes in the sky.

Dalal

"First we were in al-Zaatar. Now we're staying in Damour. My four brothers are in Germany, and I have a sister in Dubai. And the rest I work at SAMED in Martyr Kamal Jumblatt's workshop. My other sister is in Abu Ali Iyad's workshop, and I have a sister who works at the Women's Union."

"Do you see al-Zaatar in your dreams?"

"Yes, I see it. Once I dreamed that I was in al-Zaatar working with the Red Crescent treating the injured. We were nursing an injured man, and while we were treating him a missile struck us. The injured man was martyred.

"My mother woke me up to go to work."

Abu Adnan—the truck

He is a driver. He's now working at SAMED.

At sunset we rode with him in the vehicle to Damour road. We let him drive while he narrated for the camera the story of the truck he'd used to move people who'd been displaced from Palestine to Lebanon, the story he'd narrated to us during the initial meeting. Then I asked him if he remembered any dreams. "Well, one day I had a dream. There was a tall staircase, and people were running, climbing it. I followed them and ran to the staircase. Halfway up the staircase I stopped. I looked and found people still climbing except me. I didn't have the nerve to keep going and I stopped. I was scared! I looked down and saw that I was very high up. All my kids, my children, were below; I could see them. That's what I saw."

Saturday, May 17
Sabra

The atmosphere is tense. Israel is along the coast. There are deaths and casualties.

Umm Emad

"Do I dream?! A lot."

A little girl shouts, "I dream too!"

"Tonight I dreamed that we were going to make Molotov cocktails, just like we used to. I was going to the neighbors and saying, 'Give me your bottles. You drink a lot of beer in Lebanon.' My husband has never smoked, he's not a smoker. I swear, he still doesn't smoke."

"Then what did you dream, Umm Emad?"

"I dreamed that they wanted to come and visit me." We laugh, so she laughs. "I swear I dreamed that I was searching for thimbles. I sew. I'm a peasant.

"I found ten thimbles, and was very happy with them. I put the thimbles in my purse. The next morning I told my neighbor about the dream. She said, 'God willing, your twelve children will grow up, and a bounty will come from them.'"

We were collecting the lighting and film equipment to leave. Umm Emad was telling us her personal memories of 1948. We were half-listening. Then I got the idea of recording just her voice and discreetly made a sign to the sound engineer.

"They were dressed in King Abdullah's military uniform and were riding in tanks with the Jordanian flag on them.[31] They came from Nabala, one of our towns. We were standing there. At that time I was seven years old. We started applauding them. They had pictures of King Abdullah and Glubb Pasha. There were young men crammed in the mosque and the school. They came out thinking that a Muslim army was passing by. This 'army' grabbed the young men and threw them in the well in the middle of the mosque. I saw that with my own eyes, it's not something someone told me. I was seven years old. They grabbed the young men and hurled them into the well, the mosque well." The camera was on an adjacent table. Hazem and I exchanged looks and he discreetly turned the camera toward her. Without any special lighting, the camera was filming again. "We kids saw through that trick more than the adults. Then it was over. Whoever still had a son or a daughter fled that night. At that time, it was us five girls and my father. Of course, some could walk, others had to be carried. When we grew up, two of my sisters were martyred—in Palestine, thank God! One was martyred in Lydd and the other in the middle of Tel Aviv. I wish this could happen to me and my twelve children, to die in Palestine. I have a sister who's still in detention in Palestine; it's been twelve years now. My brother was also martyred, the only boy out of eight girls.

"In the 1967 war . . . you have to hear this. You have to hear it many times, not only once. You have to tell it to other people as well. Are you recording what I'm saying? Or are you letting me talk for nothing? No. If it's for nothing I won't tell the story. Keep this in your memory. You have to broadcast this. Why not? Look at the betrayals in the 1967 war. Never say that it's only today that we have traitors. There've been traitors since time immemorial. They took my husband; he was conscripted into the army. We were in Gaza. All of sudden, they took the Palestinian army and put it on the borders. They burrowed into

the ground like jackals. Poor things! They kept them there and of course kept us praying, children and adults. I was praying in the morning, when there was a knock on the door. It was Abu Emad. I asked, 'What happened?' He said, 'They gave us leave.' I replied, 'It's a state of emergency, how could they give you leave?' Of course they didn't allow them to take their weapons home. I swear he came. I said to him, 'How?' He said to me, 'Everyone's starving, Egyptians and Palestinians.' I said, 'We have a lot of flour, Ali.' We're peasants. We make our own bread. I swear to God that's what happened. I sat and baked bread. At sunrise, I heard the sound of planes. I looked at the sky and saw fourteen planes above my head.

"He was asleep. I screamed, 'Muhammad. Muhammad.' He said to me, 'Yes.' I said to him, 'There are fourteen planes flying low, and there's smoke on the station in front of us.'[32] He woke up and put on his shirt. He still hadn't seen his children. I had three children besides the one I was pregnant with. He didn't have time to put on his military uniform. Soon, Israel was in our wheat market. They reached the town, and the people were running.

"I took the bread I baked with me. Eight days later I met Abu Emad in the Sinai desert. We ran, with people running behind us. We learned that the Jews had reached Egypt. We found a mixture of soldiers—from Syria, Palestine, Jordan—exhausted, lying on the beach, dying of hunger and thirst."

The little girl calls from the street, "Mama, someone is calling for you."

"Who's calling me? Abeer, see who's at the door." Abeer goes out.

Abeer says from outside the room, "Mama, come and talk to him."

"Who am I supposed to talk to? Who is it? Is it Abu Khashab?

Abeer replies from outside, "No."

"Who?"

Abeer from outside, "It's the official."

"Abu Jihad?"

Abeer from outside, "No."

"Abu Saeed?"

"No. It's the one you asked to bring the allowance. "

"Oh, that's Abu Waheed. Welcome. Tell him to come in, that your mom's leg is tied. The film people are keeping her tied up."

Monday, May 19
Abu Subhi, the Sea

We met him behind clothes hanging on a clothesline in the narrow alleys of Daaouk, located between the boundaries of Sabra and Shatila. When he said to us, "The sea . . . the sea is a king. It never changes," we dubbed him "Abu Subhi, the Sea."

We followed him, keeping at a slight distance. He had sat down where the sand and sea met, exactly on the threshold of ebb and tide. He contemplated the sea in silence. Then he pulled out a pack of Rothman cigarettes and started smoking silently, heedless of the roaring engines of the Middle East Airlines planes taking off directly behind him.

We positioned the camera so that it would appear to the viewer as if the planes were coming out of his body. Atop the pile of sand that separated us from him he looked like a lone cactus plant, sometimes a frog situated between land and sea. Then he suddenly stood up, appearing confused and scattered.

"I started in the sea with a toushte and a pumpkin . . .

"I wanted to go to the sea of Jaffa, but didn't know how. I got a toushte for washing clothes and put it in the sea. I put myself inside it, and sailed. I threw the fishing line and the fishing rod. I used a stone so that the rod could go down and a pumpkin so that the line could float. I dipped the line, pulled it, and found fish.

"That's how my life with the sea started there, and ended here.

"On Black Saturday . . .

"In Lebanon we, the fishermen of Jaffa, worked as laborers in a Lebanese company. In our country, we worked for ourselves. We took one third of the profit. Here, they made us work for daily wages, eight Liras a day. We worked from 1951 till 1975. On Black Saturday they fired us.

"What could we do? We held a meeting and sent a letter to the Palestinian leadership as fired laborers. The leadership doesn't have companies to employ us, so they employed us in the Armed Struggle.

"I remember my first shift in the Armed Struggle. That night I didn't sleep. Why? The climate was different for me. I love the sea. I can't work on land. A seaman is like a fish; he can't survive out of water. If a fish leaves the water it dies. Now when I go to the sea I look around and don't know where I am. Everything changes but the sea."

Tuesday, May 20
Abu Subhi from Sabra

When we went back again to film later, in 1981, Suad, who had started working in the WAFA photography lab, said to me, "Did you know, Muhammad, that Abu Subhi died?"

"Which Abu Subhi?" I asked, trying to remember. "Abu Subhi, the Sea?"

She said, "No. Abu Subhi from Sabra."

"You mean Abu Subhi from Ghandour factory?"

"Yes."

To her he was Sabra camp. To me he was Ghandour factory. I remembered him, Abu Subhi from Sabra. I remembered meeting him during the scouting period, he was with Abu Krum and Abu Fawwaz. It was the evening when the wives were sitting in the corner of the room listening to the conversation with apprehension and anxiety.

Today, though, when we came to film Abu Subhi and accompanied him to his house, I was very confused, first by his life story, which he summarized between two brackets: leaving Palestine and work-ing at the Ghandour factory. I was also puzzled by his words, his face lined with indescribable furrows of agony and despair. What increased my puzzlement was his house, which appeared to be constructed of fractured and interlocking cement elongations going up toward infin-ity—in the form of a staircase. When I went up the stairs, trying to find out where they might lead, I found myself in a world swirling with spaces and objects like in a dream.

It was as if everything came from and returned to these stairs. The floor was clean and the walls were white. The rooms were empty. A yellow afternoon light diluted the whiteness of the walls with a sad and ambiguous warmth. There was nothing except for some metal cans filled with green seedlings. He stood watching as I was thinking about the space and how I wanted to film in it. I climbed the cement railing that separated the terrace from the lower part of the house, trying to find the angle from which to best capture the essence of the stairs while Abu Subhi stood at the end of the railing. I looked at him and was struck first at how his figure resembled a sword, rippled with rays of light seeping in from a remote window, and second at how the railing I was sitting on looked like a cement knife stuck in his waist. Even worse, there was a wooden ladder leaning on the wall directly behind him, so it seemed that it was attached to this series of eccentric stairs. I asked Abu Subhi to stay where he was and I quickly descended. Then we placed the camera fitted with a wide-angle lens on the railing to film him from the same angle as where I had been standing.

"Every question has an answer . . .

"I left Palestine. I worked at Ghandour and I'm still there.

"Nothing else.

"I used to write poetry. Now I can't stand finishing one line.

"I'm like an animal in a stable.

"It runs and runs and runs . . . for nothing. There's no point. One can neither be of use to oneself or to one's people. . .

"We need a miracle.

"The bitter reality of our situation as Palestinians is partially due to our lack of awareness. We should have learned and understood the lessons. I have only one dream, to start from scratch." Then Abu Subhi fell silent, and we filmed this silence.

We took numerous long takes of this man's silence, of different lengths and from different angles. At the end, we filmed Abu Subhi going up the cement stairs of his house in this camp, into this 'infinity.'

Then we went directly to the stable in Shatila camp to film the horses. Abu-l-Su'ud, who worked in the stable, opened the top half of

the stall doors so that the horses peeped out in front of the camera, their beautiful necks waving in the air.

We filmed a counter-shot of the moment these iron doors were slammed shut on the horses, which retreated, frightened, into the stall. The cold iron bolt remained in front of the camera as Abu-l-Su'ud proceeded to shut it, the sound of the closing bolt overlapping with the echo.

Wednesday, May 21
Burj al-Barajneh

The weather was suddenly cloudy. There was a sandstorm in Burj al-Barajneh. The electricity was out. There was little light. The air was dusty and yellow.

We discovered a network of stairs in the camp's passageways.

Today we just shot silent scenes and everyday details during the sandstorm.

Thursday, May 22
Umm Hatem

Umm Hatem's room in the Burj had two doors opposite each other, each facing one of the camp's alleys. The door opposite us was covered with a piece of white muslin that rippled in the hot breeze. We were seated at the room's entryway, where we asked Umm Hatem to wash her husband's military uniform in a tub on the stove.

She was surprised at this request. We explained to her that when we visited earlier she was washing his clothes and we wanted to film her as we had seen her then. She agreed. She got up to bring his suit in from the clothesline, regretting having just washed his suit before we came. She turned on the stove, positioned the laundry tub, and started scrubbing her husband's military clothes. The young husband was sitting on the threshold of the opposite room. He placed a mirror and shaving cream in front of him and started rubbing his beard.

It was morning. Maybe the husband was on a vacation that had started yesterday or this morning. My first impression was that Umm Hatem was his mother. We didn't talk to him at all and never heard his

voice. We placed the camera on the threshold. Umm Hatem and the laundry tub filled the frame. When we moved the camera a little, an Ariel soap packet and the stove's flame entered the frame. The movement of the white curtain created shadows that came and went, and a silhouette of the husband, who started scraping off the shaving cream with a razor, could be seen in the background.

"Our village in Palestine is called Akzam," she said. It's protected by four surrounding mountains. The elders came and told us, 'Go and gather pomegranate branches and stick them into the ground in the mountains around the village, because pomegranates will protect it from the Jews.'

"We started sticking branches of pomegranates into the ground and reading Qur'anic verses. The Jews never did enter the village; it only fell in the air raids. I was nine years old at the time. I saw the Jews with my very own eyes, flying low, extending their hands from the planes and firing machine guns . . . boom, boom, boom!

"Once when I was asleep I had a dream that I was on top of a very high column with a sea beneath me. I looked at the sea and saw that I was about to fall from the column. I stumbled. I held on to the column like this." Here Umm Hatem grabbed the packet of Ariel soap, using it to aid her description. "I slipped downward and woke up wide-eyed and horrified.

"Another time, I dreamed I was walking down the street. The street was narrow, and a huge bulldozer was heading toward me. I didn't know where to go. If I stayed in the street the bulldozer would crush me. I looked around. There was a mountain. I held on to the mountain, clinging to it. I stayed there and relaxed. I only woke up because I was falling off the bed, that's how scared I was."

Friday, May 23

Thuraya

"I had a dream two years ago. I saw myself on a vast highway, and there was a speeding car. Suddenly, I saw the car's tire flying. I was in shock and I ran for a while. Then I saw myself in front of a large,

green pasture covered with herds of white goats. I wanted to take one of them. I said to myself, 'Will I steal? No.' I went to a man to negotiate with him. I had twenty-five Liras on me. The man said, 'Sorry, the price of one is more than a hundred.' I withdrew frustrated, still thinking about the goat. I woke up, and I didn't get the goat."

We filmed Thuraya from the window overlooking the street. She was sitting behind a sewing machine next to the window. Her voice mixed with that of the muezzin performing the call to Friday prayers in Burj al-Barajneh Mosque.

Monday, May 26
Shatila
Abu Shaker—the eyes

I don't know why I decided to shoot Abu Shaker at night. We filmed him when he was closing the store and walking the two- or three-meter distance to his house.

We filmed him on the tiled floor in the courtyard, under the shadow of the iron banister while he washed and massaged his tired feet. In his bedroom, he put on his pajamas, lay down on the bed, and covered his body with a white sheet. The strong lighting and the camera's angle made him appear dead in the bed. His wife couldn't control herself during the filming. She screamed and wept with fright and pessimism over this omen. The only thing we asked him to say, while lying down, was what he had said during the earlier meeting. "As you just saw, from the store to the house and, tomorrow morning, from the house to the store. This is our life, our destiny, a space of just two or three meters—hoping for a more comfortable and stable life for us and for our descendants."

I said to myself that this would be the final scene in the film.

Tuesday, May 27
Ein al-Helweh

The atmosphere is tense, with Israeli warplanes and battles and assaults on Nabatiyeh, especially at sunset. There is a foreboding sense that a general mobilization is about to take place. Most conversations are

centered on the Israeli bombardment. The weather and heat are different from Beirut. There are concerns over potential Israeli ambushes and checkpoints being put in place at night in order to deal a blow to the Resistance.

Hajj Nicola

He has a velvet painting of Che Guevara in his office. The young man, who calls himself Hajj and who seems somehow to resemble the picture, stands so that his face is at the same angle as the one in the picture. We put the camera in the same spot, so that the real face blends with the one in the red velveteen frame.

"Sometimes I pass by the strawberry vendor in the market. I either buy something from him or eat there. It was about five to two in the afternoon. I left here to go to Sidon for an appointment. The strawberry vendor was in front of the church, by the lamppost. I was carrying two newspapers and walking. Suddenly, a missile was dropped. Two minutes passed before I was able to move. I saw people running around, not realizing they had been injured. They were falling on the ground and screaming. The missile was the kind that released blade-like projectiles that killed and disfigured. The strawberry vendor died in front of me. There were body parts everywhere, not a single body was left intact. A pick-up came to carry the parts away; there wasn't anything for us to carry."

The muezzin

He was an old man with a long white beard living on top of the hill overlooking Ein al-Helweh. He had a modest home with attractive fresh plants. There was a brazier for burning coal, brass coffee pitchers, a sea breeze, clear light, and a picture of al-Qassam beside a mirror that reflected the picture into a series of other mirrors. There was also a picture of Abu Ammar, and a picture of the old man's sons. I didn't have the courage to ask whether they were alive or martyred. Hajj Omar's eyes held unshed tears and a deep faith that dampened the Revolution with religion.

When he heard the sound of the camera starting up, he addressed it saying, "Welcome, gentlemen. My name is Hajj Omar, a Palestinian from Saforia. I am seventy-five years old. Every night between twelve and one o'clock in the morning, I get up to perform my ablutions and pray. Afterward, I praise God a hundred times for each prayer, that is, I praise God a thousand times, a thousand my dear sir. I finish. I have a military uniform; I put it on and go out. I pass by the Democratic Front, the People's Front, Fatah, al-Nidal. I go to all the offices and all the checkpoints and say, 'Wake up. You shouldn't sleep. People depend on you. If our enemy comes, dear sir, it will strike children and women and the elderly. I stay at each office or checkpoint for two or three minutes. I drink tea or coffee with them. Half an hour before dawn, I go to the mosque. I read part of the Qur'an, perform the call to prayer, and pray. I come here on foot, walking from there to here. I feel sleepy. I lie down and sleep until the sun rises . . . every day, every day. When I go down and find the young men asleep, I cry. I scold them and tell them, 'The people are your responsibility.'"

Thursday, May 29
Elham

In Elham's house, we felt—whether on that day of the first meeting or on this day of shooting—that we weren't strangers at all, nor guests, nor a cinema crew. There was a deep cordiality and human ease, which is rare. This beautiful Palestinian girl was willing to disclose to the camera the deepest secrets of her soul, her agony and hope. This was mainly because we entered her world through a trusted Lebanese friend. Once we overcame many of the difficulties of the first meeting, we felt we could make more complicated requests when shooting: rearranging furniture, placing lighting with narrative precision, getting the inhabitants to do household chores we hadn't been able to shoot naturally while filming in the other camps. The cordiality and intimacy that we felt in their house made us decide to create a snapshot of the geographical displacement and domestic disintegration that imposes itself on Elham's family. We conveyed this sentiment

through the shooting technique: We asked Elham to fill the house with the noise of the stove, so she turned it on for us. We asked her to make the hot steam rise in the kitchen air. Then we asked her to stand behind it and move the clothes inside in a circular motion. We also pleaded with her to stay in her house clothes, which were also perhaps her sleeping clothes.

Afterward, we pulled the camera back into a dark room to show an image of Elham—her figure slender and the light drawn warmly across her brown face—between the two black walls split in half by the kitchen door. She stood there in the background conveying a womb-like intimacy.

"Our village in Palestine was called Na'meh.

"My grandfather was a landowner and had lots of land. He's still alive now, but he's senile. He sits around making coffee and drinking. In Palestine, he was an important man. If he wanted to cross a river, a man would kneel and carry him across on his back.

"My father is in Saudi Arabia.

"My mother comes and goes from here to there.

"We are four girls. My oldest sister is married, but her husband is in Das. He comes on vacation once every three months. My second sister lives here. I worked with the Resistance for a long time doing whatever kind of work was needed. Tomorrow I want to go to Beirut to obtain a passport because I'm thinking of traveling. Why I want to travel is not what matters—what matters is that I travel. I really want to get away, I don't know where.

"My fourth sister is still studying at the university.

"My older brother is in Libya.

"Nasri was in the Resistance and is now in London.

"Nizar was martyred.

"Thaer is young.

"Once I opened the door to our house, walked in and saw that there were many people in our house. I threw down my bag. I felt that something had happened. I headed directly to this room and asked about Nasri. They said to me, 'Nasri is in Sidon.' I asked about Nizar.

They said to me, 'Nizar is a hero.' I screamed and screamed. Then I lost my voice.

Intisar

"I once saw Nizar in a dream.

"I saw him at the end of the alley. I said to him, 'Where are you going?' He replied, 'I'll be back.' I said to him, 'Okay. But your shoelace is untied. Let me tie it for you.' I tied his shoelace, then got up and kissed him. He left. I woke up."

Friday, May 30
The boat

We met Abu Muhammad, the fisherman, at the fishermen's café in Sidon. He was drinking tea and was out of work. We didn't know how he'd broken his leg, which was wrapped in a cast. Abu Muhammad told us the story of his beloved boat, which he called *Jaffa*. He said, "We left Jaffa on April 23, 1948. The sea was raging, and the wind was ferocious. We sailed in a fishing launch, and I towed my boat *Jaffa*.

"We barely reached the port of Tyre. We entered it with death hanging over our heads. Afterward, I started going to Sidon. It has the same climate as Jaffa. I settled down there and started fishing with my boat *Jaffa*. Then the government started giving us problems. They wanted us to change the boat numbers and IDs from Palestinian to Lebanese. Of course they wouldn't allow us to register them in the name of a Palestinian. We started working with 51 percent registered under a Lebanese name and 49 percent registered under a Palestinian name, and we used Lebanese numbers and boat names. This went on for a while. We faced other obstacles when the Israeli torpedo boats used to bombard Palestinian and Lebanese boats. After 1967, the Israelis detained a large number of fishermen and boats, including me and my boat *Jaffa*. We stayed in the prisons of Haifa for three months, after which they turned us over to the Lebanese army. We were forced to fish in areas close to the shore and not go too far out. But because there were so many fishermen and boats, the fish were gradually

depleted. During the latest incidents, I was randomly detained in an Arab country. When I was released, I found *Jaffa* wrecked and ruined on the beach."

"Do you see it in your dreams?"

"I don't see *Jaffa* in dreams; I see it in reality. I'll be sitting here picturing it in front of me. When I lost the boat, it was as if I'd lost one of my children because I loved it as much as I love Palestine, and precisely as I love Jaffa."

* * *

I realized that what I'd seen and filmed had overpowered me. It had affected me to a much greater degree than anything I'd be able to bring to the film or assemble into a coherent whole. I felt that the film was in my soul, but never between my hands. These people had filled my soul, but a film? We'd used up all the film and spent what little money we had. My concern about the results and my fear over postponing the development of the material we'd filmed made me decide to stop shooting in order to regroup, reflect upon what we'd accomplished so far, and search for an opportunity to resume shooting later. We returned to Beirut in the evening. I slept as sound as death, while my friend Hazem Biyaa, director of photography, collapsed under the intensity of a severe sunstroke.

On Thursday, June 5th, we all returned to Damascus.

Surveying and Scouting II

It shall even be as when a thirsty person dreams of drinking,
but awakens faint and thirsty still.

Isaiah 29:8

Saturday, July 11, 1981
Burj al-Barajneh
The Abu-l-Ashra family

"A boy is a disaster.

"Winter is relief, stagnant water an enemy.

"Intisar saw in her dream a heap of sand and white rocks.

"The sand heap means graves, and white rocks are tombstones."

Ekhlas added, "And I dreamed that Haniya gave birth to a boy. The next day, my cousin lost his legs."

Kayed said, "I get very irritated when I dream."

As for Abu-l-Ashra, he told us he always dreamed that he was fishing on the beach. And Umm al-Ashra said, "A fish is a blessing." Then this mother let herself go, drawing back into her thoughts, letting silence prevail. She resumed, uttering scattered words as if she were addressing herself. "Everything is precious, but death is cheap. Whenever one of them is late, I tell myself, 'He's gone.'

"In Palestine, we neither enjoyed the summer nor retained our honor. If a man refuses to marry a girl they say, 'We neither enjoyed the summer nor retained our honor.' Here we are . . . revolution and stuff, but nothing happens."

I don't know why it didn't occur to me to ask our friend Hala, who introduced us to lots of families, about her dreams. But all of a sudden she told us, "Once I saw myself in a dream leading a military coup in a city. The city wasn't clearly identified, but from the shape of buildings I felt it might be Damascus. The streets were full of green tanks. I was running and telling the soldiers who participated with me in the coup that we had to occupy a building, and I pointed to the Intelligence building. They said to me, 'Hala, go and write a statement.'

"I went and got a paper to write on, and I found that the paper was very big. When I wrote, I found that the font was very big. One word filled the whole paper.

"I wrote, 'And now democracy starts.'

"I ran to the radio station to broadcast the statement. I saw myself screaming, and no sound came out. I screamed and screamed. My voice wouldn't come out. I woke up."

Hala was wearing a black skirt and white shirt. Her hair was black, and her face was white. The camp was the same, as if I hadn't been gone this entire year. Cars that used to swerve at high velocity still do. Maybe what's new are the green plants that grew on the torn sides of sandbags that had been piled on top of each another to protect the entrances of houses and stores from shrapnel.

Hassan

"I see myself running on sand . . . running. But I stay in one place, unable to move forward. Sometimes, I see someone chasing me with a dagger, but the moment he reaches me I wake up.

"I used to have the same dream three or four times a week. Now, thank God, I haven't had this dream for around five months.

"I don't know the person who chases me, but the sand is like that above us at the camp's border.

"When I was imprisoned, I used to dream that I'd been set free. When I was set free, I started dreaming that I'd been imprisoned.

"When I was in Germany, I used to see myself coming back here by sea. In this dream the ship sank and the luggage was lost."

Yousef
"I always dream that I'm dead.

"I see them carrying me in a coffin, on their way to bury me. But I also see myself carrying the coffin with them—I don't know why."

Ghazi
"A friend and I were walking in a place that looked like Beit Mery. All of a sudden, we were ambushed.

"They said, 'Where are you from?'

"We said, 'We are Palestinian.'

"They all jumped up, grabbed us, and dragged us down the street.

"At first, they took my friend and tied each of his legs with a rope. Then they fastened each rope to a sycamore tree. The tree was old and perennial. One of them came carrying a big cleaver. He lifted the cleaver and struck my friend between the legs and split him into two halves. When I saw that I trembled with fear. Then I woke up."

Wednesday, July 15
I paused by the black, dusty telephone on a small, wooden shelf next to Umm Muhammad's store. Maybe it was the only public phone. It was frequently engaged, especially by the girls in the camp.

From behind the store's fridge, Umm Muhammad said, "Once I saw in a dream a gray-eyed mule going up our staircase. I stood by the door, then my daughter Khayriya called out to me, 'Mom, come here. Grandmother is dead.'"

Umm Muhammad resumed, "That night Khayriya dreamed that her aunt was a bride, but a bride wearing gray, not white."

As for Khayriya, she said that she saw the store a lot in her dreams. She said, "I dream the store's fridge is crooked." She dreams a lot that she is fighting with people because they don't pay. Umm Muhammad dreams of bunches of dried grapes. Khayriya dreams of traveling to Abu Dhabi. Once she dreamed that her deceased father asked her, "Did you pay the debts?"

He also asked her, "What time is it?" She answered, "It's four

o'clock, Baba." Then it became six o'clock. He said to her, "Take care of the children. I have to go. I'm in a hurry."

Friday, July 17

The film crew arrived in Beirut when Israeli planes were assaulting the Fakhani buildings.

All we could do was take shelter in the Jisr al-Cola neighborhood.

At first, we were terrified something might happen to the film equipment we'd borrowed from Syrian television. In the afternoon, we went over to the places the planes had struck.

The impression was utterly horrific—your head spins, you want to throw up, your stomach churns as if it can no longer hold everything in, then a gray fog sets in where, first your soul then, bit by bit, your body feels like it might fall to pieces. We have to stop.

We have to get the film crew back to where it came from.

People are outside day and night, outside the houses, outside the offices, outside the camps.

There is anticipation and fear of another Israeli bombardment.

The atmosphere is no longer suitable at all, neither for scouting nor for shooting.

Monday, July 20

I came back to resume scouting sooner than expected. I thought the bombardment of Fakhani would make my inquiries about dreams seem ridiculous, or at least inappropriate.

I didn't want to record dreams linked to a current event.

I chose to return to Burj al-Barajneh, as the bombardment made it seem relatively further away from the camps adjacent to Fakhani.

The Ashkar family

Since they were displaced, Abu Hussein has been working cultivating vegetables in the town of Jiyya. He never dreams. His nine-year-old daughter Nariman said, "We were at the mountain. I was asleep. I saw a plane falling. I thought it was a kite like the ones kids fly. We ran. We

saw two people next to the plane. We took them and locked them in the bathroom." Nariman was speaking fast because they were making children leave the camp, in fear of another possible bombardment.

As for the mother, she saw Abu Ammar: "He was dressed all in white and walking in a mountainous area covered with white tents. He was coming for the people, but the people were not to be seen." There was a photograph of Abdel Nasser on the wall. "Also I was dreaming when they bombed the school last summer at half-past-five in the morning. That day I saw Resistance members fighting each other. I screamed at them, 'Damn you! What's the matter with you? What's going on?' They said to me, 'There's a rabid dog, black, the color of tar, there behind the hill. And I woke up to the sound of planes."

Her son Muhammad said, "I don't remember that I ever had a dream with people in it.

"Once I dreamed we were walking on the sand, and there was barbed wire around us. But I saw nothing except ants. I put my hand down by the ants and found a chick. I picked the chick up out of the ants about seven times, and each time another chick would appear. The chicks had no feathers, but they were covered with blood.

"When I woke up, I told my mother. She said, 'Did you see blood, Muhammad?'

"I said, 'Yes.'

"She said to me, 'The dream was corrupted.'"[33]

Umm Marwan

She laughed when I asked about her dreams. Then she said, "You know, I swear to God I no longer like to sleep, just so the sheikh won't come to me in my dreams.

"He's a scary sheikh with a long beard. Every time he comes and says, 'I want to take your son Marwan.' I reply to him, 'No. Take me and leave Marwan.' And he says to me, 'No. I want to take him and break your heart.'

"I always wake up crying. I wake up, lay my bedding next to Marwan, and sleep beside him, hugging him, although he has become

a young man." She is in her third decade. She works at a radio station and pays the salaries of martyrs' families. Her husband was martyred at the Shaka–Tripoli checkpoint. "We have a knowledgeable sheikh who comes to me to collect his martyred son's salary. I told him about the dream. He asked me, 'Do you have this dream every day?' I said to him, 'Every night, I swear to God.'

"He said to me, 'Slaughter a hen.'

"I slaughtered a hen, but that sheikh kept coming to me in my dreams.

"I asked another sheikh. He said to me, 'Put a knife and a piece of bread under your pillow.' I did. But I'm still afraid of sleeping."

Her little daughter said, "Once I dreamed that the door was opened, and a man entered. I saw him carrying an iron rod. My father was sitting with us. We tried to hide him, to cover him with the bed sheet. We couldn't. Then my father disappeared. We started looking for him and weeping." The girl entered all of a sudden, in a state of extreme agitation mixed with embarrassing laughter. Her mother scolded her saying, "Stop it. Don't laugh."

Then Marwan said, "She's crying."

The girl resumed, "When I told my father about the dream, I said to myself, 'I wish I hadn't told him.'" As for Marwan, he said he was fond of the television show *Dalila wa Zeibaq* because when they killed Zeibaq's father, he avenged his death, seized the town, and became their governor.

The Abu-l-Abd family

This family lives in a lowland area in Burj al-Barajneh camp called the Tarshiha Depression, inhabited by people who were displaced from the Palestinian town with the same name.

Abu-l-Abd is an old man who works as the night guard in one of the Resistance offices.

He said, "I saw myself as a bird, and I was flying, flying over the mountains and the valleys. God! How happy and ecstatic I was!"

His daughter Haniya told us, "Abdel Nasser had just died, and I was still a little girl. In my dream Abdel Nasser was alive. He was

riding a ship that flew over the Tarshiha Depression. I stood watching the ship. The sky was clear, and it was morning. I saw only his face. My family behind me said, 'Hey! Isn't Abdel Nasser dead?' And I said, 'No. He's alive. All the talk about his death is journalistic propaganda.' My family said, 'What? How come it's propaganda? They killed him. They poisoned him with white cheese.'"

Haniya also said that she always sees herself in dreams wearing only one shoe. Sometimes, she sees herself going to school barefoot. Najah commented on her sister's dreams saying, "A shoe in a dream means a suitor." Najah promised to tell us her dreams later, privately. And these she told us with extreme difficulty.

Afterward Najah said, "Once I saw two rabbits. One was white, blue-eyed, and noisy. The other was red-eyed, horrible, and looked like a rat."

"I've never held a rabbit in my life. In the dream, I held the white rabbit and hugged it to my bosom. Then the other rabbit started approaching me, raising and shaking its hands as if it were imploring me. But I was afraid. After a while, I felt sorry for it. When I was about to hold it, it ran away.

"I've never ridden on a train. I saw a train going on a road full of greenery. I was surprised. Then I saw one flower in the middle of the greenery. It was yellow, but it was very big. When I saw it, the train passed through darkness, like in a tunnel. I felt that it was climbing a rope.

"A bleak train. It didn't look like the trains I see in movies at all. It was slow. It made you imagine that at any instant it would fall."

Najah was whispering to us while sitting on the bedside. A window separated us. The window overlooked the green lowland of the Tarshiha Depression. Although I don't remember accurately the color of the dress she was wearing, I do remember the plastic, butterfly-shaped, blue brooch that she had fixed on her cleavage.

A slender, fair-skinned girl, she whispered words in scattered pieces. Whenever she pushed words our way, she blew a thrust of air toward us with her head.

"Once in a dream I saw a dress, it looked like it was made of almonds. A young man stood in front of me, trying to sell me this dress.

"I was walking carrying my books against my chest and stopped to look at it. The young man said, 'Would you like to try it?' I liked the dress, but I felt embarrassed. I said to myself, 'How can I go in alone and try it?'

"I went in, laid down my books, and undressed. I tried on the dress and looked at myself in the mirror. I was surprised to find that the dress was glittery. I looked at myself . . . it was as if I wasn't wearing anything at all. I was embarrassed. I asked him how much the dress cost just to be nice, because I couldn't buy it and was sure nobody would allow me to. Suddenly, the mirror became many mirrors around me, and the dress was glittering." Najah put a plastic, heart-shaped, green hairpin in her hair. "People here are in the middle of a revolution." She meant the Resistance milieu. "They criticize the way I dress. I say to myself, 'Why, God? We are in a revolution, and a revolution is a honeymoon. Why can't I dress the way I like?' I care about appearances, and I like to look cheerful and pretty. My family accuses me of being superficial, and everybody makes me live in contradiction."

Wednesday, July 22
Samia

On the eve of the Fakhani bombardment, Samia dreamed that the planes came and landed in the grape arbor. She said she was reaching out her hand to pick the planes from the branches, trembling and scared.

She picked two planes. Then she woke up and told her husband about the dream. He said to her, "God protect us from you and your dreams!" When I asked if she had a grape arbor in her house she answered, "Yes, but not here. There's one in my family's house in Baddawi camp in Tripoli. We had a grape arbor there before I got married. The dream seemed to take place there. The house is in Baddawi, and we are in Beirut."

When I asked about the sound in the dream she said, "It sounded like the engine of a big plane, but the planes themselves were small like the ones I see in the display windows of travel agencies." When we

were talking to Samia, she received a message on a cassette tape from her relatives in the Occupied Territories. The tape included folkloric Palestinian songs and jokes.

Ahmad Khalil, seven years old

"I was in Fakhani when the air raids took place. I was about to flee. The headmaster came and said, 'Go to the mosque.'

"As soon as I tried to go to the mosque, a plane attacked, dropping red balloons. I was scared. I tried to enter a building. Dogs came up to me. I ran away and kept running. I entered a store that sold watermelon. I found a woman sitting amid the watermelons, reading the Qur'an.

"Then the planes were gone. I ran. I tried to cross the street. I saw a plane swerving and flying low. It started shooting. I hid between sand bags.

"The moment the raid was over, I ran to the house. I drank water and slept."

Umm Muhammad Khazal

She was sitting on the outer threshold of her neighbor's house, soaking her feet in a bowl of hot water.

She'd been shot in Palestine, shortly before the exodus in 1948. Her oldest son was martyred during the Israeli invasion of south Lebanon in 1978.

She took a gun out of the safe, which she'd been hiding wrapped up in several plastic bags and said, "He made this himself at the blacksmith's. He was twelve years old then."

She cocked the weapon and pulled the trigger (without loading the gun) to try it, and then said, "I shot this gun myself, using real bullets. It started heating up in my hand and ejected bullets like fire." In Palestine, she and a friend of hers always used to try to decipher the dreams they had there together: "I'd tell her about the dream, and she'd read the book and explain it to me." Then Umm Muhammad's mind strayed a little. After that, she bent and massaged her feet with hot water and said, "We left the book in Palestine.

"Stagnant water means hardship.

"Running water means a blessing.

"Turbid water means blood.

"On the eve of the Fakhani bombardment, I saw the sky over the sea all lit up, and I saw my reflection in the water.

"I saw my son Selim, who drowned in the sea, dressed like a scout with a whistle in his mouth and a pen in his hand.

"A few days before he drowned, he went on a school trip to the borders of Palestine. In the evening when he returned, he opened a paper bag he'd brought back with him. He said to me, 'Come, mother. Smell this. Smell, mother.' I smelled. Yes. It was good and grassy soil.

"In my dreams I always see Muhammad alive, not dead. Once I saw him and hugged him and smelled his neck. At that moment, my heart was soothed, and my body relaxed. I said to him, 'Darling, why is your pocket torn?' He laughed and said, 'Don't be upset, mother. I'll give it to Naqiya—his wife—to mend.' I woke up immediately, but he wasn't in front of me.

"The day I was sick and unable to speak, there were women at my house. They were talking about Muhammad. As soon as they left, Muhammad came in the dream. I heard two simultaneous voices saying to me, 'This is Muhammad.' I looked behind my shoulder and saw his face as radiant as a full moon. I didn't see his body.

"I went to a sheikh and asked him about it. He said to me, 'The two archangels brought Muhammad for you to see him and convince you that he is a martyr.'

"Forty days after his death they brought me his body. But what becomes of a body after forty days? I swear I saw nothing but his ribs. And I wasn't sure if those were my son's bones or someone else's." Abu Ahmad told us, "We Palestinians, our troubles start the moment the sperm is transferred from the man to the woman and stays in our mothers' wombs.

"The night Muhammad died, I saw him in a dream walking and lost in a wide-open land. The pistol was fastened to his waist, and he was running. I was hurrying to catch up with him, but I couldn't.

"Once I saw a wall open up in front of me. A lot of people rushed in and started saying, 'Your son wasn't martyred. Muhammad is in prison.' "Once someone came to me in a dream and said to me, 'Your son is in Cuba.'"

Abu Adnan

"When I was in Germany, I dreamed I was in a desert surrounded by barbed wire. Far away was a tower. On the tower there was a water reservoir like the ones in railway stations. I was climbing the reservoir and I heard the youths screaming, 'The planes have come.' I looked at my hand and found that I was carrying a strangely shaped machine gun, like a toy. I looked up and saw a helicopter descending toward me. Its bottom was opening up and tweezers like those at iron kilns came out of it. The tweezers attacked me, grabbed me by my thigh, and lifted me upward. Hanging there I heard my wife screaming, 'No! My son wasn't enough? They have to take away my husband too . . .'"

"In Beirut, I dreamed I was a bird flying. I was going to carry out an operation in Palestine. I was a real bird, flying in Palestine from one building to another. When the Israelis caught me, I was a human once more, not a bird."

Salwa, Abu Adnan's oldest daughter, said to us, "I work for the Foundation for the Welfare of Families of Martyrs, Prisoners of War, and the Injured.[34] In the morning, I carry the logbooks and pass by the houses. At night, I see nothing except graves and corpses.

"Sometimes I dream that the desks at the office are getting bigger and filling the view. Other times I see the files swelling and getting bigger. And sometimes I see myself filling in an application that doesn't end. I fill it out, and never reach the end.

"Sometimes when I'm eating I feel that the meat I'm eating comes from a corpse. I see myself crying. I cry because I'm crying. When I wake up from the dream and remember the crying, I start to cry."

Amal, Salwa's sister, dreamed she was lying down under a mulberry tree: "There were two little girls on the tree. They were picking mulberries and throwing them right into my mouth."

Mona, their youngest sister, saw Abu Ammar: "He was offering his condolences on the death of a martyr. He said, 'As soon as I finish the meeting, I'll come to you.' But he lied to me. He left and didn't come back.

"Once I dreamed I went to Palestine. I looked and found it a desert. I was surprised and said to myself, 'God! Is this Palestine?'"

We left Burj al-Barajneh camp at night.

We worked until late that day. We stood at the street's corner waiting anxiously for a servees to pass by.

The night was peculiarly pitch-black. It was hot and humid. There were many roadblocks and checkpoints on the outskirts. As for this empty street, the silence was dreary.

Fadia, who was worn out by these tours and didn't expect filmmaking to be so arduous, said, "This place is called Ein al-Sikka.[35] Tomorrow I'll meet you here." I was worried about her going back alone and she surprised me by saying, "Listen, either I drop you off and come back in the same car or you take this gun." Without pausing she took a little gun out of her bag. At first I was astonished by her attitude. When I thought about it, several fears popped into my mind. I am Syrian, and there are Syrian military roadblocks in the city. When I took it from her, the gun felt strange in my hands, but I liked its big white handle, which made me feel there was a femininity about it. I tucked the gun behind me, a first for me. When I walked toward the car, I laughed at the idea of an armed cinematic scouting trip. That night, I put the gun in a locker where I was staying and then totally forgot about it. I discovered later that when the Israelis invaded Beirut the following year, they took it, along with two cases of film that I hadn't yet had the chance to watch.

Thursday, July 23

In Ein al-Sikka the street was swarming with people.

When we walked toward the Burj, Fadia stopped a female passerby and introduced her to me. Then she hurriedly asked about her dreams.

Umm Mahmud was out shopping for the morning vegetables. She was holding her little son's hand. There was a pleasant eagerness about her. She smiled with her eyes, and words poured from her as if

what she was saying had just happened. "I left Palestine when I was about seven years old. Before Abdel Nasser died, I thought he would get us back every town we left.

"It's true, when we saw the moon we used to see Abdel Nasser in it. Every girl dreamed of the day she'd see Abdel Nasser. But we neither saw him nor him us, except in dreams. I actually saw him giving a speech in Jerusalem. He was standing like he used to right here. He was also waving his hand, and we were standing and applauding him."

The boy got excited and interrupted, saying, "I saw him too. I saw him riding with Sadat in a convertible car.[36] He was doing this with his hand," the boy raised his hand demonstrating the victory sign, "and the people were kissing him.

"I was standing far away, far away, watching the kissing."

I asked the boy, "Do you know Abdel Nasser?"

He answered, "I see him on TV."

Abu Ghalib

He opened the door for us in a long brown striped qumbaz.

He was a dark, slender, old man. His head popped out like a sparrow's head from its nest.

Because the small house was swarming with kids, he took us up to the roof at first and said, "Once I dreamed I was on the border. I said to myself, 'Oh my God! Am I still here? How can I cross?' I know there is barbed wire. I said, 'This is God's will.' I read the Fatiha. I saw myself flying over Beirut and said, 'Why did I go back over Beirut?'"

The young disabled men on the hospital balconies called out to him and waved. He waved back shyly and generously, then continued, "Once I dreamed that my father and mother, whom I left in Palestine, were standing at the door of our house there, welcoming me and asking me to come in. I saw that two people well into middle age were with them.

"I said to them, 'Who are you?'

"They replied, 'Damn, Abu Ghalib. You don't know us? We knew you. We are your brothers.' Of course I'd only seen them when they were young.

"Suddenly our neighbor opened the door and screamed, 'What brought Abu Ghalib here to Palestine? You're ruining us.' I looked at him and said, 'Damn, man! You're dead.' He said to me, 'I am dead, but tomorrow on Judgment Day I'll report you to the Israelis.' I said to myself, 'I don't care about Judgment Day. I want to sleep here, and it doesn't matter what happens.' And I slept. Then I heard the call to morning prayers. I woke up to pray and found myself here in the Burj."

Hearing the call to afternoon prayers, Abu Ghalib asked for God's forgiveness, hummed a supplication, and invited me to accompany him to the mosque.

When he finished praying, he turned to me as if he'd remembered a dream and was afraid he might forget it. "Once I saw King Hussein in my dream

"I saw him entering the mosque for the Eid prayers. We were inside saying, 'God is great.'

"I turned to someone next to me and said, 'The king seems to have just woken up and hasn't performed the ablution.'[37] The king himself heard this and said to me, 'I don't want to perform ablution. I'm a king, and I have the right to pray without doing ablutions.'

"I stood up and screamed, 'I swear no one will follow your Islamic law.'

"The guards assaulted and grabbed me. They took me and I was screaming, 'There's no king but God.'"

I'd decided to film him. I looked at him and tried to understand the depths of this chronic anxiety. His mind strayed then he fidgeted, trying to resume talking.

"You know? I once dreamed that I was dead. They'd put me in a coffin and were carrying me repeating, 'There is no god but God.'

"I said to myself, 'I wonder if I'm alive or dead.'

"I saw them putting me down. They wanted to bury me in the sand at the camp's outskirts. My mouth was packed with sand. Suddenly, a fight erupted between the organizations. The people who were carrying me threw me on the ground. I got up and ran with those people."

When we film, I'll stop by and accompany him to the mosque, with him wearing this qumbaz. There I'll film him while he recounts his dreams to the camera.

"I once dreamed I was smuggling weapons from Aqaba. I was carrying three Simonov guns on my shoulders, and I was walking in a desert. Suddenly, I found a helicopter on the ground in front of me. I said to myself, 'What? I swear, only the Israelis would set up a checkpoint in this desert.' I kept walking, turning away from the helicopter.

"They shouted at me, 'Stop, boy.'

"I stopped. I looked at them and saw that they were a camel corps from the Jordanian army. I said to them, 'What do you want?'

"'Who are you taking these weapons to?'

"I said to them, 'To the fighters. Do you want to buy them? I'll sell them to you.'

"'Where are the fighters? Take us to them!'

"They grabbed me and took me to prison. In the dream I spent five years in prison. Where was the prison? In Acre. It was the same prison I'd been in in real life."

The fans hanging from the ceiling were spinning above Abu Ghalib's head. The harsh light of the afternoon cast a reflection on the rugs of the mosque. I started trying to choose the angle from which to film the establishing shot of this sanctuary. But what does Abu Ghalib do for work?

"I sometimes dream that I'm a public works executive.

"I say to myself, 'How strange! You can't afford to eat, and you dream you are a manager?'

"And I wake up and find myself with nothing to do." He laughs. "When I'm awake I say, 'I'm dreaming about things I know nothing about.'"

I didn't ask him about his job. I often felt detached, not wanting to know the details. Everyone is in a state of waiting, and much of what they do acquires the quality of a fixed appointment. "Here in the camp, our houses are built on sand. The houses are low, and the sand is high. I once dreamed I was planting bamboo to keep the sand from the house.

"While I was planting, a wind came up and blew sand toward the house. I screamed, 'The house is gone!' I ran to the house and found that the storm had buried it entirely. I shouted for my wife, to get her out of the sand. Then I woke up.

"I once dreamed I was swimming in the sea. Then Moshe Dayan came, dressed in shorts and not wearing his eye patch.

"He said to me, 'You're not allowed to swim here.'

"I grabbed sand and threw it in his face and eyes, then I fled to the sea and swam . . . I saw myself in Ma'alot. I asked myself, 'How is this? There's no sea in Ma'alot!'"

Ali al-Zaatar

"I lost three brothers in al-Zaatar. I always see them in my dreams.

"I see them all the time.

"Sometimes I see my oldest brother coming and asking to pour him some tea. He says, 'Brother, I'm thirsty. Give me some tea.'

"My second brother is always hungry in my dreams. He says, 'My brother, I'm hungry, I want to eat.'

"Many times I've dreamed that my younger brother was swimming in the water with the fish—there's lots of small pretty fish around him.

"I forget the details . . ."

Gorky

His name is Abu Muhammad, but due to an unusual resemblance to Maxim Gorky, we started calling him by that name. He will remain for us, and throughout the film, 'Gorky.'

"I looked around to see what that sound was.

"I found a policeman and an officer from the Lebanese military intelligence entering my house.

"I said to myself, 'I swear I won't get up to greet them.' They screamed at me, 'Get up, boy. Your ID.'

"I said, 'Please don't make a noise. My wife has just given birth, and she's asleep.'

"He said, 'We know.'

"I said, 'How do you know?' They said, 'We saw her.' 'How did you see her?' He said, 'We looked from the northern window and saw her.' I told him, 'You're a detective. The detective's duty is to be alert, not to snoop around.' He said, 'Cut the bullshit.' I said to him, 'If I had known that you were looking at us from the window, I would've gouged your eyes out with a meat skewer.'

"He said to me, 'Get your ID and follow me to the police station.' I said to him, 'No. We'll go to the court. The judge will issue a verdict either in your favor or against me.'

Friday, July 24
Shatila
Umm Khalil

"Abu Khalil came to me in my dreams. He said, 'I want you to leave this house, woman.'

"I said, 'Where to, Abu Khalil?'

"He replied, 'To a place where you can feel comfortable. Follow me.'

"I left the kids and followed him. He led me down a long staircase underneath a high building. I went down and down. I found myself in a house. What a house! Praise God for that house!

"It was full of sofas I'd never seen before. On each sofa were flowers, white, yellow, and red flowers.

"I looked into that house and found a girl. God knows if she was my daughter. By the way, I have a daughter who was martyred, and I always think about her. The girl said to me, 'Sit down.'

"I sat down. I looked in front me. I saw a window. Behind the window was the greenery of Nazareth. I saw fedayeen amid the greenery. I was very frightened, frightened that I might not be in my country. I said to myself, 'As long as there are fighters, this means we're in our country.'

"Not that night, the night before, I dreamed I was sleeping in the mountains. The mountains were green. My face was toward the Qibla. There was no one with me except this little boy." She was referring to the one in her arms.

"I said, 'God! Where are the rest of my kids? Shall I go look for them?'

"By God's will I found Rosette, Widad, and Turkiya. Those are the daughters of our neighbor Abu Turki. I saw those girls carrying cauliflower and cabbage.

"I asked them, 'Where did you get these from?'

"They laughed and said, 'From God's bounty.' 'Okay. Give me some. I have a big family.' Turkiya came and said to me, 'Here you are.' While she was giving me the cabbage, she said, 'Umm Khalil, you have a tough road ahead of you. I wonder if you can make it.'

"I said to her, 'I will be fine, but you follow me. Don't leave me.'

"I swear to you people that I went through the mountains, as if I split the mountain and entered. The light of the sky filled the place, water was flowing between our legs, gushing from the ground. I swear by holy Mecca I'm not lying to you. Who did I see at that moment? I saw Abu Fawzi the Bedouin. He was dressed in white, and he had built a white sanctuary.

"I said to Turkiya, 'You go, but look for the kids on your way.'

"I entered the sanctuary alone. Under the dome, I found a TV set broadcasting the Qur'an. I was about to sit down, when I saw fire coming out of everywhere."

Seven years after Umm Khalil recounted this dream, I received a personal letter that read, "Do you remember Umm Khalil who told you about Rosette, Widad, and Turkiya, Abu Turki's daughters? That tall, dark, slightly plump woman, who always wore a black peasant dress? Do you remember her? All her children were killed in the massacre of Sabra and Shatila. Nobody was left except her youngest son." I wondered if that was the one in her arms when she told us about her dream. "As for the little boy, he was martyred in the Camp Wars during the siege of Shatila. Umm Khalil now lives in al-Hajar al-Aswad in Syria. Look for her if you want." This letter made me reinterpret Umm Khalil's dream, two, three more times.

Umm Amal

"I saw a bird fluttering and hovering around us, then I saw a girl running around the bird, putting out food and water for it.

"I turned to my mother and said, 'Mother, look at how this bird flutters!'

"When my mother saw the bird and the girl, I heard her shouting to me, saying, 'It's your daughter Amal who died, it's as if her father has gone to her. This bird is your husband, and she's his daughter. It's finished, my daughter. Since he didn't come from Beirut, this means he's dead.' The next day, the dream turned out to be true."

Ali

"In Tel al-Zaatar, one of the people with us in the group was from my hometown in Palestine. After the fall of al-Zaatar, he went to the South, and I never saw him again.

"Once I was asleep at a friend's family home, and I dreamed about that man.

"I dreamed I was going down the office staircase with the boss. I saw this man coming to the office. I was about to ask him, 'What are you doing here?'

"I was stunned to see the boss pull out his gun and shoot him in the chest. I looked and found this man also pulling out a gun and shooting two bullets at the boss.

"Someone from the magazine called Hassan Hamdan was coming down the stairs behind us, and the second bullet struck him. I saw the three fall to the ground and die.

"When I woke up, I told my friend's mother about the dream. I swear to God that on that particular day, at night, her son was shot dead."

After Ali told us about this dream, a tragic silence took hold. Maybe we were all thinking about how this banal dream had such a sad ending in reality. It wasn't until a while later that the phrase "someone from the magazine called Hassan Hamdan" caught my attention, and I wondered whether the man in the dream was the Lebanese writer Hassan Hamdan, who was assassinated in 1987 in Beirut, in a way that was not

so different from the one in the dream. The bureaus and newspapers of the Lebanese Patriotic Movement, which Hassan Hamdan frequented, were connected to the Palestinian organizations. They are all located in those buildings along al-Watani Street, nicknamed 'the Last Street.'

Umm Ziad

"I once dreamed I was walking on a long road full of trees. I was walking alone, listening to Abdel Halim Hafez. I was saying to myself, 'Oh my God! His voice is so close.' I looked behind me and found Abdel Halim walking and singing next to me. I reached out my hand to hold his, and he held my hand too. Then I woke up."

"What was he singing?"

"al-Jabbar."

Ibrahim

"I dreamed I'd got a house because I was getting married and that I was furnishing it. I swear not even Salha Palace had such nice furniture.

"I was sleeping on a bed that kept spinning and spinning. There was a stereo next to the bed. I said to myself, 'Get up boy and tell your fiancée's family.'

"I went. Her family said to me, 'Let's go see the house.' I took them with me. Then her father said, 'You've got to be kidding me, Ibrahim. In twenty-four hours you found the house and furnished it as well. Is that possible? Yesterday you were at our house, and you didn't have a penny.' And my father-in-law left. I ran after him. On the way, the film ended."

"The film ended?"

"Sorry, the dream."

al-Karama playground

"I had a very strange dream. I dreamed that me and my friends had grown grass in al-Karama playground. The whole playground was green. When that happened, the shepherds brought sheep into the playground. I looked around and watched the sheep grazing on the grass we grew."

Nader

"I once dreamed I was wearing pajamas, smoking arghile, and watching TV. Then someone knocked at the door. I opened the door and found Jimmy Carter and his wife in front of me. Of course I was surprised. I said to him, 'Come in.' He entered and sat down. What could I do? I offered him the arghile. He took it and started smoking. I watched him and he seemed to be happy. I said to him, 'You know, Jimmy, I supported you in the elections.' He shook his head and laughed. He stayed for a while and when he was about to leave, I got up with him. Then I woke up and found that I had been dreaming."

The carpentry workshop

In the carpentry workshop affiliated with SAMED's Organization for the Welfare of Families and Children of Martyrs, one of the workers told me about a dream in which he'd kidnapped a beautiful woman, then stolen an American car for her from Hamra Street. When I spoke with another worker, I was astonished to hear him recount almost exactly the same dream.

This was the most unique thing in my whole tour.

For some reason, without really thinking about it, I first felt like they were making fun of me and of what I was doing, whether intentionally or not.

I tried to think about it a bit more. I looked at the first worker. He was fully engrossed in what he was doing, off in a remote part of the shop, while the machines sanding pieces of wood filled the place with an oppressive racket that hung in the air, gloating, and adding an element of absurdity to the relations between things. The two young men had been friends since adolescence, each of them installed in a different place in this shop flooded with these sounds, shadows in this daily silhouette. And just as they had no choice but to tell the same dream, it's as if they had no choice but to be in this carpentry shop, until they make a leap, perhaps for a gun.

"I once dreamed I was working here in the workshop, and suddenly the blade broke and sliced off my arm. First thing, I ran and

covered the arm that had fallen on the ground with wood shavings from the floor so that the boss wouldn't see it. As soon as I woke up I looked at my arm. Thank God I was still okay."

Umm Jibril

"A little while ago, I dreamed I was going on the Hajj.

"In the dream, I saw myself walking with a mule in front of me. But I didn't know what was loaded on the animal's back.

"While I was walking, I lost the mule and felt I was alone. I started crying. While I was crying, a tall sheikh appeared and said to me, 'What's the matter with you, woman?'

"I said to him, 'I had a mule walking in front of me, and lost it.'

"He said, 'Follow me.'

"I followed him. He took me to a place full of large wooden doors. He beckoned to me. I opened a door. I found myself in a barn that had nothing except one small white goat. I looked at the goat and saw that it was eating figs.

"I heard the sheikh's voice from behind the door saying, 'Take the goat instead of the mule.' I was about to take it and leave, then the sheikh said to me, 'Give me ten Riyals for it.' I said to myself, 'I don't have Riyals. I have ten Lebanese Liras.'

"When I woke up that morning I was thinking and wondering what was loaded on the animal's back."

The little girl

"I dreamed that I climbed a huge fig tree in Umm Kayed's house. The tree was full of yellow figs.

"My grandmother came and said to me, 'Climb the tree and get me a fig.'

"I went up the tree.

"Then Umm Kayed came and said, 'Come down.'

"My grandmother said to me, 'Don't come down,' and Umm Kayed said to me, 'Come down.' I was confused as to whom to obey. I woke up, and there was no fig tree. It was still early, not yet morning."

The textile workshop

We visited these workshops many times and convinced the young women workers to share their dreams. These workshops are also affiliated with SAMED's Organization for the Welfare of Families and Children of Martyrs and occupy the vaults of the tall buildings where the men's offices are located.

In the sewing workshop Leila said, "I dreamed that everything was dark. There was no electricity in the workshop, and the girls left.

"I saw myself alone with my friend, and Muhammad was with us.

"Muhammad was fixing the sewing machine.

"I saw myself working, not caring about electricity. I was cutting buttonholes. I looked around and my friend wasn't there. I didn't know where she'd disappeared to. It was just Muhammad and I left. He was fixing the sewing machine, and I was next to him cutting buttonholes.

"He fixed the sewing machine, but I don't remember what happened after that."

Aida told us about another dream: "I once dreamed the electricity had gone out at the workshop while we were working. The girls started screaming and ran out.

"Ziad came. He locked the door after them and left.

"I stayed calm. I spread bedding next to the door and slept on it. I didn't do anything. I just slept."

I felt that she interrupted the dream to connect it unconsciously to another dream as she resumed, "And I once dreamed that my father said to me, 'I swear to God I won't let you get married until your missing brother returns.' I told myself, 'Oh no!'" Suad said to us, "I dreamed I was a bride. We were in the procession, and they were taking me to the wedding. An air raid began. We went down to the trenches to hide from the planes. Suddenly, I was no longer a bride. It was sunset. I saw mountains around us. The land was green, and there were large tree groves. My mother was carrying baskets on her head while she was running. All the people were fleeing and carrying lots of belongings. There were animal carts, and birds were flying above us."

I wanted to guess her age in order to know if this was a memory of childhood and displacement or of stories she'd heard. But then I wondered what the point was, if linking the loss of the wedding with the loss of the homeland was a connection she made on her own.

In the shoemaking workshop, little Mona—who had shrapnel injury in her thigh from air raids that disfigured her body but never changed her pleasant smile—said to us, "I once dreamed of this companion of mine." She pointed to him with her finger while he smiled with joy and shyness. "I dreamed he came to our house in the morning to awaken me. He said, 'Come on. Wake up. We'll walk to work together.' I said to him, 'It's still early, Adnan. Please let me sleep. It's not seven o'clock yet.' Then I woke up. We went out together and came here to the workshop. I looked around and saw that the workshop was empty, and that there was no one there except the manager.

"I said to Adnan, 'See? It is still early.'

"The manager got up and approached us. He said, 'Why did you come? There is no work today. It's Martyr's Day.'[38]

"At that same moment, my sister was waking me from the dream, saying, 'Come on, Mona. Wake up. You're late for work.'" Adnan laughed deeply. His laughter gave him the courage to speak and say, "Today, in the morning, I also dreamed I was kissing Mona. What a coincidence! That was just before you came. You saw the girls and I laughing, because I was telling them about the dream."

Salah

"My dreams are short, simple, and wordless.

"I once dreamed that a red-bearded old man dressed in white came to me.

"He said, 'I am the Prophet Moses.' That was it.

"Three days ago, I saw a very pretty and colorful butterfly. It was flying around in front of me, circling the room and back.

"For three consecutive days I dreamed of this butterfly flying and fluttering around. Sometimes I dream of fish—they are always small fish.

"Once I dreamed I was at the sea. I was sitting on the beach. I looked and found a half-Lira in the sand. I reached out my hand and took it. Then I found a half-Lira under it. I also took that. Then I found another half-Lira under that, then another, then another. They could fill a house, and they were endless."

A theater director

I had wanted to avoid drawing any intellectuals into conversation about their dreams, but Saeed was an exception. When I heard his dream I knew nothing about him or his job. In many cases I didn't even ask the question, especially during the survey phase. But Saeed's dream prompted me to ask about his job. He smiled and said, "I'm a theater director." At the time, I was tempted to include his dream and felt that this dream would be like a time bomb amid the others: it would detonate questions about dreams and imagination, and how they come together to form the special conscience of a people, like the Palestinians.

Saeed said, "I dreamed I was walking in the city streets. Something inside told me it was Beirut. But I don't know why the streets were old and the buildings ancient. I don't know why I felt as if I knew it, and wasn't a stranger in it.

"It was bizarre. As if the people were wearing clothes from the used-clothing market—American clothes and Mexican hats. People were shooting each other with toy guns. I don't know how things got suddenly serious. The games turned serious, and the guns became real. Bullets poured down like torrents of rain. People were fleeing.

"I was injured by a bullet. I imagined I was dying, but I kept running and jumping to escape. All of a sudden, a flood occurred. The water was rising. The flood was sweeping away cars and old carts, people, and animals. The water was rising more and more until it came above us. We were about to suffocate under the water. The torrent became a sky, and we were beneath it. I looked up and saw the carts and mules in the sky as if they were behind glass. They were wriggling. They wriggled then stopped. They froze in place as if they were in a movie clip that had been paused.

"During the events of April 1970,[39] I had a dream. It was the first dream that frightened me.

"It was red all over. I was running and running.

"I said to myself, 'Where did my friends go?' I was running to look for them. Bit by bit it became dark, and I didn't find anyone.

"I saw myself entering a place, like a room. I found that it was full of people. But it was dark, and people couldn't recognize each other. I remember smelling something. Because of the smell, I ran around searching through the people until I found my friends among them.

"I remember I sat down next to them because I was exhausted. Tired and happy to have found them, I leaned on my elbow to sleep next to them. The moment I leaned on my elbow, I saw my arm sinking into something fluid and hot, as if it were flesh and blood. I got really scared; it was as if I'd understood or feared that my four friends were dead. I got up. I tried to scream or run. The door was locked. I screamed until I fell down. I felt I was about to die, and my body was as stiff as wood. I woke up.

"After I awoke, I stayed frozen in place. For a few seconds, I couldn't move anything inside me. I tried to recite a verse from the Qur'an, but at that moment I'd forgotten everything I'd memorized. I couldn't remember a single verse. Then I got up. I went out and started searching for my four friends to find out whether they were dead or alive."

Ibrahim

"Why do you want to know how old I am? "It's nineteen all in all. I finished elementary school while I was at the fighter's base. All my studies are independent; I don't go to schools. Now I've also started university. My family lives in Yarmouk camp in Syria.

"When I have a break and go see my family, I think about staying there with them. And I do, for a while. But when I hear particular news—a raid, an aggression, a suicide operation—I get really upset and feel that I can't stay there. I hate myself for being far away from the Resistance. So I pack and come back to the base here in the South.

"I stay here, but my mind wanders all night long. I walk. I dream. I think. Sometimes I wonder why I'm here. But frankly I feel more comfortable here.

"Sometimes I dream of my fiancée. I see her wearing my ring; other times I see her taking it off. We, the three of us—me and two of my friends whom I love a lot—always dreamed of carrying out an operation in the Occupied Territories. Once I dreamed that we carried out an operation and were returning.

"In the dream, my two friends were injured while nothing happened to me. We were returning and were very hungry. All of a sudden, we were overtaken by an Israeli ambush. We engaged in a fight with them. We defeated the people in the ambush; we killed them. Out of extreme hunger I started slitting their stomachs, taking out their entrails, and eating them.

"I started feeding my remaining provisions to my two friends. By the time we reached our region I had gone wild. I attacked anybody I saw and wanted to devour them.

"Then I dreamed that our men took me and put me in prison.

"I had this dream during the fifteen-day war.[40] I remember it often and can't forget it."

Abu Ismail

"When we were in Mezzeh Prison I dreamed that the doors of our cells were opened—as if there was a divine power in the dream—and we started to come out of our cells. The prison guards were looking at us without saying anything. When we reached the prison yard—are you familiar with Mezzeh Prison?—the guards started shooting at us from above. But the strange thing was that they fired and no bullets came out.

"The prison was full, and there were lots of us. We all came out as if we were in a demonstration. The guards ran toward us. They encircled us and started shooting, and no bullets came out. So, they attacked us physically and started beating us. Out of excruciating pain and hunger, I woke up. I looked around me and found that I was still in the prison cell. The doors were closed, and people were asleep."

Looking for the flag

"Okay. Please listen to this dream and tell me how to interpret it.

"I dreamed I was asleep here. Someone knocked on the door. I opened the door and found some people saying to me, "'They were martyred.'

"I said to them, 'Damn! Who?'

"They said to me, 'Your husband and Abu Ammar.'

"I said to them, 'Where? How?'

"They said, 'In an accident on the highway.'

"I ran. I went to the highway to see them. I saw people assembled. I looked and saw it was neither Abu Ammar nor my husband.

"I asked, and they said to me, 'The president died in a car accident.'

"Someone I know ran toward me and asked, 'Can you go and get a flag to wrap the president?'

"I said to him, 'Which flag shall I get?'

"He said to me, 'The Palestinian flag.'

"Long ago, we organized an exhibition at the Women's Union hall, in the village of Shemlan, near the Shemlan Intelligence Center. In the dream I saw this exhibition in a school. I started going from room to room searching for a flag. At the end of one room I saw a woman in front of me wearing one of the Palestinian dresses we had displayed in the exhibition. She looked at me, started calling out to me, and said, 'Come in.' I said to her, 'Sister, I want one of the flags we embroidered for the exhibition.' She said to me, 'Why do you want it?'

"I said to her, 'There was a car accident on the highway, and the president died. We want a flag to wrap him in it.'

"She said, 'The president? No, I'm sorry, we don't have a flag.'

"Then I saw myself going back to the highway, dashing through the assembled people and telling them I hadn't found a flag. I was looking around and then I saw the president's body in front of me, torn to pieces and mangled, and every part was packed in a clear plastic bag.

"I felt like I was about to throw up. I looked around and saw people lined up on both sides of the highway. I saw one group of people laughing and another ululating. I was about to throw up, then I woke up."

"I got a visa"

"I once dreamed that I got a visa, but I didn't know it.

"In the dream, I saw my relative running toward me saying, 'What? You're not ready yet? Come on. Go. The visa was issued.'

"I ran. I took the bag from above the closet. I packed and went with her.

"In the dream, her flight was before mine, but we went to the airport together. When we were inside the airport, I looked and I no longer saw her. I lost her completely. I thought I'd search for her. I searched, but I didn't find her. I was afraid I might miss the flight, so I grabbed my kids, picked up the bag, and went down to the gate.

"At the door, a policeman stopped me and said, 'Where are you going?'

"I said, 'To Qatar. I'm traveling to Qatar, to my husband.'

"He said to me, 'What's your name? Wait till I check your name.'

"I stood waiting and was afraid to miss the flight. The policeman was gone for around a minute. He came back and said, 'We don't have your name.'

"I replied, 'How? I swear they told me I have a visa.'

"He said, 'No. No. You don't have a visa at all. Come on. Go back.'

"I saw that it had got dark. Out of frustration, I pulled my kids behind me, carrying the bag, and we left. As soon as I arrived home, I lifted the bag and slammed it on the floor. It split into two halves. And I woke up."

When I turned to the third woman who was sitting and listening to us, and asked her to tell us about a dream, I was surprised by her firm refusal to do so because it was the month of Ramadan. She promised she would tell us about a dream after the end of the holy month. I didn't understand but also didn't inquire about the relation between talking about dreams and fasting. I really regretted not asking her.

After listening to the dreams of many fighters at a Palestinian military base in the South, I chose a Lebanese fighter's dream.

This was the first, and possibly last, time I chose a non-Palestinian.

Sejaa said, "After the Israeli invasion during the 1978 war, my family ended up on the other side of the security zone on the border.[41]

"I haven't seen them for five years. I often dream that my mother is dead. Sometimes I see bombs being dropped on them, right in front of me, and I'm unable to put out the fire or see what happened to them.

"Yesterday I dreamed that my mother came to me here. I woke up frightened. But when I woke, I didn't find her. After that, I went to do my guard shift, feeling very sad and frustrated. After the shift, I slept. I dreamed that Abu Ammar was engaged in a fistfight with the Senegalese who worked in the UN forces. Abu Ammar was coming to us, and the Senegalese didn't allow him to pass. I saw him holding a cane and brandishing it at them. He screamed, 'I will pass, let whoever has the guts try to stop me.'"

Monday, July 27

In the early morning, I headed to the Women's Union office located on Last Street. When I entered the small apartment, they were preparing breakfast for children in the camp's nurseries. Children who had been sent here out of fear of possible Israeli raids were stuffed in a small parlor. The room was dark. The electricity was cut off. The floor was clean, but still wet. The desks were still empty.

I caught sight of the young girl who was supposed to wait for us. She stood at the apartment balcony with her back to us, leaning on the railing that overlooked the street. She was contemplating this Last Street in silence and distraction. When she realized we'd arrived, she turned to us abruptly and tried hiding her surprise by feigning shyness.

I don't know why I thought her name was Shadia. Anyway, had it not been for her dark complexion, she would have reminded me— somehow—of the Egyptian actress. Seven years after this visit—that is, in 1988—I met her amid the ruins of Shatila on the day the last siege on the camp was lifted, after the camp had been totally destroyed. She had lived under siege for three whole years. On that day, I learned that her name was Amna.

Amid the noise of little children and her pleasant confusion, I took the pack of cigarettes and lit one for her.

I noticed a distraction behind her Palestinian features, and it seemed there was a peculiar disappointment or lack of fulfillment in her eyes. The line of smoke between her fingers spread in waves from the West Bank to Fakhani, and from April 1970 to July 1981.

"Ghada was a close friend of mine." She said it like that, with no introduction, as if she were continuing an internal monologue. "Ghada was a blaze of enthusiasm at work with us, here at the Women's Union. Half an hour before the raid, Ghada told me she dreamed she gave birth to a dead girl. She was pregnant at the time. Yeah, this is the Ghada whose belly exploded in the raid, and the baby flew out of it. You know, Muhammad, they found the baby on the floor among the debris, and it was alive. It was a girl. They named her Palestine."

Amna took us to her mother.

Her mother said to us, "I always dream between the white thread and the black thread." This of course is the time when fasting starts. "He who has no land has no saints. We, the Palestinians, no longer have saints to promise offerings to. When we want to make an offering, we go to Sayyida Zeinab.

"A lamb in a dream means a blessing." I noticed that Palestinians make the word 'dream' feminine. When it is masculine, it means 'something desirable.'

"Birds mean reunion, olives paradise, the sea bewilderment, vegetables hope, out-of-season fruit a loss, a car a coffin, shoes a suitor, turbid water a bad sign, death life, milk a shroud, gold misfortune, a gate . . . Damn! May God protect us from the evil of their coming." She points upward to emphasize that she means Israeli planes.

"I once dreamed I was in a totally barren land. I was walking and looking for something. I don't know what I was looking for. Then a big bird slowed down and started pecking the floor with its beak. Then water gushed from the ground, and I saw myself surrounded by green olive trees in an orchard." She now addresses her daughter Amna. "Do you know where the olive orchard is? On your aunt's land if you remember, exactly between the Jews' land and our land.

"Three months before we left Palestine, we lived by the Tobacco Company in Haifa, on Nazareth Street. At that time, I had a dream I will never forget. I was carrying my children on my shoulders. My youngest son's legs were dangling on my bosom. We were running toward the sea.

"I said, 'My God! How can we cross the sea?'

"Three months after the dream, they took us to the port of Haifa, put us in boats, and sent us to Lebanon."

Umm Ali said, "I dreamed I was sitting here in the camp. A person entered—maybe a man, maybe a woman, I don't know—gave me a white paper and said to me, 'Come on. Get up. Go to Palestine.'

"I got up and went right away. I saw myself amid green trees, grapes, figs, and olives. That was it. I woke up. When I woke up, I found nothing here."

On that day I also visited the sewing workshops affiliated with SAMED. These were different groups from the ones I had already visited.

These workshops are located in small apartments among those occupied by the sub-offices of the media, social, and political organizations situated at the outskirts of Last Street.

A visitor would be surprised by the number of women workers crammed into these small apartments. The women are connected not only by being from the ill-fated camps, but also by the hard and exceptional circumstances they have endured.

On the outside, you can't help but notice the strange mixture of weary features that denote poverty and the random influences of Lebanese fashion on their clothes and vaguely garish street makeup. There is a kind of absence of self-restraint. Gradually, you observe this in the internal world as well.

Harba is around thirty years old. She's very slender and dark. She wore a short dress swarming with dazzling colors. She said, "I don't know the woman I saw in the dream at all, but she was wearing an abaya. We, Palestinians, wear the abaya. We also wear headscarves and face veils.

"My family left Safad in 1948. They came to Hibariyeh in south Lebanon. Then we left for Tel al-Zaatar and worked. My oldest brother, who was martyred, was a carpenter. The second one, who was lost in the mountains, was an accountant. Who are we going to ask about him? He's been missing for five years. We haven't heard anything about him. He's gone." She talked about her missing brother with an odd fatalistic resignation, one that was totally different from the sense of anguish that was in her voice when she talked about the martyr. "The city I saw in the dream looks like a village in the South called Sohaila, almost the same. I had the dream I'm telling you about ten or thirteen years ago. On that particular day I remember that my deceased father went to Palestine to visit our relatives there.

"I was young. He said to me, 'I can't take you with me, darling. You can come with me some other time.'

"I started crying because I wanted to go. I wanted to go because everybody was talking about Palestine, and I didn't know what it looked like. That night I was very nostalgic. I dreamed I followed my father. I was walking in a void, and Palestine was in front of me. I was about to enter it. I looked around me and saw trees and greenery and flowers. At that moment, I saw the woman I don't know. I saw her dragging her kids behind her and walking, as if she were taking them to school.

"I stopped the woman and asked her, 'Where am I?'

"She said, 'You are in Palestine.'

"I said, 'Really? Are you serious?' "She said, 'Yes! I'm serious.'

"The woman also told me the name of the city we were in, but I don't remember it and I don't know why I forgot."

Faiza

"I once dreamed that my friend Harba and I were riding in a car. The car was like the bus that takes us every day from Damour to the workshop and back from the workshop to Damour. In the dream the car was empty. There was no one but me and Harba. The car was moving but there was no driver.

"The car went onto a bumpy road, and the houses around us looked like Gypsies' tents. After a while I saw the car going into an alley, then into a room where young men were assembled. The moment the youths saw us they started talking to each other and pointing at us.

"I looked for Harba and didn't find her. I was alone, frightened. I was really scared because I didn't know any of them. I opened the car door and got out running. In front of the tent I found two women who wanted to leave.

"I said to them, 'Take me.'

"They said, 'No.'

"I asked, 'Why?'

"They said, 'Because it will take twenty years to get there, the way we're going.' "I said to myself, 'Oh no! Twenty more years!'"

Wednesday, July 29
Back to Burj al-Barajneh.

Whenever people in the camps saw me wandering around with my notebook and recorder, they called me over to tell me about the new dreams they'd had after I left. There was a sense in the air that people were paying attention to their dreams and trying to remember them, and that they were eager to relate them as well. With Abu Hatem, I stood for a long time contemplating how, as an old man, he had demolished a wall in his house with his own hands to create a store to work in. When I asked him about this I learned that he had received five thousand Liras as compensation for his twenty-five years of work in Ghandour factory. He said, "I have no other solution. This is life. As for dreams, I don't remember any of my own, but my father had one that I remember.

"This, sir, was after we left Palestine, before we were living in the camp. My father and I lived in a village called Jwaya. My mother and siblings stayed in Palestine.

"I had a friend whose family also stayed in Palestine. One day my friend came to me and said, 'Let each of us rent a mule cart and go to town to get olive oil.' I said, 'Okay. I like the idea, Ya'qub, but you're your own boss and I've got my father to answer to. I have to ask him first.'

"I liked Ya'qub's idea a lot, but was afraid of my father. I went to a friend of my father's and pleaded with him to convince my father to give me permission.

"My father refused. Ya'qub found someone else and started a smuggling business.

"I was upset about it. I'd come home upset, leave home upset. Two days later, around midnight, my father, may he rest in peace, woke me up and told me, "'Son, you come home distressed and leave home distressed, but I swear to God, Son, you don't know anything. I just dreamed that your friends who work as smugglers in Palestine were being robbed at Akbara meadow.'

"I woke up the next morning telling myself, 'Has he gone crazy?'

"But by God it was barely nine o'clock when Ya'qub and his friend arrived. They had nothing on except their underwear, and they had been robbed at exactly the same place as in my father's dream."

Faisal

"Just as our parents told us how they left Palestine in 1948, I dreamed that we—the residents of the camp—were riding in trucks, carrying our belongings, but we were going back to Palestine. After we crossed Naqura, I saw a big lake. I looked at it and asked my father about it. He said to me, "'Damn, Son! That's Tiberias. Don't you know it?'

"I was relieved by my father's statement. I started looking around from the moving truck and saw an extremely green terrain with olive trees everywhere. "In the dream, the moment we reached Palestine I saw all the camp's people scattering. Everyone went to his town. Those from Haifa went to Haifa. Those from Jaffa went to Jaffa. I saw that I was alone, and all my school friends were gone. I felt utterly lonely. I started saying to myself, 'I wish we, the camp people, would build a small town—a town or a village or a camp.' I mean something like Shatila where we used to live. I started searching for my friends to tell them, 'Let's build a town in the heart of Palestine to reunite us and be like the camp.' But at that moment I woke up."

I asked Faisal, "You didn't see Israelis in the dream?"

He answered, "Frankly I never saw them, maybe because I was too preoccupied by my joy in returning to Palestine, so I never thought about them."

Friday, August 7
Umm Hussein

"I swear to God, I dreamed about Hussein on the night of his capture—and this was before I knew he'd participated in a guerrilla operation in the Occupied Territories." Her son was captured in the aftermath of the marine operation called 'Kafr Qasim' and was taken to Palestine and sentenced to twenty-two years in jail. Umm Hussein visited him, and this was her only chance to see Palestine. "I dreamed he was coming home—his face was as pale as amber. When he entered the house, he fell to the ground. I ran to him and asked, 'Shall I get you a doctor?' He replied, 'Stay next to me mother. God is the best healer. If you go mother, I'll never see you again because the seas separate us now.'

"When I got a permission to visit him in jail, I stayed in Palestine for a month. I had lots of dreams while I was there.

"Once I dreamed that the people I left in Lebanon were running, and warplanes were above their heads. I was with them in Damour screaming and saying, 'Damn! How could they forget little Haytham in the camp? I swear to God when Hussein gets out of jail, he'll be mad if Haytham is hurt by Israeli warplanes.' My daughters were comforting me, saying, 'Don't be frightened, Mama. We didn't forget Haytham. One of the neighbors took him.' I woke up and found myself in Palestine. I was crying out of fear for my children in Lebanon.

"The cousin I was staying with in Palestine tried to comfort me, saying, 'Don't be afraid, Cousin. I think Damour is a little far from Burj al-Barajneh.

"I started telling her how Israeli warplanes attacked and bombarded us and how we ran and fled. I said, 'It's sad and funny at the same time.'

"I remember that she asked me why.

"I said, 'It makes you sad for the children who wake up and start running around, and the way the women come out dressed in their nightgowns makes you laugh. Like me. When they bombarded the Burj, I ran to the bathroom and couldn't find anything to wear. I went out wearing my pajamas. When I arrived at my brother's house, he started laughing at me and said, 'A runaway, and barefoot too!' Once, little six-year-old Haytham woke up in the middle of the night, came to me, and said, 'Mama, Mama. I brought Hussein back from jail with the Land Rover.' He'd started crying out, 'I'm sure I brought him with me, but I didn't find him when I woke up!' I told him, 'That was a dream, darling.' He said, 'What does that mean?'

"I said, 'It means pictures you see when you're sleeping, then they're gone when you wake up.' What could I say to him?"

Khalil

"When I was in Shata Prison in Palestine I dreamed about my father. He was a little child, sleeping on sheepskin in the middle of a green land that looked like paradise. When I approached, he opened his eyes and said to me, 'Son, why don't you pray?' I replied, 'I don't know how, Father.'

"Then I woke up, and I didn't find him."

Ahmad

"I dreamed I went back to Palestine.

"Looking around, I saw it had changed since we left in 1967.

"I saw myself not knowing how to walk or how to work.

"I saw a bus going by. I ran and jumped onto it. I entered the bus and found only one empty seat. Of course I sat in it. I saw an old Israeli woman beside me, and the bus was full of Israelis. There were no Arabs except me. I felt I'd got on the wrong bus. "Suddenly the old woman looked at me and screamed, 'An Arab thief! A thief!' Everyone on the bus jumped up, grabbed ahold of me, and took me to the police station.

"'Where did you come from?'"

"From Jordan."

"'Where are you going?'"

"To my family."

"They put me in jail. After a while, a huge policeman came to me and said, 'Come! What's your name?' 'Ahmad,' I replied. He said, 'The old woman forgot her money at home then found it later. The charge has been lifted.'

They released me, and I found the old woman in front of me. She ran toward me and started kissing me. She gave me a check. I was very happy. I took the check from her and ran. I wanted to cash it. Then I woke up."

Jamal

"I dreamed about the camp. In the dream it was small and the houses were made of zinc. While we were standing in the alley, the Israelis started bombing us. Helicopters were above and we were surrounded by soldiers. I didn't know what to do. Somehow I found a knife in my hand. I was happy and stabbed an Israeli soldier with it. I tried to escape but was afraid they would take revenge on my family. I stood there. My sister ran and grabbed the knife from me and said, 'Run Jamal!' Then I saw my mother running, and she grabbed the knife from my sister saying, 'Run Hanan!'

"We argued and each one said to the other, 'No. You run.' While we were arguing, the Israeli soldiers shot all of us.

"I saw my sister dead and then my mother dead. I woke up from the dream frightened and sweating."

Traces of the frailty in Jamal's voice when he uttered the last sentence will haunt me for a long time.

Yousef, the carpenter

"I looked at the sky and saw a plane split in half. The two halves were held together with a bar that looked like the lathe bar we use at work here.

"The Israeli plane was flying over us. It was close and low-flying, about to bomb the camp. I saw a young man who works with us in the carpentry shop. He took my cane, then ran and hid under the tree.

When the plane flew next to the tree, he struck it with the cane. I saw the plane twist and burn. Smoke came out of it and filled the sky."

Tuesday, August 11
Omar

"I always dream of my brother who was martyred in an operation inside the Occupied Territories, whose body I never saw afterward. I always see him . . . sometimes in a café, sometimes in a restaurant, sometimes in a movie theater.

"I ran into him once in a restaurant. I was surprised. He was sitting alone at a table, and the restaurant was empty. I asked him, 'What are you doing here, Brother?' He replied, 'I'm eating.' I said, 'You haven't visited us in the camp for a long time. Come and join us.' He said to me, 'I'm too busy to visit you. And you know how many detectives and spies there are in the camp. If I come, they'll report me.' I said, 'Okay, but where do you sleep?' He said, 'I sleep at my uncle's.' I said, 'Okay. Stay at your uncle's, and I'll come to you. I'll get you whatever you want.'

"Once I dreamed he came to the movie theater on a cane. It was the Rivoli movie theater, and in the dream it wasn't as damaged as it is now.

"Sometimes I see him looking at me from the sky, dressed in white.

"He looks and shouts at me, 'Brother, we need to liberate Palestine. To make things easier, I just want you to make a plan.' And I dream that I'm sitting and making the plan, wondering how we'll enter—by air, land, or sea?

"Once I dreamed I was in East Beirut.

"I said to myself, 'How is it that I'm Palestinian and in East Beirut?' I was afraid and started running to escape.

"Then I got stopped at a Phalangist checkpoint. Bashir Gemayel himself approached the checkpoint and asked me, 'What brought you here?' I answered, 'I swear to God I myself don't know. I just found myself in East Beirut.' He said to me, 'Now do you know what we're going to do to you?' They kept coming and going, and I didn't know what they had in store for me. I looked around like this and ran.

"I dreamed that I was escaping, I was running, running and looking around me. I was still in East Beirut. I ran and was still in East Beirut. I was so afraid I no longer knew where to go. I found a grocery store and entered it. I said to the grocer, 'Please, brother, tell me. How do I get to West Beirut?' He said to me, 'You're in West Beirut! What's wrong with you?'"[42]

Eman, thirteen years old

"There's a young man who works with us here in the workshop. I dreamed he was martyred.

"They carried his body and brought him here. I looked and saw his hand hanging in the sky.

"They took him and left, but his hand was still hanging in the sky.

"I once dreamed that my uncle's wife was struck by a missile that severed her arm. She doesn't work here, but I saw her running here and I was running after her. Then we were in a white desert. There she was also running, and I was running after her.

"I once dreamed of a man who was beating me up, and I didn't know him. He was beating me, and my mother was saying to him, 'Beat her.' I was screaming.

Twenty-four year old Suad, who sat hidden in one of the workshop's corners, seemed to emerge from the folds of cloth that were heaped everywhere, or from the boxes crammed with trimmings. When Suad spoke, I said to myself that it was time to get out the camera, time to end this stage, in the corridors of these souls.

Suad said, "He left. And we, we left. We never found out anything after that. He dropped by that night and said, 'I'm going.'

"Later people came and said, 'He died.' "A woman said, 'We saw your brother carrying a hatchet and breaking the wall to get out.'

"In the dream, he came to the Damour house. It was night, and we were up late. Someone knocked on the door. My father said, 'Come in.'

"He entered the house and proposed to me.

"I screamed and said to my father, 'No, Baba. He's my brother!'

My mother looked at me and said, 'Shut up. That's not your brother.'

"I turned to him and asked, 'Are you Lutfi, my brother?'"

"He looked at me and was silent. He didn't say anything."

"I screamed and ran saying, 'This is my brother! I won't marry him!'"

"The night Lutfi died we went to Dikwaneh. It was almost midnight. My younger siblings were thirsty, and I had to get them water to drink.'

"Where was I going to find water? "I went to the house in al-Zaatar. I found the camp empty. I was frightened and confused. I ran to the church downstairs. I saw a young man I know there, someone I used to work with in the aluminum factory. The moment he saw me he ran to a National Liberal Party checkpoint and called out to them, I don't know why. I heard him saying to them, 'She is Palestinian. I know her from when she used to work in the factory.'

"Someone from the checkpoint ran toward me. He grabbed me around my chest and said, 'You came to your doom.' I saw the metal cross sparkling on his chest. The armed man pulled and dragged me to the building's entrance, and said, 'Take off your clothes.'

"I said to him, 'I won't take off my clothes.' He was carrying an M-16.

"He said to me, 'Are you a virgin or married?'

"I said to him, 'Married, with kids.'

"He said to me, 'Palestinian?'

"I said, 'Syrian.'

"He said, 'Liar. I'll shoot you if you don't take off your clothes.'

"I said, 'Shoot!'

"He said, 'I swear, I'll make you bleed . . .'

"I said, 'I won't take off my clothes!'

"He tore my skirt. I was wearing pants underneath it. He hugged me and started kissing me, and I was pushing him away from me.

"I caught up with my family later. My father was crying. He asked me, 'Did anybody hurt you, Daughter?' My mother held me and hugged me and cried.

"I love al-Zaatar because I was born there. I also love Dekwaneh, but I don't want to go back there ever again.

"Lots of people told me about Palestine, and I heard a lot about it as well. Once I dreamed about it. It was exactly like they told me. But

I also saw that there was thick iron separating it from Israel, like the kind they use for the big checkpoints." I walked around for a long time in Haifa Hospital. A silence of a special kind came over me.

A seven-year-old girl talked to me about her dream and said, "I saw the hospital submerged in the sea.

"I saw myself and my family, all of us, sitting at the hospital door. The sea was surrounding us from all directions, and our legs were under water.

"When I saw that, I got scared. I told my family about the dream as soon as I woke up. They told me, 'Water means confusion, doesn't it?'"

When I visited the rooms of people who had sustained spinal injuries, I stopped at one of the patients. He was lying down on his bed with deathless tranquility and had fixed his gaze on a small mirror placed right next to him. The mirror reflected his face, only his face.

I imagined these injured people at the seashore. They were sitting on the beach, in wheelchairs that had sunk into the sand. I contemplated this image, silently. Their faces were toward the sea and their backs to the camera. The sun was about to set.

The shot fixed itself in my mind at a wide angle It was a long, static shot. I was seeing their injured spines moving while they inhaled the drizzle of the sea breeze.

Calm waves touched the surface of the sand, then withdrew after wetting their bare feet.

On that day I decided that this shot would be, for me, the end of the film.

Shooting II

He who is inspired by a vision is a prophet. And he who is inspired by the king's word is only a messenger.

Ibn Sireen

Thursday, August 20, 1981
Rashidiyeh camp

The opening known as 'the checkpoint' was situated on the beach, enveloped by carefully piled sand bags. When the ten year-old Ibrahim stood at the checkpoint entrance, his height was exactly the same as that of the entrance. Wild green plants sprouted from the corners of the bags.

When we set the tripod in the sand, I studied him standing at the entrance. Through the camera lens he looked like an embryo in its mother's womb.

Ibrahim said to the camera, "I was asleep, and I dreamed . . . I dreamed that warplanes were striking and dropping bombs. I saw the 800s shooting.[43] Houses were collapsing and people were dying.

"I dreamed that I ran to a two-year-old boy and carried him. When I grabbed him, the plane shot a volley of 800 rounds at us. I ran and hid under the olive tree. The plane left and came back. On its way back, I saw it bombing the base. I kept running. I went down a valley. I saw dead people. I asked them, 'What's wrong with you? Are you dead?'

"They said to me, 'We were killed by the planes.' I stopped walking and I picked up the boy.

"The boy started screaming, 'Mama, mama!' and I looked around and saw his mother.

"I gave him to her and left. I saw myself in an olive grove. Then I was hit by an 800. Where? In my chest. I ran, injured, but no blood came out of me. I ran, and no blood came out. I woke up at night. I asked myself, 'What's this dream?'"

From inside, this checkpoint was filled with warmth and tenderness.

Threads of sunlight leaked through cracks between the sand bags while sounds of the undulating sea enveloped things in an atmosphere of tranquility.

There were two metal beds, a table, and red glasses of hot tea. There was a beautiful photograph of Abdel Nasser in a golden frame swaying in the breeze that blew it around the wooden beam supporting the checkpoint's roof.

We manipulated the lighting to give the other boy, Muhammad, a warmth that separated him from the blue light of day. Curls of smoke from the boys' cigarettes mingled with the rays of sun coming in from outside. Looking at the strange black lens, Muhammad said, "I dreamed of a slaughtered cow hanging in the sky.

"There were around twenty planes hovering and circling the cow, and the guerrilla fighters weren't shooting at all. Suddenly the cow fell. Boom! It slammed to the ground and landed by the house.

"Our house looked like it'd been uprooted from Rashidiyeh and placed in the spot where the cow fell—as if it were in the Shawakir region.

"I asked, 'What's wrong with you? Why aren't you shooting at the planes?'

"One of the guerrilla fighters answered, 'What's wrong with you, Muhammad? We are under a ceasefire.' We picked up the cow, left together, and buried it in the sea."

We moved away from the sea a little. Each of the boys and ashbal tried to show me a small white spot like a pinhead, their outstretched arms and forefingers pointing to the horizon. I tried very hard to look in the same direction.

It was Ras al-Bayada, which is the beginning of Palestine.

When we walked toward land, we came to a guerrilla base in the open air. It was a base on the grass, under green orange trees, overloaded with dew-covered fruits. Although the space between these trees was limited, we found military tents, beds, mobile restaurants, guests, lectures, ammunition, and lots of different weapons.

One of the most beautiful Palestinian faces, as far as I was concerned, was in one of these military tents. It was the face of the young Abu-l-Hajr. He conveyed an openness that inspired familiarity. The kindness of his soul flowed from his eyes. That's why we wanted his tent to be wide-open in front of the lens.

We folded the edges of the tent so that the orange trees became visible behind him, and so that the natural light from the green surroundings infiltrated the tent. Meanwhile, the sky was adorned with a sash of scattered clouds.

The clouds hid some of the light that day, periodically clearing for a few seconds to allow light back into the tent again. Following this rhythm of light on Abu-l-Hajr's face, we decided to shoot.

While lying on his bed with the camera running, he said, "I don't know. That day I was tired, exhausted from the call to fight. The area was being bombed. I slept normally, the usual, like all nights. But that night I dreamed of Sheikh Zayed. What made me dream of him? I don't know.

"I dreamed of something like a conference or a meeting. There were people from OPEC with Sheikh Zayed. Anyway, when the meeting ended and Sheikh Zayed left with the Arab kings and presidents, there was a long line of people standing. I was standing in the line with them. What made me stand with these people? I don't know.

"Sheikh Zayed started shaking hands with them. When he came to me and extended his hand to shake mine, I heard the escort behind him saying, 'He is Palestinian.' He said this about me of course, although I didn't know him at all and don't know where he knew me from. Sheikh Zayed stood in front of me and gave me an inscrutable look, one I didn't understand and couldn't interpret, and I still can't explain it now.

"In that moment, I woke up. There was the sound of gunfire. I realized that there was a fight at the beach checkpoint, the one with the ashbal. The checkpoint wasn't far, around two hundred meters away. There were Israeli torpedo boats. They seemed to be deploying troops. Then the dream ended. I woke up frightened by the sound of gunfire. I carried my weapon and headed, running, toward the sea."

At the ashbal's school, a pitch-black night came upon us. In the stillness, the whispering of the sea inspired a sense of dread. Nobody could feel safe by the sea on a night like this. For the cadets, the absence of security automatically turned into an anxious anticipation and a curiosity flavored with a desire to avenge themselves on the enemy.

We were absorbed by the cadets' stories. Fathi told us about a dream, so I decided to film him at night.

We started working right away. I didn't know the names of the tall wild plants that grew here. We were sitting in a desolate yard close to the beach checkpoint.

At our request, Fathi went to get us the big photograph of the guerrilla group he was a member of that had carried out an operation inside the Occupied Territories where everyone was martyred except him. This was the subject of the dream he narrated to us.

The photograph was enclosed in a golden frame. It was taken immediately before they entered Palestine. We hung it on a post in the open air so that it swayed slightly whenever the breeze blew, like Abdel Nasser's photograph at the checkpoint.

We set up the lighting so that it illuminated the photograph and the plants in a way that enabled Fathi to converse with the photograph while narrating his dream.

But staging the lighting in this way and focusing it so strongly made the school director anxious. Without our knowledge, he summoned a special car to monitor the torpedo boats with radar—maybe he feared our repeated lighting experiments would arouse the suspicions of the Israelis.

As a matter of fact, as soon as we were ready and about to start shooting we received very strict orders to leave everything immediately and

move away from the location. Israeli torpedo boats were three hundred meters away from the beach.

Later that same night Fathi told the camera, "I dreamed I was sitting here in the school, looking up the hill. I looked closely and saw two young men coming down. I saw that it was brother Abudi and brother Rostom." Fathi pointed to them in the photograph and his own reflection was projected onto the glass of the frame so that he blended with them in the camera's eye. The sea air rocked the photograph so that the glass reflected the light we'd placed in front of it, making the photograph flash and the faces in the photograph disappear.

"I asked Abudi and Rostom, 'How did you come? You were martyred.' They said to me, 'We haven't been martyred yet. Don't you remember? We hid after the battle, and now we came here.'"

Abu Shaker, the cadets' elderly trainer, suddenly interjected with a dream he hadn't told us about before: "That's true. One week after the young men were martyred, I dreamed that they returned. Abudi was carrying a bunch of mulukhiya and was running in front of them saying, 'Umm Muhammad! Umm Muhammad! Where are you? I brought you mulukhiya from there. You have to cook it for us today.'

"I was horrified. I woke up with a mixture of horror and joy."

Friday, August 21

In the alleys of Rashidiyeh seven-year-old Jihad was trying to hunt sparrows with a slingshot.

Without paying any attention to the filming, he answered our question about his dream while he was hunting: "We were very young. I was in al-Zaatar then. My father left to bring meat. He was hit by shrapnel and died. My mother went and got him. When we saw him, he was all bones, only bones."

Then we met Ibrahim—the young man who told us during our survey of the dream about returning hungry from a guerrilla operation and eating his enemies' flesh—on a mountain top that overlooked Palestine.

The peak was very high. Ibrahim was at this guerrilla position looking out at Palestine from a military trench. The ditch fitted his body perfectly, and to me it looked like a grave.

Ibrahim placed an empty fruit box next to the ditch and arranged small personal possessions inside it: two or three books, newspapers, a small radio, toothpaste, and shaving cream. Beside the box was a small Samsonite wallet.

We wanted him to tell us another dream. We filmed an establishing shot while he was lying down, relaxing on his back inside this ditch of his. In the background of the image were two fighters with their backs to us, keeping watch on the distant Palestine.

Ibrahim said, "And once I dreamed I was going home on vacation.

"When I reached home, I found that my brother had also returned from abroad. I looked at him and saw that his hair was gone; he didn't have one single hair on his head. He was fighting with my siblings. I tried to pull them apart. My siblings told me that he came back and wanted to take their hair. The idea made me furious, and I started fighting with him. Then my father came out of the room and kicked me out of the house.

"I left the house confused and miserable as if I was lost. I didn't know where to go. I suddenly remembered that I have another brother who lives far away. I walked. On my way, I was overtaken by a group of dogs that started to chase me.

"The dogs barked at me. They wanted to eat, and I screamed at them, 'I don't have anything.' Then I woke up."

On another mountain top the morning sun drew lines in the gray fog, which zigzagged like the ripples of the Awali River.

At this height the rays of sun leaked through the leaves of orange trees and mingled with an enchanting purple hue.

The military beds, spread among short tree trunks, were enclosed by mosquito nets whose edges were spread out in all directions. This view was amazing, as if it were designed for shooting in a fantasy studio. At first, I decided to film a special shot for the poster and film credits. This idea came upon me suddenly, inspired by the view.

I put a military bed stripped of covers under a tree loaded with oranges. Then I hung a white lace mosquito net on one of its boughs.

The camera was rolling and filmed each time the mosquito net flew in the air above the metal bed and the sunbeams penetrated the focus of the lens. Hassan, the young fighter, grew up on a military base like this. He has now become a fighter, but for the others he remained one of the ashbal.

Hassan stood there next to the bed, his complexion clear and dark, his hair thick and curly. The white mosquito net flew in the breeze, covering his face intermittently like a calm wave. We filmed him like this while he told us the following dream:

"When I was at Qal'at al-Shaqif, I'd get bored in the evenings and I used to go up the fortress roof to amuse myself by keeping watch with the guards.

"Sometimes I used to look through the telescope. I'd look at al-Matla and Kiryat Shmona. And I saw Safad. But because it was night, I used to see them as lights.

"But as soon as I went to sleep I'd see them clearly in my dreams; that is, I'd see them as houses like the camps here."

Monday, August 24

Ein al-Helweh

In the early morning before dawn, we landed at the sand border encircling Ein al-Helweh camp.

I've been enchanted by this camp since the first time I saw it. I love its name, its meaning and rhythm. The inhabitants of the camp, with their purity and kindness, played a major role in this personal enchantment. I wondered whether this was a characteristic of the regions those people came from in Palestine or because of their current proximity to them. There were flowerpots in each of the houses. Some of them were lined up next to each other along the walls of the alleys. There was a sheer beauty to the water and color of things.

With these sentiments, we filmed the camp at dawn, at sunset, during the day, and at night. The scattered defense lines inserted in the sand's depths around the camp are called 'protections.'

An anti-aircraft gun, a blanket, one or two young men . . . I never wanted to include weapons in the moving world of the film.

Today, I decided to film one shot of a weapon: the two muzzles of the anti-aircraft gun just at the bottom of the frame. The two muzzles turned and the camera turned with them, while the camp looked dormant in the background.

The fighter al-Turk told us his dream while sitting between the wheels of the gun. He said, "I dreamed I was looking for a girl I knew—we were in love with each other.

"In the dream I couldn't find her.

"I started going into stores. I'd look around and leave. I couldn't find her.

"Suddenly I saw an old man with a young boy. In front of them was a box with a telescope inside it, like one of those old-fashioned peep shows. The box was very big and covered with a black cloth, and only the telescope's lenses were visible.

"They said to me, 'Hey young man, come and watch what you want.'

"I paid money and started watching. I saw things I'd never seen before. As far as I remember there were huge places and strange, big animals. I moved the telescope a little and saw an Indian girl dancing. It was as if I suddenly remembered the girl I'd been looking for and I moved the telescope to the other side and saw her in front of me. Her face was exactly the same size as the telescope's lens. She was laughing and saying to me, 'Come! Come!' And I answered her, 'No, I don't want to. I'm mad at you.' Then it was like we were standing on the surface of the sea and I was sinking bit by bit. I was drowning, and she was laughing and saying to me, 'Come.' Her face was exactly the same size as the telescope."

The moment we finished shooting this scene, I greatly regretted filming al-Turk between the wheels of the anti-aircraft gun. Despite the directness of the connotation, I wished we had filmed him the same size as the barrel of the gun. But we didn't re-shoot the scene because I sensed that I might not use this dream at all, based on my vision of the overall structure of the film.

When Abu Atef, also present at one of these 'protections,' told us his dream, I thought of recording it with his voice only, without filming him. This was because I realized that his voice could be used as a background for the earlier scene where we shot the two muzzles of the anti-aircraft gun. Abu Atef said, "I dreamed Israeli planes were heading toward us and started bombing the camp. I was standing at the anti-aircraft gun. It was as if at that moment—when I saw houses being bombed—I remembered the children I'd left at home and I left the cannon and started running. I saw myself carrying the children and looking for shelter.

"When I returned to the base, I found the officer screaming at me, saying, 'How could you leave the gun? Who did you leave it with? See how the camp is burning?' I was shouting, 'I swear to God I didn't run. I was looking for shelter for my children. I'm not a coward.' It seems that my head banged against the bed while I was shouting in my dream and I woke up."

I liked the first part of the dream—that is, before he went back to the officer. I thought about it a lot, and decided to use the dream without including Abu Atef's return to the base.

Tuesday, August 25
Burj al-Barajneh

We had met Umm Hussein during the survey phase—she was the young mother whose son Hussein was captured by Israelis in the aftermath of the Kafr Qasim marine operation. This time, with the film crew, I first wanted to know how she received the news of her son's capture. This was out of personal curiosity, and I didn't expect to use this material for the film. We were sitting in a room in the house located on the elevated side of the outskirts of Burj al-Barajneh. The zinc roof over our heads was giving off a metallic heat that made us sweat even more. She said, "The day I had the dream I told you about—do you remember it? The dream where Hussein said to me, 'God is the best healer, mother' and 'seas separate us, mother'? That afternoon, my friend Umm Rabi' came to see me." Abu Hussein had heard about the operation on the radio, but he didn't tell her about it.

"When I saw Umm Rabi' coming, I don't know why I felt heavy-hearted. I said to her, 'What is it, Umm Rabi'?'

"I asked her, 'Did something happen to Hussein?'

"She said, 'What? He's okay.'

"But honestly I wasn't relieved. I sent my daughter to the kitchen to make coffee. After a while, I followed my daughter and started watching Umm Rabi' through the mirror in the kitchen.

"I saw her stand and look at the photographs on the wall. Then I saw her lift Hussein's photograph from among them and kiss it. She turned to her daughter and told her things I couldn't hear.

"I put on clothes to go to the market and said to her, 'Drink the coffee, I'll be right back.'

"I went to the office immediately. The young men ran to the officer and said to him, 'Umm Hussein has come.' The officer was disconcerted and said to me, 'Welcome. Come in. Would you like some coffee?'

"I looked at him and said, 'Listen. This is our revolution, and we know its calamities. We know that some are martyred, that some are in shorts, some are short-sleeved.' He said, 'Uff . . . What do you mean by 'shorts' and 'short-sleeves?'"

"I said to him, 'I mean some lose their legs, and some lose their arms. So tell me honestly. That's better for you and me. Did something happen to Hussein?'

"He said to me, 'Hussein and the other young men were captured by Israel.'"

We immediately set up lighting in the kitchen, in the corridor, and in the room with the framed photographs. We asked Fadia, assigned to facilitate our introduction to Palestinian families in the camps, to stand in front of the framed photograph while we filmed, and to take Hussein's photograph out of it, contemplate it, then return it to its place.

We put an electric fan next to Fadia to make her hair move, hoping it would create a humanizing and aesthetic effect in the background of the shot. Fadia would be visible to the viewer in the kitchen mirror through which Umm Hussein would be watching her.

We begged Umm Hussein to assist us in reenacting that moment by entering and standing in front of the mirror right when we asked her to.

Abu Hussein is a carpenter in a shop that was initially part of the house itself. This store is also open to the camp's alley.

One of the shop's walls has a strange window opening onto the house's kitchen. Its strangeness lies in the fact that it resembles, to a great extent, the windows of dungeons, with iron bars.

We placed the camera in the shop and left Abu Hussein to work while listening to his wife recount the dream from behind the bars.

The camera would move around during the narration. We had agreed that Abu Hussein was to continue working until Umm Hussein finished narrating the dream. Then he would turn to her and nod absentmindedly.

This is how we filmed the dream she hadn't relayed to us during the first meeting. She said, "You know, Abu Hussein, I dreamed I was going to see Hussein in Palestine. I was met by an Israeli soldier on the bridge. He looked at me and asked, 'Where have I seen you before?'

"I replied, 'I don't know.'

"He said, 'No, I'm positive I've seen you before.'

"I said to him, 'How do you know me? Where did you see me?'

"He thought for a while and then said, 'Yes. You're the one whose photograph was in the newspaper. You were kissing the cadet and raising your hand in a victory sign.'

"I said to him, 'Yes, that was me.'

"He said, 'So you don't deny it!' I said to him, 'No. And I'm not afraid of you either.' "Then, Abu Hussein, he raised his hand and slapped me. I screamed loudly. Then I woke up."

Wednesday, August 26

Out of the many dreams Abu Ghalib shared with us, we chose only the location—that is, the place where his dreams occurred. It was the mosque: "I dreamed I was in the mosque. After a while, King Hussein came and wanted to pray with us. I told him, 'You haven't performed your ablutions'"

We took Abu Ghalib from his house in the qumbaz he slept in, and we went with him to Burj al-Barajneh Mosque to film him there while narrating his new dream.

At first we took close-ups of him in the ablution lavatory—rinsing his mouth, sniffing, washing his ears, wiping his neck, washing his feet to the heels, and reciting that there is no god but God and Muhammad is his Prophet, while lifting his forefinger in the air.

He followed his ablutions with supplications to God, which he recited in a clear voice: "God, grant us victory and vanquish our enemy, generous God." We recorded each of these supplications.

Inside the mosque, we spread ornate, multi-colored rugs borrowed from neighboring houses over the existing straw mats. We waited until the sun had moved a little so the shadows from trees in the alleys spilled through the windows onto the rugs, giving the room a sense of familiarity and intimacy. The prayer niche, library, and clock were in the background while the electric fans hanging from the ceiling circled above Abu Ghalib's head during his prayer.

Abu Ghalib proclaimed, "God is great!" in front of the camera. He knelt, prostrated himself, sat, hummed a supplication, and turned to the right then to the left. After this, he looked to the camera and said, "I once dreamed I was in Nabatiyeh and had become an office official. In the dream Abu Ammar came and said to me, 'I want to sleep, Abu Ghalib.' I said to him, 'Go ahead Abu Ammar. Sleep in my place.' He said, 'No, you sleep and I'll sleep next to you.'

"We slept. Suddenly we woke to Abu-l-Za'im's voice saying, 'Who's that sleeping next to the old man?'

"I got up and said to him, 'I am Abu Ghalib.'

"Abu-l-Za'im looked at me and said, 'Come on. Get up. Let the old man rest.'

"I was about to get up, then Abu Ammar said to me, 'Don't get up, Abu Ghalib. Go back to sleep and don't answer him. In the morning, we'll pray together.'

"Then Abu Ammar turned to Abu-l-Za'im and said, 'Go. May God improve things for you.' Then I woke up."

Although I know why I chose to film Abu Ghalib in the mosque, I really don't know what inspired me to take Abu Adnan to the barber shop in the camp's main street. We let the barber shave his beard in front of the camera while he narrated his dream to his reflection in the salon mirror.

Abu Adnan said to his reflection, "I dreamed we were in a military base, sitting on the floor. Officers and soldiers were gathered around, and Abu Ammar was also sitting with us.

"We were sitting happily and harmoniously, as if at a picnic.

"Suddenly we heard a sound at the entrance. We all turned and heard the guards screaming, 'Brother Abu Ammar! Brother Abu Ammar!'

"We all got up. 'What happened?'

"They said, 'King Abdul-Aziz bin Saud has come.'

"We looked at each other surprised. We said, 'Damn! You blind people. What's wrong with you? Are you delirious? King bin Saud died long ago.'

"They said, 'No. We swear it's him in person. And the sign is that his eye is jelly,' meaning he has no eye. 'Come brothers. King Abdullah is also with him.'

"We turned to brother Abu Ammar and said to him, 'Go ahead brother Abu Ammar. Relief is in sight, God willing!'

"After a while, I had the sense that we were in a palace. The floor was covered with trays of cooked lamb. They said to us, 'Go ahead. Eat.' I reached out my hand to eat. Then I woke up."

Speaking of Abu Adnan's reference to lambs, two days earlier, on our way back from Ein al-Helweh to Beirut, we passed by Sidon. It was before dawn, and in a street close to the sea we were drawn to the sound of sheep bleating bitterly. So we stopped.

The sheep were making this noise while being pushed toward the slaughterhouse.

We shot close-ups with the camera: dangling heads, the butcher severing tongues, cutting off ears, gouging out eyes. We also filmed the other butcher while he lifted a carcass with a roller and chain upward, out of the frame. We took extreme close-up shots of knives being sharpened as well as of the blood on the floor.

In this shoot, we relied on a technique where we kept the camera very close to what we were filming. We used special wide-focus lenses that allowed us to give the things and actions we filmed an element of unfamiliarity, stripping them of some of their realistic structure.

When Abu Adnan told us this dream of his, I immediately understood where I could use the shots we had filmed two days earlier. I also decided to interfere a little in his dream and eliminate the last section where he talks about the trays. I would end with "Relief is imminent God willing!" so that these slaughterhouse shots would replace the omitted section.

Fadia

Burj al-Barajneh camp consists of a number of hills and depressions linked by a series of ascending and descending stairs that unite the houses into a single unit, called the 'camp.' We asked Fadia, the Palestinian girl assigned to help us and whom we'd sometimes used as an extra, appearing in or seen walking out of certain shots as needed for the film, to let us film her in a special scene. She was to walk with a young man, Khalil, the assistant photographer, holding hands and wandering together on the high sandy streets arcing out over the camp. This place appeared in the dreams of some of the inhabitants as a place of death or of storms that buried houses and people in sand.

I wanted this shot in the film in order to show a special, intimate side to life in the camp.

It was a short, fleeting shot. The camera filmed from a remote distance as the young man and woman moved further and further into the distance. Everything in the camp slept in the pale afternoon light. It was a minor shot, but it lingered in my mind, breathing life into my emerging sense of the film.

After this, Fadia told us her dream, and we filmed her not as an extra but as herself. We filmed shots of her with the shoulder mount camera following her as she descended the camp's stairs down to the bottom where the camp fuses with the outskirts of Beirut's southern suburb.

She said, "I once dreamed I was in a prison with big, black bars. There was a lot of fog in the dream. A warden whose face reminded me of pictures in history textbooks or statues of Assyrians in museums, which we read about in the fourth or fifth grade, appeared before me from out of the fog and smoke.

"This warden approached and hit me. I screamed and cried. He said to me, 'Get down on your knees!' And I said, 'No! I won't. I won't get down on my knees!' At the end he looked at me and said, 'By God you should all be slaughtered. You should all be slaughtered!'"

Thursday, August 27

Abu Muhammad is a fifty-year-old worker. He is tall and slender, with a worn out face and body. He was wearing a white shirt that was clean and ironed.

He works at the SAMED shoemaking workshop on a machine that attaches rubber soles to military boots using thermal pressure. This machine makes metallic opening and closing sounds and has a harsh echo that we recorded for various possible uses. When the machine attaches the rubber sole it emits charges of pungent smoke. We put the camera right in front of the machine, a little lower than eye-level, and adjusted it so that the machine filled the frame. Abu Muhammad was visible to us—and to the audience as well—behind and between its jaws.

He was totally engrossed in his work. He seemed lonely and immersed in his silence and his world. We noticed that when he finished a boot, he placed it with a dull movement on the upper end of the machine so that, for us, they were lined up in the foreground of the image.

Despite fears that the audience would think we asked him to do this—due to the cinematic significance triggered by the motion of military shoes mounting the machine—we didn't interfere to change anything. Our only interference was in choosing the angle and height of the camera. But everything harmonized precisely, including the dream this worker chose, which surprised us:

"I once dreamed of Gamal Abdel Nasser. He was standing in front of us, as youths, and telling us, 'Come on. Let's go to war and liberate Palestine.'

"Abdel Nasser walked ahead of us, and we followed him. Suddenly we saw him stop and look around. We looked around. To me the place looked like Nabatiyeh.

"Then Abdel Nasser raised his hand, pointed off into the distance, and said, 'We will enter from here.' I opened my eyes and woke up while he was pointing in the air."

The young woman worker we met this time in the same shoemaking workshop told us a dream narrated to her by a friend who was absent from work that day. I think we met her during the survey. She told us of a dream that had greatly affected her and which she seemed to consider more worthy than her own dreams, none of which she relayed to us.

Working behind her machine, she grabbed the boots finished by the adjacent machine and carried out the final process of attaching the heels. This required that she use her hands and legs in an alternating manner. When she pressed her foot down, part of the machine rose and hid her face—had we placed the camera in front of her. She pressed her foot down many times and this part of the machine dropped forcefully with a hissing sound. Then the heel was nailed to the boot.

Because she was narrating the dream on behalf of her friend, I first thought of filming her from behind. She was also wearing a white shirt that hung down loosely over her black skirt. The treading motion of her foot on the machine was reflected in the jolting pulse of her vertebrae through the folds of shade and light on her shirt. But the suggestive connotations in the rise of the machine's compressor in front of her face, hiding it from the camera before dropping back down, made me shoot this dream twice, once from the front and once from the back. This would allow me to choose or combine them while editing.

Aisha said, "A while ago, Iman told me that she dreamed of her brother Muhammad a week after they buried him.

"She dreamed she saw him again, and his wound was very deep, deeper than it had been. He called out to Iman and not to his mother. She got up and went beside him. She saw little kids with him, around

a hundred little boys wrapped in white muslin and making cooing sounds. There was a woman with them who was feeding them. When they arrived at Damour, the electricity and water had been cut off. I don't know why, but whenever Muhammad entered a house the electricity would come on and the water would start working."

Monday, August 31
Shatila

The green leaves of the mulukhiya Abudi returned with and asked Umm Muhammad to cook while Abu Shaker, the cadets' trainer, narrated to us, became increasingly enticing to me. For me its color was exactly the same green as what Palestinians always refer to in their memories from or about 'there.' On the way to Shatila, we stopped at the Sabra vegetable market and filmed many short shots of Sabra and Shatila women buying mulukhiya. Then we bought huge bunches of it without deciding what we wanted to do with them. I thought we'd definitely need them for the day's filming.

The leaves were fresh, damp and green, with an amazing intensity. In Shatila, Rawda—assigned to help us here—talked to us about her mother and about the dreams she narrated to them every day while showing us her place of birth and her childhood home. That is why we searched eagerly for Rawda's mother and finally found her in the house of Umm Tareq, whose husband we met and filmed in the first shooting. They were together. Maybe it was my imagination that made me think that they were exchanging stories about their dreams when we suddenly dropped in on them.

The day we filmed her husband, Umm Tareq had withdrawn silently behind him at the kitchen door while he sat in his Turkish cap and recounted his story and the story of the camp. Now she disclosed to us a rich inner world full of amazing fantasy.

Sitting together like this, they decided they would film themselves telling each other their dreams. We went up to the roof to escape the colors Abu Tareq had used to paint the walls of his courtyard, fleeing also the gloomy shadows evoked by the fig tree in the yard.

On the roof we spread the mulukhiya bunches between the two of them, so they sat plucking its leaves. We suggested that the pretty Rawda go to the neighbor's house and peer out of an adjacent window onto this conversation between the two women. When she did that she could catch pieces of their conversation. We only used electric lighting to illuminate Abu Ammar's photograph, which hung in the remote depths of the image, on the wall, behind Rawda's window.

With the camera rolling, Umm Tareq said to Umm Riyad, "I dreamed—and I pray to God it's a good sign—that I was walking in a vast space. The surrounding hills rose and fell around us. I saw some-one riding a green horse.

"I thought I recognized him from a distance. I approached him. I studied him closely. I realized that he was my brother-in-law, Abu Ali Salama." Abu Ali Salameh is a Palestinian leader who was martyred in the Ras-al-Ein battle in Palestine.

"I saw him standing there, not moving.

"He said to me, 'Hey, Umm Tareq.'

"I replied, 'What are you doing here? Aren't you dead?'

"He said, 'As you see, I'm here day and night, standing on the bor-ders in case the bastards catch up with you and enter Lebanon.'"

Then Umm Riyad said to Umm Tareq while the camera was run-ning, "Believe me. Human beings are always nostalgic.

"Of course, I know myself well. We're in Lebanon now, and I have lots of Lebanese neighbors, many of whom I like very much and would hate to part with. But in the dream, I see myself going and taking them with me, going with them. I want to show them Palestine.

"As soon as we get there, where do I take them? To Acre, where we used to live, to Megadla alley to be precise. I started showing them around the alley, one house after the other. I was surprised, all the doors were open—nobody locked their doors.

"I turned to the women with me. I said to them, 'Listen. Now all of you have to cover your faces with handkerchiefs. No woman's face should be exposed.'

"They asked, 'Why?'

"I said, 'I know the men of Acre. Their eyes are penetrating, and they like looking at women.' We entered the street, but there was no activity, no one coming or going. I didn't see any human beings at all!

"Praise the Lord! I woke up from the dream this time feeling completely alert, as if I'd really been in Palestine.

"I woke up in the morning and said to my daughters, 'You know girls? Today I am very happy.'

"They asked, 'Why, mother?'

"I said to them, 'Because I was in Acre last night.' I started laughing, laughing out of happiness, I swear on the Qur'an."

Umm Tareq said, "You're right. The soul feels happy."

Umm Riyad replied, "Yes. The soul feels happy, and the heart feels nostalgic."

Umm Tareq said, "You reminded me . . .

"Once, Umm Riyad, I dreamed I was walking; maybe it was Jordan. Then I saw an old man standing and putting his hands behind his back. He stood with his head lifted, watching the sky, his mind wandering. "I approached and asked him, 'What are you looking at, Hajj?'

"He said to me, 'Can't you see?'

"I looked up and saw horses in the sky being ridden by soldiers.

"I said to him, 'Yes. You're right. Praise God! But how can there be horses riding around in the sky?' I swear to God, Umm Riyad, I saw them with my very eyes, a line of white horses and another line of green horses. And the soldiers were fighting with swords.

"Then I saw a line of horses going up and another one going down. I was standing and saying, 'God! God!' Suddenly, the horses came down to the ground. I looked at the ground and saw that they had become like huge roosters, like turkeys. There was a line of blue roosters and a line of brown ones. There were no soldiers or swords at all.

"These roosters attacked each other and started fighting. Each one was jumping on the other.

"The sheikh turned to me and said, 'You see, daughter? They're fighting so we can liberate Palestine.'"

At this point Umm Riyad interrupted, saying, "Like Cain and Abel that is. Praise God! *God does not change a people until they change themselves.*"[44]

"Then I woke up and didn't know what had happened."

Before we gathered the film equipment to leave, we took shots of the plucked mulukhiya leaves.

After we came down from Umm Tareq's sky and walked in the alleys of Shatila, stumbling under the load of heavy film equipment, we noticed a young girl slowly approaching us. Her slight plumpness and peculiar elegance intrigued us, even if just a little. When she saw our looks, the only thing she could think to do was smile. When we stopped her and asked about her dreams, her response was enormously gracious, as if the dream was right before her eyes. But what set her apart was her accent, which made me guess that she was half Lebanese and half Palestinian. We said to her, "Where are you going?"

She replied, "To the medical center."

We followed her to the center. On the way, I'm not sure why, an aggressive mood welled up inside me, maybe because of the effect of Umm Tareq's dream about horses and roosters, and maybe for other reasons I didn't fully realize. I had the idea of filming this girl while she was devouring food among colored bottles of medicine that I imagined would be at the medical center. Maybe that was the first time—and the last—when I chose the form and subject of filming before listening to the person's dream.

At the center I asked about the food. The patients' meal that day was suitable for what I had in mind, zucchini in tomato sauce.

The generous Leila didn't object to this strange decision of ours. She put the food in front of her and started telling us her dream while eating or holding on to soft slices of zucchini.

She sat in a wheelchair in front of a corner full of medical equipment and colored medications suitable for urgent first aid use.

She said, "A few days ago, I dreamed I was sitting in the office, daydreaming, and it was unusually empty. Suddenly the face of Abu-l-Ra'id appeared." Abu-l-Ra'id was a martyr. "He appeared wearing a

suit and tie. I was surprised because he had never worn a suit and tie in his entire life.

"The moment I saw him in front of me, I gasped and said, 'Oh! You are dead.'

"He said, 'Shame on you! You still think you know everything?'

"I was silent.

"I immediately got up from behind the table and pulled him with me. I started walking with him in the office. The walls of the office were packed with his photographs, which we had printed after he was martyred. I walked with him while removing the photographs with my hand from behind, so that he wouldn't realize that his photographs were on the wall because we thought he was martyred—so that he wouldn't get upset."

Tuesday, September 1
Salwa

"I dreamed I was in a spacious cemetery, and it was dark. I was dragging graves from one place to another. I kept dragging graves around until I'd rearranged the whole cemetery."

This short dream that Salwa told us about in our first meeting (when we were in their house with her sisters Haniya and Naja, Abu-l-Abd's family) was the one we chose to film.

We walked with her to her job at the Foundation for the Welfare of Families of Martyrs, Prisoners of War, and the Injured. This office was located in the small area where the ground floors were usually allocated to doormen.

Inside the office, the four walls, up to and nearly including the ceiling, were covered with shelves crammed with dossiers, the files and registers on the families of martyrs, prisoners, and the injured. These were the families eligible for the care offered by this foundation. We were only interested in the dream she narrated to us in the investigation and how she saw herself filling out gigantic applications that never ended. At the bottom of these files, red handwritten phrases referred to al-Zaatar, Maslakh, Karantina, Jisr-al-Basha, Mieh-Mieh, Rashidiyeh, and others.

Salwa sat behind her desk. She donned a scarf that totally hid her hair and was wearing eyeglasses.

She is very slim, and now looked even smaller behind the desk. The presence of the registers around her had a strong effect on the shot's structure and reinforced the impression of Salwa's confinement within herself.

We put two thick registers on the table, which made her disappear even more. I started to get a Gogolian feel from the scene, so we immediately decided—despite the narrowness of the place—to place the camera as far away as possible in order to take a wide, establishing shot.

After we'd done all this, she told us her dream where she was dragging graves from one place to another.

After we filmed this dream, Salwa remained and allowed us to record the following story on audio: "Abu-l-Ra'id, the man Leila from the medical center talked to you about, is one of my relatives. He was martyred by a sniper's bullet in Shayah. He was injured in the spinal column. This led first to paralysis, after which he was transferred to Moscow. He was martyred a few hours after the surgery.

"I once dreamed I was standing in the road, waiting for him. When Abu-l-Ra'id came I said to him, 'I want to ask you for something.'

"He said, 'I know what you want. Go to the office and take it.'

"I ran to the office. The office looked like a big, old warehouse. I found a girl sitting inside. I asked her about what I wanted. I saw that I myself did not know what it was. As I was about to explain to her that I'd seen Abu-l-Ra'id and asked him for something I wanted, and she said, 'Follow me.' I walked behind her and we walked between the many objects in the warehouse. I found her handing me an innertube, for swimming.

"I took the innertube from her and went out to the street. On my way out, I found Abu-l-Ra'id coming. He ran into me at the door. I said, 'Here I am. I took the inntertube.' He said to me, 'I'm sorry, Salwa. You have to ask for it from the leadership.' And he actually took the tube from me and went inside. I was alone at the door. Then I woke up."

Wednesday, September 2

Now we have, on our list of the dreams we've chosen to film, the dream of Abdel Nasser flying over the Tarshiha Depression. We wanted to find Haniya to retell the dream in front of the camera. So we asked her sister Salwa about her, and she said, "She is at WAFA."

I asked, "Is she an editor?"

She said, "No. Not at all. She develops photographs." Salwa laughed, and I was surprised.

I found a new place for filming—a different and special place. On the way to Haniya, I started to imagine how we'd film the next dream.

The photography lab appeared in the film many times, but this didn't make me feel that the idea of filming her dream was clichéd. I was deep in thought, searching for links between the dream she would narrate and the photographs she would be developing while the camera recorded her.

Thus we made a narrative intervention, one that went further than those we'd made previously. I picked out photographs of four Arab leaders from the agency's archive who'd accessed power through the army and became, after Abdel Nasser's death, an exemplar of the new leaders of the seventies.

We went ahead and took pictures of the four photographs, quickly developed the film, and gave it to Haniya to print in large sizes.

In the darkroom against the red light, Haniya immersed the exposed photographs in the developing sink, rippling them with her hand to speed up the process. Just as the images of the four leaders started to appear on the white sheets of paper, we started running the camera to capture the audio and video narration of Haniya's dream. We were trying hard to synchronize her story about Abdel Nasser's death with the gradual appearance of the new leaders in the developing sink.

"In the dream, I saw that Abdel Nasser was alive. He was riding a ship that flew over the Tarshiha Depression. I stood watching. The sky was clear, and it was daytime. My family was behind me saying, 'Abdel Nasser is dead.'

"And I was saying, 'No, he's alive. All the talk about his death is journalistic propaganda.'

"My family said, 'He's dead. They poisoned him with white cheese.'"

That night we ran into Abu Ahmad (Gorky) doing a night shift guarding one of the Resistance offices in Burj al-Barajneh camp.

Gorky was sitting at the office entrance in pitch-black darkness. When we set up lighting for the shoot, we used limited light directed only at his face in the darkness. This lighting reminded me of the return of the martyr Abudi in the dream the cadets' trainer narrated for us. There was a faint light visible on the muzzle of the Kalashnikov next to Abu Ahmad.

He said to us, "While I was asleep, there was a knocking on the door. I got up and opened the door."

I remember that at this point in his dream when we spoke to him the first time policemen and military intelligence officers knocked on the door after having peeked through the window at his wife who had just given birth. "After I opened the door, I saw a tall man in front of me. He was dark. His beard was unshaven. He wore dirty, sooty khaki clothes. There was something black on them, like tar, soot, or car grease.

"I looked at him and said, 'Come in.'

"He said, 'What? You don't recognize me, Abu Ahmad?'

"I said to him, 'I swear I don't. Who are you? No offense.'

"He exclaimed to me, 'I am Abu Khalid, Gamal Abdel Nasser.'

"As soon I heard him say he was Gamal Abdel Nasser, I ran toward him and started kissing him, and he kissed me. I was saying to myself, 'Oh God! Why is Abdel Nasser working in a car garage? What's going on?' I woke up to this question."

Sunday, September 6
The last day

God, all we have left are rolls of unused film . . . What should I do? Have I filmed enough material to make a film?

I really don't know.

This world of individual dreams is like swimming in water filled with whirlpools you can't pull yourself out of. Whenever I try to dive downward to find my way out, the vortex gets stronger. As with the open beginning, I feel there is no end to this. What should I do?

Rawda, who accompanied us today to see the alleys of Daaouk, was leading me. Whenever we met she would describe these alleys in an enchanting way and I would fear falling prey to the enchantment of the place and failing to find enough material for the film. There was something in her description of Daaouk that made me feel I was in a dream space. Today I succumbed to it, and decided to go there with the film crew. I intended to convince this young Palestinian woman, who accompanied us silently while listening to the dreams of others and then swallowing in deep sadness, to disclose her own dreams.

Only once did she talk to us about something that fit into the film. That was when she told us about her childhood house in Shatila camp, and her memories of it.

On a mission to lure Rawda into recounting a dream, and driven by a belated desire to discover the alleys of Daaouk, we spent the day holding our last breaths and our last meters of unused film.

Entering an alley in Daaouk is like delving into a thick mass of rough, salty water, a mass that allows very little space to pass through, and which, not long after you leave it reassumes its primary secrecy or seclusion.

These narrow dark curving alleys don't reveal a beginning or an end, or even an exit. Housing units arrayed with an unknown fatal power rise around them in a nightmarish manner, looking down at you as if mocking you. They are static and you are dynamic. They will remain and you will pass. The people have discovered their own special ways of meeting their personal needs, hidden behind a wall, or behind a clothesline, or in a huge cardboard box in whose space a life might be laid out. Rawda walked under the clotheslines which extended from one end of the narrow alley to the other, dotted with plastic colored clothespins and loaded with various pieces of clothing used in daily life and sleep, recalling the dream she had one morning.

The camera recorded her saying, "I dreamed I was on the beach. I was wearing a white wedding dress.

"There were lots of people—both in the water and out. The people had grabbed hold of me, pulling me by my two arms.

"Some pulled me toward the sea, and others pulled me away from the sea.

"Each side was pulling really hard and it felt like my arms were being dislocated. After a while, the people in the sea won and they dragged me to the middle of the sea and I dreamed I was drowning."

Moustafa, who had emerged from somewhere in Daaouk, was watching us while we filmed her. He listened while she was recounting her dream. When we turned to him, we noticed that he was extremely touched by what she had said. Then he laughed deeply and uttered a sigh like that of someone who discovered all of a sudden that what she was narrating was exactly what had happened to him. At that moment, he immediately said to us, with an extraordinary childish amazement, "Damn! I swear I also dreamed I was drowning in the sea. It was night, and the sea was dark. When I felt I was about to drown and would die, I gave up and dove into the water. But when I looked up before losing it and dying, I saw a light in the sky. I swear that light looked like the map of Palestine, it was the same shape that we hang around our necks or on the walls of our houses. I saw it lit up in the sky."

Development and Production

O
n the last day of shooting, Sunday, September 6, 1981, as we left Daaouk, walked past the doorways of Shatila camp and by the Sabra vegetable market—even crossing through the alleys of Sabra camp itself—the divergent echoes of those voices and faces we had lived with lingered inside me, along with a sense of the daily movement of light and shadow in different places. We walked, carrying cases of film wrapped in light-proof tape and pouches of magnetic tapes with recordings of trembling voices disclosing their dreams to us. The people we'd got to know or met disappeared into the dreams of the coming nights and days, while their images and voices, which we'd captured on tape, came with us to the production labs to be treated with chemical acids.

My notebook is now filled with scattered records, statistics, and ideas:

In the first and second surveys we met about 230 people and listened to more than 300 dreams.

In the first and second shoots we filmed 65 people who narrated 58 dreams before the camera.

We filmed 40 men, 22 women, and three children. Ten dreams included the return of a martyr, four of which were about Gamal Abdel Nasser and five about Palestinian leaders. There were five dreams about prison and torture.

The dreams we heard during the survey phase were not included in these statistics and remained in a random, scattered mass, as there was no opportunity to include them in the next stage of filming. Even their inclusion here, in this notebook, was selective, since there was no way for me to include all the dreams we recorded or wrote down in this text. For instance, I listened to more than 225 dreams in the second survey phase, out of which I only chose 58. While the audio and video went to the labs and I set my memories and notes aside, reality was taking its course.

In June 1982, Israeli military forces invaded the Lebanese territories targeting the Palestinian presence. Then they put Beirut and its camps under siege. After a fierce and heroic resistance, Palestinian fighters left Lebanon. Sabra and Shatila camps fell victim to the massacres named after them.

In the following period, up until 1985, the camps lived through the sporadic bursts of what was called the Camp Wars. Then these camps were placed under a siege that lasted until 1988. During the siege, Daaouk, then Sabra camp, were wiped off the map, and Shatila and Burj al-Barajneh camps were repeatedly destroyed until they fell completely.

I was unable to complete the film until 1987. I never visited these camps after I left or personally saw what happened to them until I finished the film. All I knew, other than what was in the news broadcasts, were bits of journalistic information or photographs. I was strongly affected by everything that happened and was happening in the camps while I edited and completed the film. I was particularly upset about Shatila and Burj al-Barajneh, which had been under siege for two years by the time the film was completed.

Many of the hopes I had for this film were dashed. The nightmarish charge that had underlain reality with deep and internal misgivings splintered into many scattered nightmares, far beyond anything foreseen in the film, and greatly removed from its time.

At the time all I could do was take apart the dreams laid bare of the bodies and places streaming before me on the small screen of the

editing table—the fates of which were unknown to me—and race to reassemble them into a dream about dreams that are now a memory of a dream.

All I could do was to draw from that love a breath that would animate the cells of light and darkness, so that the life onscreen would create a time of its own and charge this gloomy day with strength and hope. On September 29, 1986, the film was completed with a duration of forty-five minutes. Only twenty-three dreams endured the siege of filmmaking and editing.

Shatila camp was under siege at the time. A copy of the film was smuggled to those inside the camp, who were among the first to watch it.

Lights On
in the Theater

Monday, March 14, 1988

Yesterday the siege on Shatila camp was lifted.

The mere suggestion of visiting the camp was met with the silence of young children left momentarily speechless. We were all curious, each in our own way, and each in nearly the same way. But it was the faces hidden behind the siege, faces that neither the satellite channels nor the relief trucks nor the ambulances managed to convey to us over the years—unlike the intifada in the Occupied Territories, where the cameras show nothing but faces—there was a magic to these faces that made us all curious and which cut through the forbidden distance the siege had created between us. Perhaps it was this, their faces, which had made us speechless at the prospect of visiting. I knew perfectly well that we averted our eyes from the images of destruction, having already stored so many of them in our memories, and I knew perfectly well that we were tired of stories. I knew I was afraid of running into someone we'd filmed seven years earlier, afraid of looking at them and feeling the magical power of the cinema which, despite the siege, could keep the body alive, the complexion clear, the face a little rosy, the voice intact, and the eyes full of depth. In spite of all this, we longed to see the faces. We spent the night before our visit trying to

feel things out in the darkness of a rainy, cold Beirut, waiting silently for morning. At the outskirts of Daaouk, we stepped in to explore 'the dream,' entering as if through a paper screen. When the sand barrier enclosing the horizon emerged, the sky appeared unexpectedly. I know the sky in Beirut does not become visible until you draw near to the sea. Our steps involuntarily slowed, shortened, then we scattered a little, as if wandering or pushed apart by magnetic particles of an unknown form. The damp red sand gave way underfoot, and I noticed the absence of human sounds, hearing only muffled voices reminiscent of the kind heard when approaching holy sites.

The sun was giving out a yellow light even though it was past sunrise. The place had a waxy texture and flavor and the air felt prickly, as if strewn with sharp metal needles.

Behind the sand barrier, the scene looked to me as if it were wrapped in a cloak that suppressed all sound, scattering life into pieces, ornaments in an open-air studio where dimensions comingled and perspectives intertwined. You weren't sure whether this was a film made by God or the Devil. Those who had the courage to come out of their low doorframes seemed as if they had come out to get some fresh air. They dispersed, standing on caved-in roofs, over the trash, or on burned remnants of supply trucks sent by the Custodian of the Two Holy Mosques. Catching the translucent light, they became silhouettes, emerging like characters waiting for the director's signal to start or end the performance. We walked slowly from one narrow alley to another, from one dream to another. Making our way toward Shatila, I was surrounded by the cold, brittle humidity. I'd never dreamed of a sun that emitted such gray light; the feel of its rays on the body was confusing. I recall descending into a narrow passageway formed by two collapsing roofs, each of which leaned into the other, rising sweetly to protect those who sought refuge beneath their wings.

At that moment, I was thinking about the camera, and how I'd solve the challenge of crossing this narrow passageway. How, though, would the camera solve this abysmal feeling, the aura of gray light that

surrounded everything, saturating it with desolation and dampness? We walked . . .

The passageway widened three or four extra centimeters. We breathed. Swallowed. Tasted the odd dryness. Pale faces stole cautious glimpses at us, and we discovered windows behind water or behind a bowl of bananas. Our faces, exposed to the air and the sun, seemed to be returning from a 309-year slumber in the cave.[45]

We walked . . .

Out of the darkness the sheen of almond wood came into view, resting on two gray knees, and I saw the lower end of a beautiful weapon. Bit by bit the faint clamor of the engine of an electric generator reached us, then people laughing behind a doorway, followed by the smell of coffee, then a patch of water rimmed with soap flowing like a river from behind a curtain, and a little girl battling her way up slanting cement pillars to peer down and see us walking by then laugh. Climbing a cement staircase, we moved from grayness into darkness and I was unable see. Trying to overcome the dizziness of the transition and adjust my eyes to the darkness, I remembered again Christ's saying, "The eye is the lamp of the body." I recognized a table—yes, a table, clean, with a lit candle on a glass plate and a bundle of the morning's latest newspapers on its smooth surface. A kind old man was smoking his cigarette with a luminous joy. "Have a seat." We sat down. The sofa had a velveteen touch, long and cozy. Next to him was a brunette smoking silently. A lighter and a pack of cigarettes separated her from me.

At first nobody spoke. The only sound nearby was that of shoes being wiped firmly against the door's threshold, then the sound of them crossing the room to an adjacent cement staircase. It was a peculiar human silence—passing, going down stairs, puffing on cigarettes, newspapers being folded and wrinkled, the sipping of coffee and tea. Apart from these sounds and this silence, everything seemed to have taken on a distant eternal dimension—life, motion, light, sunshine, the past, words. The present moment had accumulated into a mass chipping away at one thing: Shatila. Shatila—this word now contained

only letters. It was no longer a 'camp' or possibly even 'Palestinian.' It was a word that had regained its figurative meaning or essence. I tried to draw more of the candlelight toward me and break though some of the estrangement we'd suddenly felt. Yesterday, I was amazed by the presence/the dream. Now I was seized by something else. Their looks were ardent. But I very much wondered to myself about this darkness that hid within it the soul's meanings. Was it the passion of reproach? Or blame? On one wall was a photograph of Abu Ammar and on another wall was written a statement he had made that revoked the Palestinian self and cast it toward the kinship of another self. It may have been a beautiful saying in politics or ideology, even in some literature, but at that moment, I wished I were someone who couldn't make out words very well. I envied our mothers and fathers their illiteracy and tried to imagine myself looking at these words hanging there, unable to decipher them, how they'd fall into the realm of the unknown or magical. Maybe I would imagine them to say, "*I seek refuge in the Lord of the people, the King of the people, the God of the people, from the evils of sneaky whisperers, be they of jinn or man.*"[46]

There was a familiarity among them that I hadn't noticed previously in the offices—a cordiality, tenderness, a generosity. They were telling jokes and gesturing with their hands, moving in a way that verged on hugging. The formality was gone—the meaningless rigidity, the throatiness of voice, the horrid monotony.

"Coffee?"

Oh my God! Is this possible?

It was hot. The warm steam drifted toward me. The intense smell penetrated the air. With a perfectly synchronous motion, the woman picked up her pack of cigarettes and offered me one, and I could see her face. I definitely saw her face. I became confused. Was it bronze? Fair or brunette? I shamelessly contemplated her face, and sensed a tinge of blueness and paleness.

She said with a smile, "You have to have a cigarette with coffee." The familiar tones of her voice brought it all forcefully back.

Oh my God again! What delicious coffee!

"Delicious," I said, loudly. The old man smiled with a bottomless depth and gloating insinuation when he said, "We have lots and lots of coffee."

Amna came in.

She entered cheerfully. For a fleeting moment, she lost her poise, which made me feel a strange rush of warmth. Her hair was wet and she approached us wrapped in something white and fluffy, like a little girl in new Eid clothing. We knew we were the first visitors, and even though I still hadn't realized that we'd met before, she was here to see people she knew.

I'm not sure why I imagined her wrapped in a white lamb's skin that was supple and fresh. The thought horrified me when it made me remember the first scene from the script of my film "Advertisements of a City that Existed Before the War," about a white lamb that falls from the sky to be snatched by two hands that immediately place its neck in front of a saw that cuts off its head and splatters blood in our faces.

Amna said, "Welcome, Muhammad!"

She approached me, hiding behind the shyness of a woman who believes, perhaps, that the siege must have taken away some of her femininity. Her eyes wavered between looking down at the ground and sad glimpses around, hungry for faces, movement, or light. She shook hands with me then stepped back smiling pleasantly. She said in a proud and husky voice, "We saw your film *The Dream* during the siege. It's good. We laughed a lot, and it also made us sad. We laughed hearing the dreams we used to have. Don't you want to make another 'Dream'? Why not, we have new dreams, different ones. How are things outside? We're alright, as you see." Then she trembled a little and thrust her hands in the pockets of her white jacket. Her mind wandered, then she scrunched up her eyes like someone surprised by a strong light. She asked us to speak. Then, without waiting, she added, "Or, I know, let's go outside, and I'll show you around."

We went out.

We walked with narrow, short steps, slipping between slanting walls in a twisting black line as if we were a serpent with disjointed vertebrae.

We walked single file because the place was so narrow. The small passageways turned us into a herd of captives walking behind her, while she, in her white fur, peppered us with words. When she stumbled on a pile of debris, she would continue with her memories while trying to find a path forward. Then she'd start walking again, telling the rest of the story. Scraps of memory about death—the death of children, pregnant women, an old man, a fighter. And because they were always about death, I lingered a little, lagged behind, until they moved further away. I wanted to enjoy the splashing of the water under my feet. I walked further, to let my soul be immersed in the silence of the water. That day it was the water.

The water splattered, trickled, dripped, gushed, welled up. There was water on the walls, on the roofs, on the ground. Water everywhere takes on the color and light of things, except here, where the water has no color or light, other than its own. There was a spot in the water wherever there was a bend, an alley, a chair, a garbage can, the cane of an old man remembering, a cigarette butt that had been put out one day by Abudi or Rostom or Rawda. There was a piece of chewing gum in the water that had been given to a child by Abu Tuq after he'd received the good news that his wife was having another baby during the siege, and who had then left. There was a scrap of a torn letter in the water that a horrified girl had thrown out of her window, not knowing who was sneaking up on them, the siege or a missile? There were furnace embers in the water, a bullet, milk, urine, dung, a whisper of affection, and Abu Shaker's wink. We'd met him somewhere around here; no one could find out where he was. Umm Muhammad's telephone was in the water. As for her daughter's crooked fridge and the gray-eyed mule that mounted the staircase in that dream of hers, we never found them in the water.

I was about to sigh, the water trickling under my feet. I paused a little and looked around. Looking closer I realized that I was standing next to the roof where Umm Tareq and Umm Riyad had sat telling each other about their dreams of those days. The roof has collapsed, and Rawda's window has been carried off into oblivion. The mulberry

tree with the bleak shadows, from which we had fled, had been burned down. I recalled the image of the green bunches of mulukhiya. When I turned to look for its leaves in the water, I discovered that the water was but a requiem for the dream and the *cine. . . ma.*[47]

<div style="text-align: right;">

Damascus,
September 6, 1988

</div>

Notes

Notes to the Introduction

1 A significant portion of the audience for this retrospective, comprised of the intellectual class in Egypt, knew Malas to be a leftist whose films characteristically involve a critique of social and political issues. These implicate, if not take direct aim at, national Syrian and regional causes, embedded though these critiques may be in their narrative subjects.

2 Ever since completion of *al-Layl* (The Night), Malas's relationship with the Syrian National Film Board has been difficult, and he has since raised his own funds for his films, largely obtained from outside Syria.

3 See miriam cooke, *Dissident Syria: Making Oppositional Arts Official* (Durham: Duke University Press, 2007) and Lisa Wedeen, *Ambiguities of Domination: Politics, Rhetoric, and Symbols in Contemporary Syria* (Chicago: University of Chicago Press, 1999).

4 Such as Rebecca Porteous, miriam cooke, Rasha Salti, and Nadia Yaqub.

Notes to *The Dream*

1 al-Watani Street means 'the Patriotic Street' or 'the National Street.'

2 Any filmmaker or journalist interested in covering life in the camps had to obtain permission through a Lebanese bureau for media affairs that would direct them to the appropriate channels in the camps.

3 Zinc is commonly used for doors and roofs in refugee camps because it is a cheap building material.

4 The People's Committee was an unofficial body, separate from the PLO, composed of different influential figures among the camp residents. It was a respected body that solved day-to-day problems and challenges faced by the inhabitants of the camp.

5 At this time, Shimon Peres was acting prime minister of Israel, prior to which he had served as head of various ministries in the 1970s, including the Ministry of Defense.

6 While the Haganah was already active at that time, the reference here is to oppression by British authorities in 1936 during the British Mandate.

7 Although it is not clear whether he refers to the house's original owner or the Israeli who became the owner, the point is still that the dreamer does not understand why in the dream the owner would leave the ruins intact.

8 Palestinians in Lebanon are only allowed to work in seventy professions. As workers, they are not allowed to participate in unions or any workers' activities like strikes.

9 Referring to a Saudi princess.

10 Nahariya, Tiberias, Ramla, Acre, and Haifa are all located in historic Palestine.

11 It is unclear which 'syndicate' or association she is referring to; she is describing her husband as an employee of a syndicate although she is intentionally vague.

12 This text was first published in 1959 as *Year Five of the Algerian Revolution*, and is now published under the title *A Dying Colonialism*.

13 Meaning the Bedouin refugees from Raml, Palestine in the district of Haifa, following the 1936 expropriation of their land by the British, who later settled in the Maslakh neighborhood. This

is to be differentiated from the city of Ramle close to Lydd.

14 Swayt, Sobieh, Hamdun, Hayb, and Fayez are all Palestinian tribes from Raml.

15 'They' here refers to the right-wing Lebanese forces fighting the PLO in the Lebanese civil war; he's saying that they used hatchets on the Palestinians just as the Haganah did in Palestine in 1948 and before.

16 This was a gas-powered lighting apparatus, commonly referred to as 'Lux' in the camps.

17 Referencing the fighting in Tel al-Zaatar.

18 An ironic reference to Bashir Gemayel.

19 This could mean he is from Hebron, which is called 'Khalil' in Arabic; 'Khalili' is a family name, meaning 'of Khalil.'

20 The reference is ambiguous but she is most likely referring to what is now a mixed city in a mountainous area in northern Israel established in 1963 through a municipal merger of the Arab town of Tarshiha and the Jewish town of Ma'alot.

21 A reference to the holy person after whom the village of Qasmiyeh is named.

22 *I'lanat 'an medina kanat ta'ish qabl al-harb* (Advertisements of a City that Existed before the War) was Mohammad Malas's first novel, published first in Beirut in 1979 and later in Damascus in 1990.

23 She is referring to a series of incidents at the outset of the Lebanese civil war—government repression of a labor strike in Sidon and right-wing attacks on Palestinians in Beirut that triggered clashes between the leftist Lebanese National Movement and the right-wing Lebanese Front.

24 This is a vague statement but it suggests there might have been fighting going on.

25 The American University of Beirut.

26 A reference to the incidents of 1947, that is, the fighting and ethnic cleansing leading up to the Nakba (the mass expulsion of Palestinians from their homeland in 1948).

27 A quotation from the Hadith. The Hadith are the alleged sayings, deeds, and traditions of the Prophet Muhammad that were recorded by early Islamic scholars.

28 The reference here is unclear; there is no record of a UN secretary during that time by the name of Rock Philly.

29 The Giaconda is another name for the Mona Lisa; Malas is alluding to Umm Alaa's enigmatic qualities.

30 May fifteenth is simultaneously simultaneously the official anniversary of the Nakba for Palestinians and the national day of independence for Israel.

31 A reference to an Israeli terrorist operation where Israeli Defense Forces were disguised in the military uniform of King Abdullah of Jordan.

32 This could be any kind of station—a bus, gas, power, television, or radio station—but the exact kind is unspecified.

33 This means that the dream will not come true.

34 This was a PLO institution.

35 The name of a street in Burj al-Barajneh camp.

36 A reference to former Egyptian president, Anwar Sadat (1918–81).

37 The Islamic ablution is the *wudu'*, the act of washing certain parts of the body before prayer.

38 Martyr's Day, could refer to either one of two days: (1) the anniversary of the death of guerrilla fighter Ahmad Musa on January 7, 1965, which became identified with a day to remember all Palestinian martyrs; or (2) the anniversary of the 1973 assassination of three Fatah leaders, Kamal Udwan, Kamal Nasir, and Yusif Najjar, by Israeli forces on April 10.

39 The reference is ambiguous. It may be referring to events that took place during the War of Attrition between Egyptian, Israeli, Jordanian, and PLO forces in 1967–70.

40 It's not clear which war the speaker is referring to. He may mean the 1973 October war, which lasted some twenty days.

41 The reference is ambiguous but most likely the "security zone on

the border" was the region of southern Lebanon that Israel occupied in one form or another since its invasion of 1978 until it was expelled by Hezbollah forces in the year 2000.

42 During the civil war, Beirut was divided into predominantly Christian East Beirut and predominantly Muslim West Beirut, separated by the Green Line.

43 A type of barrel gun that has 800 rounds per minute.

44 From *Surat al-Ra'd* (The Chapter of Thunder: Qur'an 13).

45 An allusion to *Surat al-Kahf* (The Chapter of the Cave: Qur'an 18), which tells of a group of people who fled persecution for the refuge of a cave where they fell asleep for 309 years. When they awoke, the world was unrecognizable to them.

46 From *Surat al-Nas* (The Chapter of Mankind: Qur'an 114).

47 Here the special emphasis on the word 'cinema' turns the second syllable of the word into *ma'*, the Arabic word for 'water,' connoting the capacity of both water and cinema to reflect the images and dreams of the human protagonist.

Glossary

abaya: a woman's garment, worn over her clothes.

Abdel Halim Hafez: one of the most popular Egyptian singers (1929–77) of the 1950s–1970s, closely associated with the pan-Arabism of the Gamal Abdel Nasser era. His song, "al-Jabbar" (The Strong) was a very popular romantic love song, which featured in the 1963 musical film *Ma'budat al-gamahir* (The Beloved Diva) directed by Helmy Halim.

Abdel Nasser: Gamal Abdel Nasser (1918–70), president of Egypt from 1956 to 1970, who, with Muhammad Naguib, led the Free Officers Movement that overthrew the Egyptian monarchy in 1952 and established a republic. Nasser's popularity soared after his 1956 nationalization of the Suez Canal and the ensuing Suez Crisis, and despite Egypt's defeat by Israel in the 1967 war he retained his iconic status in the Arab world as a champion of pan-Arabism and the third world's struggle against Western imperialism.

Abra: a town in southern Lebanon, near the city of Sidon.

Abu Ali Hassan Salameh: the son of Palestinian resistance fighter Sheikh Hassan Salameh, who was killed in 1948 by the IDF. He was chief of operations for Black September, the organization

responsible for the kidnapping and killing of Israeli athletes during the Munich Olympics in 1972. He was married to Georgina Rizk, Lebanon's only recipient of the Miss Universe award, and lived somewhat flamboyantly in Beirut, allegedly protected by the CIA. His 1979 assassination by a car bomb in Beirut was executed by a Mossad agent.

Abu Ali Iyad: the nom de guerre of Walid al-Naser (1934–71), a senior Fatah commander in the 1960s, who set up a military intelligence headquarters and managed a highly disciplined guerrilla training camp in Syria. He took part in the Battle of Karameh in Jordan in 1968 and died fighting in northern Jordan in the aftermath of the Black September battles that took place in 1971.

Abu Ammar: the nom de guerre of Yasser Arafat (1929–2004), leader of the Palestine Liberation Organization (PLO), and later, the Palestinian Authority.

Acre Prison: a prison located in the old Ottoman Citadel of Acre, which was used by the British Mandate forces to imprison many Arabs for participating in the 1936–39 Arab revolt in Palestine.

Afula: a town in northern Israel close to the border with the West Bank. A wealthy Lebanese family, the Sursocks, owned and sold the land of the town in 1924 to the American Zionist Commonwealth, thus facilitating the uprooting and eviction of the Palestinian inhabitants.

Amal: a Lebanese Shia militant group that initially sided with the PLO in the early years of the Lebanese civil war but eventually began to fight against PLO factions, causing many Palestinians to mistrust Amal by the time Malas was in Beirut.

Anjar: a town in the Beqaa Valley where the French resettled Armenian refugees from Turkey in 1939.

Aqaba: a Jordanian coastal city on the Red Sea and the site of the Battle of Aqaba of July 1917, in which the forces of the Arab Revolt were victorious over the Ottoman defenders.

arak: a distilled alcoholic drink made from grapes and aniseed. It is produced throughout the Levant and has a milky white appearance when mixed with water.

arghile: a water pipe used to smoke flavored tobacco. Popular throughout the Middle East, it also goes by the names of hookah, narghile, and shisha.

Armed Struggle Headquarters: the headquarters of a body established to unify all the armed factions of the PLO, although it proved itself to be unsuccessful in representing these factions. It also acted as a military police for the PLO.

ashbal: (sing. *shebl*), meaning lion cubs; a term used to refer to teenage Palestinian fighters.

Awali River: a river that flows through southern Lebanon into the Mediterranean Sea.

Baddawi: a Palestinian refugee camp near Tripoli in northern Lebanon. Its inhabitants hail primarily from the Safad and Acre districts of Palestine.

Bashir Gemayel: president of Lebanon (b. 1947), a Phalangist leader, and supreme commander of the Lebanese forces during the civil war until his assassination in 1982.

Beit Mery: a town on Mount Lebanon overlooking Beirut.

Black Saturday: a series of massacres and armed clashes in Beirut, with mostly Palestinian civilian casualties, that occurred in the early stages of the Lebanese civil war, from December 1975 to January 1976.

Burj al-Barajneh: a Palestinian refugee camp, located in the southern suburbs of Beirut and established by the International Red Cross in 1948 to absorb Palestinian refugees coming from the Galilee. Nearly one fourth of the camp's population was displaced during the Lebanese civil war.

Burj Hammud: an industrial area, one of the most densely populated in the Arab world, with a large Armenian presence.

Burj al-Shamali: both a Palestinian refugee camp and a town located in southern Lebanon, close to the city of Tyre.

Camp Wars: the wars that took place in Lebanon during 1985–87 in which Palestinian refugee camps were besieged by fighters of the Amal party. They began with intense fighting between Amal (with the backing of the Syrian regime) and Palestinian camp militias over control of the camps close to Beirut: Sabra, Shatila, and Burj al-Barajneh. The second siege took place at the camp of Ein al-Helweh and the third at the camps around the town of Tyre. The aim was to eradicate all armed Palestinian militias from Lebanon.

Dalila wa Zeibaq: a 1970s Jordanian television series starring Syrian actors and set during the Mamluk era. The show revolved around the strong-willed female character Dalila, whose husband was murdered and whose murder she avenged by having the head of police assassinated.

Damour: a Christian Maronite town located south of Beirut; it was the seat of Phalangist power and the site of a fierce battle in January 1976 between PLO forces and the Phalangist fighters that took place days after the Karantina massacre.

Deir al-Qasi: a Palestinian village that was located northeast of the city of Acre. It was officially occupied by Israeli forces in October 1948 and completely ethnically cleansed by May 1949. Most of its inhabitants fled to Lebanon.

Dikwaneh: a suburb north of Beirut, predominantly Maronite Christian.

Ein al-Helweh: the largest Palestinian refugee camp in Lebanon, located in the south close to the city of Sidon. Established in 1948 by the International Committee of the Red Cross to absorb and tend to the flood of refugees pouring in from northern Palestine, it came under UNRWA's administration in 1952, and remains so to this day.

Fakhani: a Palestinian enclave in Beirut, considered the PLO's headquarters in Lebanon.

Fatiha: the opening chapter of the Qur'an, with which every ritual prayer in Islam commences.

Ghandour: a famous food factory in Lebanon that employed many Palestinian workers to produce food items such as chocolate, chewing gum, and cookies. The factory still stands.

Glubb Pasha: Lieutenant-General Sir John Bagot Glubb (1897–1986) was a British soldier, best known for training and leading the Transjordan's Arab Legion from 1939 to 1956. Glubb Pasha led the Arab Legion across Jordan to occupy the West Bank in the 1948 Arab–Israeli War. He was dismissed in 1956 by King Hussein, his dismissal serving the anti-imperialist sentiments that were felt across the Arab countries at the time.

Haganah: the main Jewish paramilitary organization in British Mandate Palestine from 1921 to 1948, which later became the core of the Israel Defense Forces (IDF).

al-Hajar al-Aswad: a Syrian suburb four kilometers south of Damascus.

Hajj: the annual Islamic pilgrimage to Mecca, one of the five obligatory duties or pillars of Islam, performance of which is required at least once in a lifetime. Also a title of respect to a man who has completed the pilgrimage.

Hassan Hamdan: prominent Lebanese communist intellectual, writer, and teacher (b. 1936) who was martyred in 1987. He was known to the people as 'Comrade Tariq' and as an intellectual who took on and explained the causes of nationalism and liberation in simple and clear language.

hatta and 'aqal: the head cover and headband respectively that men wear in some Arab countries.

Hibariyeh: a village in southern Lebanon in the governorate of Nabatiyeh.

Historic Palestine: The part of Palestine that became Israel in 1948. Also commonly referred to as '1948 Palestine,' as distinct from Gaza and the West Bank.

Holon: an industrial center close to Tel Aviv that was once the area of the depopulated Palestinian villages of Tel Arish, Darwish, and Abu Kfir. Jewish settlement in the area began in the 1920s.

Ibn Sireen: Muhammad Ibn Sireen was a Muslim interpreter of dreams who lived in Iraq in the eighth century AD.

Jiyya: a Christian coastal village in Lebanon, in Mount Lebanon governorate, south of Damour.

Jwaya: a village in southern Lebanon in the center of Jebel Amel, near Tyre.

Kafr Qasim: a Palestinian militant operation conducted by sea, named after the 1956 massacre of villagers of Kafr Qasim by the IDF.

Kafr Rumman: a Palestinian village located 11 kilometers from Tulkarm in the West Bank.

Kamal Jumblatt: Druze politician and an unorthodox intellectual of his times who was against authoritarianism (thus against the Baathist regime of Syria) and supported a secular government in Lebanon, in addition to supporting the PLO. He was born in 1917 and assassinated in 1977.

Karantina: a slum neighborhood in the Christian section of Beirut with predominantly Palestinian inhabitants. It was the site of bloody fighting between armed militias in 1976, namely the Christian Lebanese Front and the PLO, resulting in between 1,000 and 1,500 casualties. The Karantina massacre spread into the neighborhood of Maslakh and occurred prior to the Tel al-Zaatar massacre, which took place later that same year.

Khalda: a coastal town and crossroads at the southern entrance to Beirut. It was a strategic location for the warring parties to the Lebanese civil war.

Khalsa: a Palestinian village in northern Israel that was ethnically cleansed and destroyed in 1948. In its place now stands the Israeli city of Kiryat Shmona, which was established in 1949.

King Abdul Aziz Bin Saud: the first king of Saudi Arabia (r. 1932–53). Petroleum was discovered during his rule, transforming the country into a major regional and international power.

King Abdullah: the first king of Jordan (r. 1946–51). He was the grandfather of King Hussein, who succeeded him upon his assassination in 1951.

King Faisal: the third king of Saudi Arabia (r. 1964–75), credited with modernizing the country and promoting certain pro-Palestinian positions through his foreign policy.

King Hussein: King Hussein of the Hashemite Kingdom of Jordan (r. 1952–99).

King Saud: King Saud Bin Abdelaziz was the second king of Saudi Arabia (r. 1953–64). He died in 1969.

Kiryat Shmona: Israel's northernmost city, located near the Lebanese–Israeli border.

kunafa: a dessert of shredded pastry with cheese or nuts soaked in sweet syrup. A delicacy of the Levant, especially Jordan, Lebanon, Israel, Palestine, Syria, and northern Egypt, it is eaten on special occasions.

Land Day: an annual day of commemoration for Palestinians all over the world for the events of March 30, 1976, when six unarmed Palestinian activists were killed in a West Bank town and a hundred others were wounded by the IDF in retaliation for their coordinated demonstrations from the Galilee to the Negev against land appropriation. It was the first time since 1948 that Palestinians had participated in a collective demonstration against the Israeli occupation.

Lebanese Patriotic Movement: a group of leftist Lebanese political factions that were allied with Palestinian groups during the Lebanese civil war.

Liberation Army: the armed faction of the PLO that was established, trained, and equipped in 1961 by the Iraqi Baathist regime at that time.

Lydd: The Arabic name for Lod, which is the Hebrew name for the Palestinian city located in the district of al-Ramle. Lydd was the site of fierce fighting between Zionist forces and Arab fighters in 1948, and is known for the courageous fighting of its Palestinian inhabitants in defense of themselves and of their neighboring towns from Ramle to Jaffa. Eventually they lost, after which a massacre of hundreds of Palestinians occurred, followed by the expulsion of most of its inhabitants.

Ma'alot: a town in northern Israel built close to the remains of the Palestinian village of Tarshiha, which was largely ethnically cleansed in 1948.

mana'ish: aromatic herbed flatbreads made from bread dough topped with zaatar and olive oil and baked in the oven.

mashayikh: elderly men or clerics. It can also be used to mean heads of tribes or wealthy Gulf Arabs.

Mezzeh Prison: a notorious prison for political and military prisoners in Damascus, Syria; it was closed down in 2000.

Mieh-Mieh: a Palestinian refugee camp in southern Lebanon close to the city of Sidon on the outskirts of the Druze village of Mieh-Mieh. It is much smaller than Ein al-Helweh, which is nearby.

Moshe Dayan: Israeli politician and military leader (1915–81), who began his career when he joined the Jewish paramilitary organization, the Haganah, in Palestine in the 1930s. He fought in the war against the Arab Army of 1948 and in all major operations carried out by the IDF in the 1950s, including leading the Sinai invasion of 1956. He is best known for his role as Israel's defense minister during the 1967 war.

mulukhiya: a green leafy vegetable (Jews' Mallow or *Corchorus olitorius*) that grows wild in the Middle East, and is prepared in Egypt as a mucilaginous soup-stew; a hallmark of home cooking in Palestine, Egypt, and the Levant.

Nab'a: a very poor eastern suburb of Beirut.

Nabala: or Beit Nabala, an ethnically cleansed village in the Ramle area of Palestine in 1948.

Nahr al-Bared: a Palestinian refugee camp in northern Lebanon, 16 kilometers from the city of Tripoli. Founded in 1949, it was named after the river that runs south of it and was economically prosperous due to its proximity to both the sea and the international highway. Its inhabitants came primarily from the Palestinian cities of Safad and Acre.

Nakba: literally, 'Catastrophe'; the term used by Palestinians to describe their exodus and loss of home in 1948, when 700,000 Palestinian Arabs fled or were expelled from their homes during the Palestine war.

Na'meh: a town located halfway between Beirut and Sidon, it was a battleground of the Lebanese civil war.

Naqura: a small town in southern Lebanon where the UNIFIL forces were stationed in 1978 after the Israeli invasion.

National Liberal Party: a right-wing Christian group founded by Camille Chamoun, which fought in the Lebanese civil war.

al-Nidal: the name for the Marxist–Leninist Palestinian Popular Struggle Front (PPSF) founded in the West Bank in 1967 in the wake of the Six Day War.

Palestinian Film Association: The PLO film unit founded by Mustafa Abu Ali in Beirut in 1973.

People's Front: a leftist Palestinian faction.

pessoptimist: A reference to the protagonist of Emile Habibi's 1972 novel, *The Secret Life of Saeed the Pessoptimist*, which is about the absurdity of living as an Arab in Israel; the novel makes heavy use of black humor and satire.

Qal'at al-Shaqif: also known Beaufort Castle, is the remains of a Crusader castle situated near the village of Arnoun at a strategic point overlooking the Litani River on the road to Tyre in southern Lebanon. It is one of the few cases where a medieval castle proved of military value in modern warfare, having been initially defended by Palestinian militias but then taken over by the IDF when Israel invaded Lebanon in 1982.

Qasmiyeh: After the Nakba (the mass expulsion of Palestinians in 1948), Palestinian families settled in Bint Jbeil (located on the Lebanese border with Palestine), and then moved to Qasmiyeh, an unofficial camp in southern Lebanon, located on the coast, five kilometers from the UNRWA camp of al-Buss.

al-Qassam: Ezzedine al-Qassam (1881?–1935) was a Syrian sheikh who fought and led a peasant resistance against the British and

Zionist forces in Palestine in the 1930s. His death in 1935 by British forces in retaliation for the murder of a British constable is said to have inspired the Arab revolt of 1936 in Palestine.

Qibla: the direction of Mecca, which Muslims face in prayer.

qumbaz: a long, loose-sleeved garment worn by men in Levantine countries, open in front and fastened with a belt.

Raouché: an upscale neighborhood of Beirut, popular for its seaside walking and café area and the two large rock formations off its coast known as Pigeon's Rock.

Ras al-Bayada: a town in southern Lebanon close to the border of Palestine.

Rashidiyeh: a Palestinian refugee camp in southern Lebanon, near the town of Tyre, and a frequent target of Israeli bombing.

Regie: the name of an industrial center in southern Lebanon.

Resistance, the: the term commonly used to refer to all armed Palestinian resistance groups. At the time all factions of the armed resistance were in the PLO even if they differed ideologically. A Resistance leader could be any leader of any faction within the PLO and did not have to be of high rank.

Revolution, the: At the time when Malas was writing this diary, the word *thawra* ('revolution') referred specifically to the PLO coalition, which was headed by the Fatah faction of the PLO, although the coalition also included factions of Marxist orientation such as the Popular Front for the Liberation of Palestine (PFLP) and the Democratic Front for the Liberation of Palestine (DFLP).

Revolutionary Council: a political group that split from Fatah in the early 1970s and was headed by the infamous figure of Abu Nidal (Sabri Khalil al-Banna).

Safad: a mountain city in the Galilee, not far from the Lebanese border. It is strategically located on the trade routes between Syria and Egypt and was one of the scenes of conflict during the 1948 Arab–Israeli war. It was ethnically cleansed by the Zionist Palmach forces in 1948.

Saforia: one of the depopulated Palestinian villages in the Galilee, almost 10 kilometers from Nazareth. Most of the inhabitants of Ein al-Helweh are from Saforia.

Saint Simon and Saint Michel: two of Beirut's oldest and most well known beaches.

Saksakiya: a town in southern Lebanon not far from the town of Nabatiyeh.

SAMED (Palestine Martyrs Works Society): the most significant Palestinian institution in Lebanon—it is the economic arm of the PLO, which provided jobs, goods and training in many areas, even after the PLO was expelled in 1982. It is still active in Lebanon and Jordan and somewhat in Syria.

Sayyida Zeinab: both a shrine in Damascus and a mosque in Cairo, dedicated to Zeinab bint Ali, granddaughter of the prophet Muhammad and a daughter of Imam Ali (the fourth caliph).

servees: from the French 'service'; this is a public and communal taxi service.

Shadia: popular Egyptian film actress (1929–) of the 1950s and 1960s.

Shata Prison: a maximum-security prison used to hold Palestinian political prisoners in Israel.

Shatila: an UNRWA-administered Palestinian refugee camp established in 1949 in southern Beirut, near the neighborhood of Sabra. Its inhabitants are primarily from the villages of the Upper Galilee. When Malas was writing his diary, the Sabra and Shatila massacres of 1982 had not yet occurred, but Shatila had absorbed many refugees from Nabatiyeh, Tahta, and Tel al-Zaatar camps, which were destroyed by Israeli shelling and the Lebanese civil war between 1974 and 1976.

Shawakir: a region close to Sidon in southern Lebanon.

Shayah: a town in Mount Lebanon where a battle was fought.

Sheikh Hassan Salama: Palestinian national hero and resistance fighter who led the fight against British occupation in Palestine during 1936–39 and as a member of the Arab Army against the Zionist forces in 1948. He died in battle in 1948.

Sheikh Zayed: Sheikh Zayed bin Sultan al-Nahyan, one of the founders of the United Arab Emirates and ruler of Abu Dhabi from 1966 to 2004.

Shemlan: a village in Mount Lebanon, also a stronghold for Phalangist fighters during the Lebanese civil war.

Sohaila: a village in the governorate of Mount Lebanon.

Tantura: a Palestinian Arab town on the Mediterranean coast where Jews, Christians, and Muslims coexisted prior to 1948. It is also the sight of a massacre conducted by the Alexandroni Brigade of the Haganah, effectively depopulating the village of its Arab inhabitants in 1948.

Tarshiha: a Palestinian village northeast of Acre, whose Palestinian inhabitants were ethnically cleansed by aerial bombardment on October 28, 1948 by Zionist forces.

Tel al-Zaatar: a Palestinian refugee camp in northeast Beirut (its name means 'Hill of Thyme'), established in 1948. It was home to 50,000 to 60,000 refugees at the time of the Tel al-Zaatar massacre, which took place on August 12, 1976, one year into the Lebanese civil war. The massacre was the result of fierce fighting between Syrian-backed Christian Phalangist forces and PLO factions, from which the civilian casualties were estimated at between 1,500 and 3,000 people.

The 1967 war: also known as the Six Day War and referred to as the Naksa ('Setback') by Arabs, the 1967 war took place between 5 and 10 June 1967. In just six days the Israeli Defense Forces (IDF) wiped out the entire Egyptian air force, took the Sinai Peninsula and Gaza Strip from Egypt, the Golan Heights from Syria, the West Bank from Jordan, and killed tens of thousands of fighters from the Arab forces.

The 1978 war: The Israeli invasion of 1978 (also known as Operation Litani) was when IDF forces entered Lebanon from its southern border and fought their way up to the Litani River, ostensibly in retaliation for a bus hijacking by Palestinian militants in Israel that had taken place three days before, although

there had been many other exchanges between Lebanon and Israel to which this operation could be attributed. According to local hospital records, more than 1,000 Palestinian and Lebanese civilians were killed in the process, and hundreds of thousands of civilians became internally displaced.

The South: the Shia-dominated southern region of Lebanon, which has figured prominently in the conflicts between Israel and Lebanon, and was briefly declared the "Free Lebanon State" by the forces of Saad Haddaad in 1979.

Tiberias: a city on the western shore of the Sea of Galilee, named after the Roman emperor Tiberius. Before 1948 it was a cosmopolitan city where Jews, Muslims, and Christians co-existed in relative harmony.

toushte: a multi-purpose bowl used for many things, including washing clothes, washing dishes, bathing.

Umm Kulthum: legendary Egyptian diva (1904?–1975), arguably the most popular and influential Arab singer of the twentieth century. Hailing from humble origins in Egypt, she rose to fame in the 1940s and 1950s, her passionate songs and exceptional vocal range endearing her to millions of listeners in Egypt and beyond.

WAFA: or the Palestine News and Information Agency, is the official news service of the Palestinian National Authority, and was prior to that the PLO's official news agency.

Warda: iconic Arab singer (1939–2012); her full stage name, Warda al-Jaza'iriya, means 'the Algerian Rose.' Born Warda Fatouki to an Algerian father and a Lebanese mother, she spent most of her adult life in Egypt. Known for her rich, sultry voice, she achieved her main professional breakthroughs in Egypt, which won her fame across the Middle East.

Yarmouk: the largest Palestinian refugee camp in Syria prior to the events of the Syrian uprising (2011) and subsequent civil war. Established in 1957, it lies on the outskirts of Damascus and is effectively a neighborhood of the city. It is an unofficial camp only in the sense that UNRWA does not deal with solid waste

collection, but otherwise UNRWA operates it much as it does in any other official camp.

zaatar: an aromatic blend of spices, commonly made of ground thyme, oregano, sumac, and sesame seeds, the ingredients varying slightly depending on the country, and eaten, traditionally for breakfast, with bread and olive oil.